THE ART OF
DIGITAL
PHOTOGRAPHY

THE ART OF
DIGITAL PHOTOGRAPHY

Tom Ang

Amphoto Books
An imprint of Watson-Guptill Publications
New York

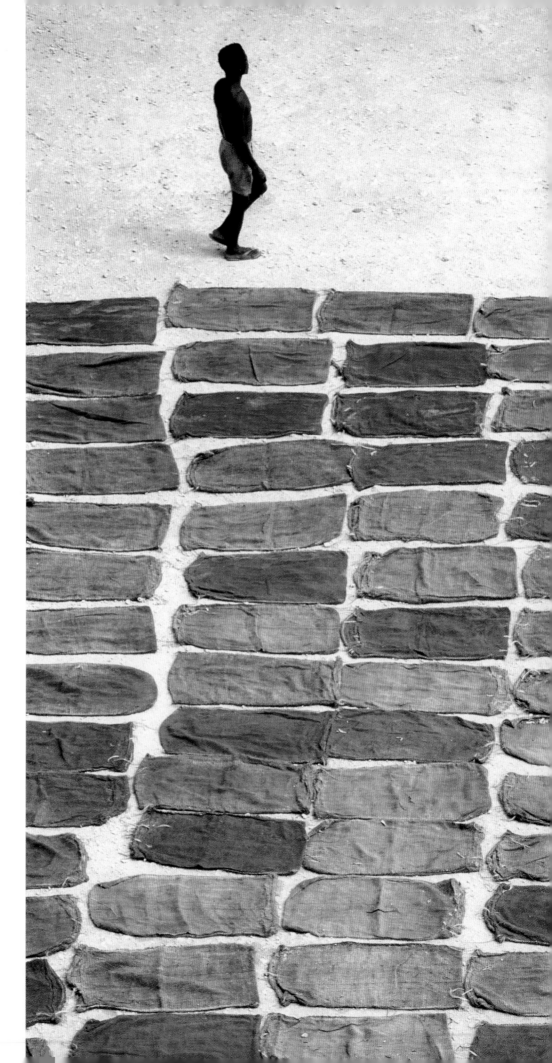

The Art of Digital Photography

This book is dedicated, with thanks and love, to Wendy

First published in 1999 by Amphoto Books,
an imprint of Watson-Guptill Publications,
1515 Broadway, New York, NY 10036

Executive editor **Judith More**

Executive art editor **Janis Utton**

Project art editor **Simon Joinson**

Designer **Mike Lucy**

Project editor **Michèle Byam**

Contributing editor **Jonathan Hilton**

Production controller **Rachel Staveley**

Indexer **Hilary Bird**

CIP catalog data for this book is available from the Library of Congress

ISBN 0-8174-3794-0

Set in Myriad

Printed and bound in China

CONTENTS

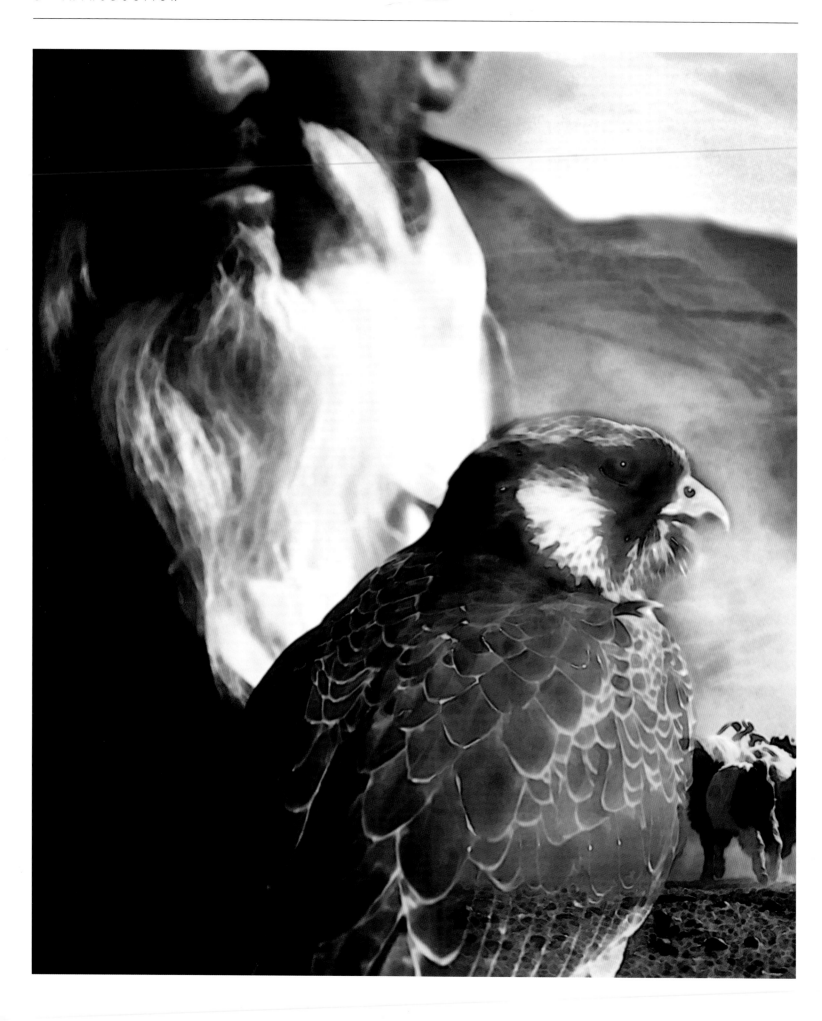

Introduction

We love to record new and exciting scenes. We want to see good-quality results, and see them quickly. We demand flexibility in the way we obtain our images. And we like to be creative while pursuing our leisure activities. Digital photography satisfies all these requirements, while offering us so much more.

Digital photography is a completely new way to capture images, and it provides new techniques to work with them afterward. As a result, it is changing the way we think about the entire photographic process. And with its speedy and convenient delivery of pictures, digital photography may eventually fulfill our entire wish list for image-making.

Better yet, one of the great advantages digital imaging has over conventional photography is that you can produce any number of different images all without using any paper or chemicals. In fact, the only thing you use is the little electricity it takes to run your computer. Digital photography is arguably more environmentally friendly than conventional photography. What is more, you do not need to convert some unused corner of your home into a darkroom – on the same desktop that you play games, surf the Internet, or do your tax returns you can carry out all of the digital elements involved in digital photography.

But will digital technology remove the fun from taking pictures? Have digital technologies made it so easy to create photographs that your hard-won photographic skills will become irrelevant? Will the digital process replace conventional photography? Will digital photography allow you to turn a boring snapshot into a great picture?

There is only one way to learn the answers to these questions. You have to do it, and do it yourself. This gives you the challenge of learning new skills. It gives you the fun and excitement of creating your own images, and at the same time you know you are working with leading-edge technologies.

The aim of this book is to provide the essential grounding you need to start experimenting with digital photography. It is designed to be your reference and your inspiration, a sourcebook of ideas and techniques brimming with facts, clear explanations and pictorial examples. The book itself is an example of what can be achieved with modern technology: it combines many years' photography with digital imaging. Most of the images in this book were taken on conventional cameras and film, scanned in widely available scanners, and the resulting files prepared for publication on a desktop computer using standard software. (*See also How this book was produced on page 157.*)

The more effort you put into mastering the techniques of digital photography, the more rewarding, enjoying, and fulfilling results will be. Just to get you excited about this new world of image-making, here are just some of the things you can do with digital images that you cannot do with conventional photographs:

• Publish them on a web-site so that thousands of people can view them at the same time.
• Attach them to an e-mail.
• Make numerous copies without any loss of quality.
• Make catalogs of your images so you do not need access to the originals.
• Stitch images together to make a panorama.
• Turn a sequence of pictures into an animation.
• Automate actions so that you can, for example, change the size of hundreds of images at the press of a button.
• Change one color without altering any others.
• Have a lot of fun without producing any mess or spending any money.

If you have not already realized it, this is photography's renaissance. It is a privilege to be a part of it.

Tom Ang

◁ *Two different prints, one of an old falconer in Kyrgyzstan and one of a flock of sheep in Uzbekistan, were first double exposed in a conventional camera on the same frame of film. I then scanned the result and worked on it to clean the cloud of dust away from the falcon's face in order to smooth the blend between the two images.*

About this book

By encompassing basic photographic techniques, this book is broader in scope than a simple introduction to digital imaging, although it is not intended as a complete guide to design techniques.

The first two chapters, *Welcome to Digital Photography* and *Digital Shooting*, are a gentle introduction to the potential of the fascinating world of the digital camera. It assumes you know nothing about it and explains the basic equipment you need to get started, how digital photography differs from working conventionally, and highlights the fact that much of your traditional experience as a photographer can simply be transferred to working digitally. If you come across a term you don't understand at any point, just refer to the comprehensive glossary at the back of the book.

The next chapter, *Revitalizing Existing Images*, will come as a relief to all those photographers who may have feared that years and years of their images may have been rendered obsolete by the new technology. It is not so! Any existing film original or print can be scanned and tidied up, and is then available for you to work on via the appropriate software running on practically any computer available today. And if you want to take your image-making to a completely new level – perhaps combining elements of different images, altering color, correcting contrast, or creating fantasy effects – then the chapter on *Picture Processing* will set you on the right path.

Master Class is a showcase chapter, presenting the work of digital masters and how they combine artistry with technical accomplishment. Many photographers will find *Digital Photography Projects* especially useful, since it shows how to apply your new knowledge of digital technologies to areas of particular photographic interest. And *Sharing Your Work* helps you link up with a wider audience by explaining how you can publish your images conventionally or electronically via the Internet.

Understanding the Technology aims to take you further, with more advanced explanations of the technologies involved in the digital processes. And finally, to speed you on, apart from the glossary, there are suggestions for further reading and useful worldwide web-sites to visit.

▽ *Digital-imaging techniques work in perfect harmony with conventional photography. The original of the image here was an underexposed negative. It made a poor scan, but tonal manipulation and the application of a duotone created in the computer helped to rescue what information was available in order to create a simple and effective image.*

WELCOME TO DIGITAL PHOTOGRAPHY

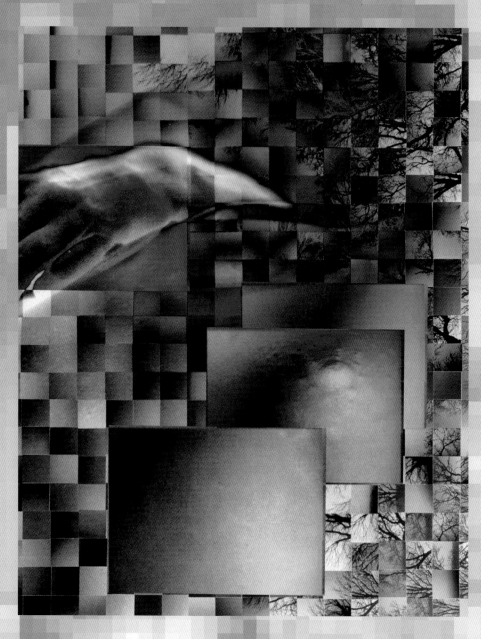

What is digital photography?

Digital photography uses electronic devices to capture and store images transmitted via an optic, or lens. If you use a digital camera to take your pictures, then the process is digital from the outset – from image capture right through to final printout. However, many photographers work with conventional cameras and film, making what are known as analog (*see box on right*) records of subjects and scenes, which they then turn into digital form. This, too, is regarded as digital photography because the digital step is crucial to the creation of the final image. In this way digital photography greatly extends the scope and range of conventional, or normal, photography.

As you will see throughout this book, there are many practical as well as theoretical differences between using normal and digital cameras to take the initial picture. The key difference is the light-sensitive medium used to capture the image. In a digital camera, an electronic sensor converts, or transforms, light falling on it into variations of electrical charge. The charge is then measured by electronic circuitry and turned into a code that computers can read (*see also pages 134–5*). This process is analogous to normal photography in which the film represents the sensor. In film, silver salts suspended in the emulsion convert the amount of light falling on them into a latent image. The amount of silver deposited from each part of the latent image depends on the amount of light that has fallen on it. It is the chemical processing the film undergoes that magnifies these changes to make the image visible.

Even with a digital camera, the first step – capturing the image – is, in fact, an analog process. This is important since certain problems associated with recording on film – such as its limited ability to record brightness and darkness at the same time (the dynamic range) and a fixed relationship between sensitivity and image quality – cannot be eliminated.

Once the image is in digital form it is very similar to any word-processor, spreadsheet, or database file. You can store it on normal computer hardware, such as floppy disks or hard disks, transfer the file between computers, send it anywhere by telephone, and so on. Like any computer file, however, it must be in a form that can recognized by the program before you can use it for image manipulation, combining with other images, or printing. But once an image is in digital form, the control you have over its appearance is endless.

Furthermore, because a digital file is essentially a long string of ones and zeros one can make absolutely perfect digital copies of any file. It follows that copies of copies will also be perfect: so, for the first time in photography, duplicate images can be perfect.

Subject

Digital Camera

Internet

WWW

Conventional Camera

Computer

Disks

Films and negatives

Printer

Scanner

◁ *This illustration shows how, starting with either a digital or a conventional film image, the two technologies can converge. Digital cameras produce computer-readable images, while film images first need to be scanned. After that point, image files can be worked on in the computer before being printed out, stored on removable media, or published on the Internet.*

Current applications

Scientific photography is the root from which digital photography has grown. Ever since Marie Curie discovered X-rays, scientists have experimented with different ways to record images, using all manner of electromagnetic radiation. Many chemicals are sensitive to specific types of radiation and so can be used to make permanent records of, say, infrared, ultraviolet, cosmic radiation and, of course, visible light. The most sensitive and versatile way to record images is, however, to use electronic sensors.

A great deal of research has been invested in producing electronic sensors for use in video and surveillance cameras, spy satellites, astronomical telescopes, and medical imaging. These sensors are generally variants of the CCD – charge-coupled device – a semi-conductor chip like those used in the main processor of a computer. What makes a CCD special is not that it is sensitive to light – for most semi-conductor chips are – it is that a CCD has its light-sensitive element arranged in a regular array. It is this that enables a CCD to capture an image electronically.

Many of the exciting visual events of the late 20th century were the product of such electronically enabled, computer-interpreted vision. The closeup views of Mars and Venus, the fantastic images of deep space from the orbiting Hubble Space Telescope, and the awe-inspiring satellite visions of our world were all first "seen" by electronic eyes. The sensors in satellites send their signals via radio to receiving stations on the ground. The signals are decoded and interpreted to turn them into pictures. The system is essentially like domestic satellite TV transmission, the difference being that the images are "created" by the satellite itself as it orbits the Earth, looking down at storms and ice formations as well as monitoring human activities, such as forest fires or oil spills.

All the technical and scientific experience gained from these highly capital-intensive studies have gone to make digital photography the relatively inexpensive and easy process it is today. We can enjoy digital photography in our homes and offices because of all the preceding scientific research and application experience in the fields of astronomy, remote sensing, spy satellites, and robotic machines of many types. It is but a small step from this to everyday consumer use of digital photography.

While the scientific motivation for digital photography centers on the desire for versatility and the need to transmit the image electronically, the exciting growth of digital photography for the general public centers on the visual equivalent to fast-food – the hunger for rapid response. Digital photographers now roam the world in search of news, and every major news agency uses digital cameras. They supply magazines with the peak of action from sports worldwide, and they deliver instant records for anybody from surgeons and generals to fashion designers and marketing managers. The interval between a shot being taken and its transmission, via a portable satellite, to a picture editor's desk on the other side of the globe can be measured almost in seconds. Photojournalists are also learning to appreciate the high capacity of digital cameras – a single memory card can hold more than 300 pictures, and changing it for a new one takes just a few seconds. And the images are immediately available for use.

Digital photography saves not only time, it saves on film and processing. By avoiding the need for chemical-based processes, digital photography reduces the need for personnel skilled in darkroom techniques. The overall effect is to make photography available to the great number of people who are competent with computers. Thus, two formerly different groups of people can now share a common interest in photography.

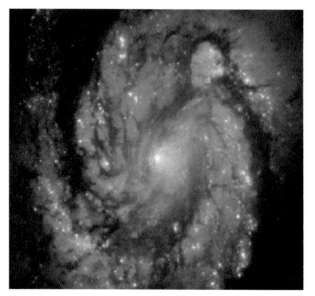

◁ The Hubble Space Telescope orbiting the Earth looks into deep space. It uses CCD technology that works almost with the individual light particles arriving at the sensor to construct its images. The money-devouring space industry has provided the expertise used in today's digital cameras and software. This image, released in 1994, shows the spiral galaxy M100 in the Virgo cluster, one of the most distant from Earth of all galaxies in the universe.

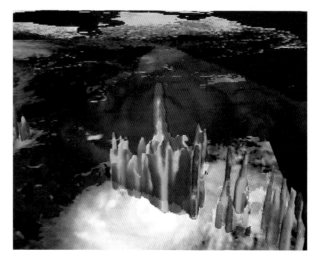

◁ This is a representation of the cumulonimbus storm clouds of Hurricane Bonnie, recorded in August, 1998, over the Caribbean by the Tropical Rainfall Measuring Mission satellite – the first space-borne rain radar. It shows, with exaggerated perspective, the incredibly high chimney clouds – some reaching a height of 59,000ft (18km) – created by the hurricane's intense low pressure.

New pathways

Far from being a threat to classical photography, digital processes have opened up new possibilities and new horizons. The dream of using different speed films in the camera at any time is close now that some digital cameras allow you to choose different CCD sensor sensitivities. You can even swap from black and white to color at will. To the usual pathways – from taking the photograph to the final print or presentation – can now be added a new world of possibilities.

The key part of the process is scanning. Once the image has been turned into a digital copy, you have something that can be copied perfectly, without any further loss of detail, as many times as you like. In addition, it makes no difference how the information is stored, where it is stored, or how it is moved around. This is why a digital copy of one of your slides could be on your hard disk and, simultaneously, a million other people can see it on their computer screens through the Internet, while at the same time you (and, indeed, any number of others) can print the picture out.

Choice upon choice

When you combine these properties with classical photographic processes, your creative choices multiply. You not only have more ways of achieving the same ends, you have a greater choice of end-products. A picture of your child on the swings, for example, does not have to be just a paper print. You could print it out on thin cardboard, which can be folded to make a greeting card. You could print it on ink-jet paper and then transfer it with a hot iron on to a cotton T-shirt. You could also put the picture on to a china plate, or even spray it on to the side of a bus using a giant ink-jet printer.

One of the secrets of professional photography is that every extra step of production you undertake represents an additional opportunity for creative intervention and invention. That is why sending your film to a processing laboratory is so dull and uninvolving. If you develop your own films, you can choose exactly how to adjust each stage of the processing. If you have access to a darkroom, you can make prints exactly how you want them to look. With digital photography, there is an added opportunity to work on the image by manipulating it in the computer. And when you print out, you can vary the image's appearance yet again through your choice of paper, playing with different textures, colorings, and preprinted images (*see also pages 122–3*).

Once you have worked on a digital picture file you can choose to stay in the digital domain or you can return to an analog way of working by "exposing" the digital file back on to photographic materials – either film or paper – using

special equipment. If you go the film route, the result is a negative or transparency from which you can make prints in the normal way using the whole range of traditional darkroom techniques – both exposure manipulations such as masking or solarization and chemical changes like toning and bleaching – to alter the image's appearance. On the other hand, if you go the paper route, you will have a photographic printout of your digital file. In either case, you will have an image that could be almost indistinguishable from one that was created entirely through analog processes. And you benefit because every extra step gives you a chance to intervene creatively.

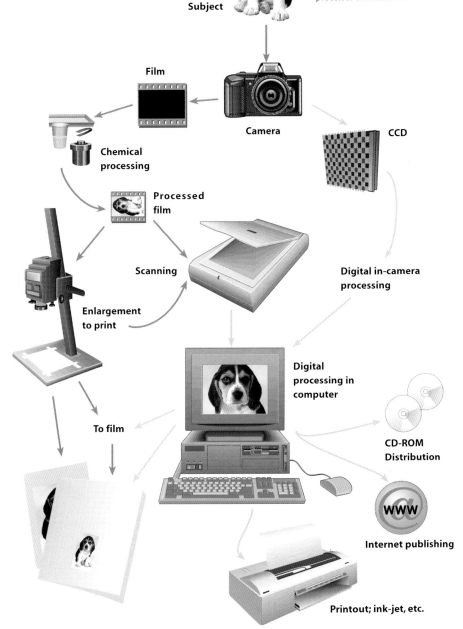

▽ *The diagram below shows schematically the choice of pathways to the final product, with the largely digital processes on the right-hand side of the diagram and the conventional processes on the left-hand side.*

Subject

Film

Camera

CCD

Chemical processing

Processed film

Scanning

Digital in-camera processing

Enlargement to print

Digital processing in computer

To film

CD-ROM Distribution

WWW

Internet publishing

Printout; ink-jet, etc.

Equipment

Digital photography actually needs fewer specialized pieces of equipment than normal photography. This section describes the main items of equipment and the jobs they do. Pages 16–19 describe in detail how digital cameras work.

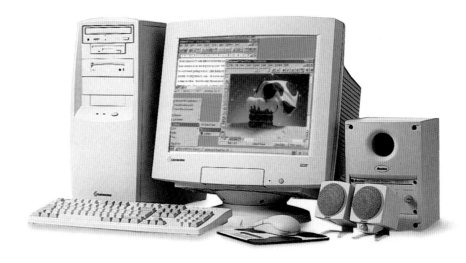

Computer

A computer receives information in a digital form and, on receiving commands from the user, changes the information according to a set of instructions provided by the software, or application program. Computers consist of a box containing the electronics, a storage medium for digital files, and connections to various devices, such as the keyboard, mouse, printer, and monitor.

Computers for home use are generally of two types: the PC-compatible (or just "PC") and the Apple Macintosh (often shortened to "Mac"). PCs are far more numerous, but Macs are more suitable for digital photography and creative work (see box on page 15). You will meet a number of terms used to describe and specify computers, such as:

Processor (or chip) type and speed The faster the chip speed – 333MHz compared with 200MHz – the better, but for the same speed, some processors are more efficient than others. For example, speed-for-speed the G3 or G4 chips in Macs compute faster than their Pentium equivalents in PCs.

System RAM The more the better. RAM (random-access memory) is very rapid memory used to store data and instructions. Since digital photography produces large files, it is an advantage to have a lot of RAM. A large RAM capacity also allow you to run several programs at once.

Hard disk This is a longer-term or mass-storage memory facility. It is where you keep programs and files being worked on. Once again, the more the better. Aim for a capacity of at least 4GB.

Connections These allow you to expand the capabilities of the computer by adding peripherals, such as printers and scanners. They are also necessary for downloading images from a digital camera. For digital photography it is most useful to have high-speed connections, such as SCSI, USB, or FireWire. Fortunately, you can add these features to most modern computers when you need them or as new equipment demands. If you want to share your work with others on the World Wide Web you will need a modem to connect your computer to the telephone line.

Removable media Modern computers have a built-in CD-ROM player. You need this, not for playing music, but for loading new software, which is now nearly always supplied on a CD-ROM. Most computers also have a floppy disk drive. This is useful only for small text or spreadsheet files.

For digital photography, you will need something with more data storage capacity, such as a Zip drive. While these drives will store 100MB of data, even they are rather on the small size for many digital image files.

Keyboard You may think that once you have seen one keyboard you have seen them all. In fact, quality varies enormously and, considering how much time you spend using it, those with noisy or uneven key actions can become very irritating to use very quickly. Take the quality of the keyboard into account from the outset, rather than having to pay for a replacement.

Monitor

This is a video display that shows you what the computer is doing. For digital photography work, you must have a color monitor. How many colors it can show is determined by the amount of VRAM (Video RAM) in the computer, the graphics card, and the design of monitor.

For digital photography, you want a monitor capable of showing at least thousands of colors, preferably millions. Monitors are described by the size of their screen – nominally the length of the diagonal of the viewable area. There are different technologies for producing the image, each of which has its strengths and weaknesses. Modern screens use relatively, or even absolutely, flat glass for the front of the screen – the flatter, the better. It is worth making the effort to see one in action before deciding which to buy as some differently priced makes are in fact internally identical.

△ Today's home computers, such as the multimedia model shown above, are powered by a processor chip (above). This device has all the power needed to process professional-quality digital images while, at the same time, it is also capable of handling all your domestic and business computing needs.

▽ A good monitor, at least 17in (43cm) across the diagonal, is a must for the hours of work you are likely to be performing.

Printer

The most widely used type of printer is the ink jet: you can achieve incredibly good-quality prints using very inexpensive machines. The best for photographic use are those that print with at least six colors (cyan, magenta, yellow, black plus variants of light magenta, and cyan or orange and green). It is worth buying the largest printer you can afford – A3 size at least. Running costs are somewhat higher than making traditional color, and black and white prints.

Another type of printer worth considering uses dye-sublimation. The readily affordable models produce only enprint-sized images (4 x 5") of about the same quality as photographic prints, but there is one inexpensive model that produces images of near photographic quality up to a A4 size (210 x 297mm).

Scanner

Scanners (*see also page 48*) turn flat artwork and film into digital facsimiles that the computer can work with. Most scanners are flat-bed types: like photocopiers, you put your original face down on the glass and then close the lid. Purchase one with a transparency adaptor, which enables you to scan transparent artwork or slides.

Another type of scanner is the film scanner. This is the only really specialized piece of equipment that you might need, and some scanners can produce professional-quality scans at a reasonable price. For the keen digital worker, a film scanner is likely to be much better value than any comparably priced flat-bed scanner despite the higher price.

Other accessories

Graphics tablet This device allows you to paint and draw in the computer as if you were using a real brush or stylus. Graphics tablets are five or more times the price of a mouse, but for digital photographic work it should be the first of your non-basic buys becuse it enables you to perform finer adjustments and changes to an image than you can with a mouse. The A5 size is best for most people – it is large enough to be useful without taking over your entire desk. Few workers will need a graphics tablet larger than A4. But don't give away your mouse: it is still the best tool for all other computing work.

Extra mass storage This will allow you to keep many image files and encourage you to make back-up copies of all the work you do. Economizing on mass storage is always, and often disastrously, a false economy. For anything important, such as images for an exhibition, it is best to keep two back-up sets. Ideally, you should buy an extra hard-disk drive to back-up your computer's internal hard disk, as well as removable media, such as 100MB discs or 1GB cartridges. As the number of discs or cartridges rises, it will pay you to buy an image database

program to keep track of them all by creating thumbnails and lists of file names along with their exact locations.

CD-ROM writer This allows you to make copies of your work in the most universal and durable of electronic media. Having one is important if you want ready access to magazines. Models are available that burn at different speeds. To make use of a CD-ROM writer, you will need special software for "burning" discs.

Modem Connecting your computer via a modem to the telephone system allows you to reach other computers and, through the Internet, to access the World Wide Web. Buying the fastest-available type of modem will save you a great deal of thumb-twiddling time. In addition to the modem, you will also need "browser" software (widely available and free of charge) to access the Internet. You will have to subscribe to an Internet service provider in order to gain access to the Internet and World Wide Web.

Uninterruptible power supply This electronically controlled battery automatically powers the computer for a short time after a power surge, long enough for you to save work and shut the computer down in an orderly fashion. It will also effectively protect your computer from sudden drops or surges in electrical power. It is essential for anybody living in an area prone to brownouts, power outages or electrical storms.

As you acquire more and more peripherals you may run out of power outlets. If you can't accommodate any more multiple sockets, don't be tempted to wire different equipment together. Keep to safe practices. Unsafe electrical wiring endangers not only your equipment, but could result in a fire. If you are not sure about the safety of your electrical arrangements, seek expert advice.

Furniture As digital photography plays a larger role in your life, you could find yourself at the computer for many hours at a time. It is, therefore, important to look after your health, and that includes making sure that you have comfortable working conditions:

• Put your computer and equipment on a stable desk.
• Sit on a comfortable chair, preferably one that gives good support while encouraging you to sit with a straight back.
• Don't place the monitor with bright windows directly in front of or behind it – bright light or reflections on the screen will strain your eyes.
• Point any table lights away from the screen.
• Finally, although a near impossible task, keep the cabling between your equipment tidy and label all power leads. It will be less of a strain when plugging and unplugging items – a task that you will become familiar with.

△ Ink-jet printers produce near photographic quality at low cost on a variety of media.

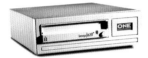

△ A CD-ROM writer is indispensable for archiving files.

△ A graphics tablet gives pen-like control of the computer, using a stylus to 'draw' on a tablet. Many digital photographers find it an invaluable device.

▽ Flat-bed scanners turn flat artwork into digital facsimiles or scans with ease and can provide good quality at a low cost.

Setting up

If you already have a home computer, all you need additionally is a digital camera or scanner. However, if you already own a conventional camera and a computer, you may prefer to start with a scanner. But if you are starting out on your exploration of digital photography from scratch, all you need to buy is a digital camera and a compatible printer. With this basic set-up, once you have taken a picture just connect the camera to the printer and in minutes you will have a colorful print in your hand.

Budgeting

When it comes to buying equipment, the best advice is that the more you are prepared to spend the higher the specification of the components; the higher the specification, the better the results you can expect and the more flexible your method of working will be. Bear in mind that your investment in digital photography will give you hours of fun and rewarding recreation.

Basic outfit The outfit for a basic set-up capable of giving you good-quality color prints up to enprint size (4 x 5"), or for the Internet, is as follows. (Its cost equates approximately to a 35mm camera plus standard lens.)
• An Apple Mac computer (or PC if you already have one) with a processor running at least at 266MHz, with a minimum 128MB of RAM, 4MB of VRAM, a hard disk with at least 4GB, and a CD-ROM or DVD player.
• A 15in (38cm) monitor with a resolution of at least 1024 x 768 pixels.
• A digital camera capable of at least 960 x 480 pixels or a scanner with resolution of at least 600 points per inch (ppi).
• Software, such as Adobe PhotoDeluxe or MGI Photosuite, which often come with the camera or scanner.
• An ink-jet printer, printing to A4 size at a resolution of at least 600dpi.

Semi-pro outfit The following outfit can produce good-quality prints to A3 size and provide you with the basis for semi-professional work. (Its cost equates to that of an advanced 35mm outfit with several high-quality lenses.)
• An Apple Mac computer (or PC if you already have one) with a processor running at least at 266MHz, with a minimum 256MB of RAM, 4MB of VRAM, a hard disk with 6GB or more, and a CD-ROM or DVD player.
• A 17in (43cm) monitor with a resolution of at least 1024 x 768 pixels.
• A digital camera capable of 1280 x 960 pixels, or flat-bed scanner with an optical resolution of at least 600ppi, or a film scanner with optical resolution of at least 2500ppi.
• Adobe Photoshop software.
• An ink-jet printer, printing to A3 size at a resolution of at least 720dpi using six or more colors.

• Removable storage media with a capacity of at least 100MB per disk.

Professional outfit For this next higher level, you should consider investing in both a flat-bed and a film scanner. Next, consider purchasing the following items, which will enable you to work to high levels of quality and professionalism. (Total cost is about that of a medium format camera and several high-quality lenses.)
• A graphics tablet – using this is close to using a pen or pencil. Control is much more precise than with a mouse; it is also less tiring to use and your movements are freer.
• Digital photography is RAM-hungry because typically files are very large. The more RAM you have installed on your machine, the faster you can work, and some software effects are impossible to achieve on a large file without enough RAM. You cannot have too much RAM, although benefits lessen when the total is more than about 300MB.
• Extra mass storage – you cannot have too much of this. The easiest form to buy it in is as an additional hard disk drive – the biggest you can afford – to supplement your computer's built-in drive. For removable storage, consult widely on which system is used by most people, since this tells you much about reliability and compatibility.
• A modem enables your computer to connect with the Internet. It also allows you to view other people's pictures, to show other people your work, and gives you the chance to download tens of thousands of images for your own use – some of them free of charge.

△ A modem is a device that converts digital signals of the computer into the analog tones that a telephone line handles, thus enabling computers to use the telephone system to log onto the Internet. Get the fastest modem you can afford to minimize phone bills – at least 56K (i.e., it can transmit data at a rate of over 50,000 bits of information a second).

Mac versus PC

The main question for anybody thinking of buying a computer is: "Mac or PC?" The main practical difference between PC-compatibles and Apple Macs is that Macs are easier to use. That is because the operating system – the program that you first see when the computer is ready to work – on a Mac is far easier to understand and work with than that on PCs. Macs take peripheral devices and expand very easily and can network almost immediately. On a PC, the addition of anything beyond a printer is tricky at best. For serious digital photography, you will want to increase RAM greatly: on most PCs, it is difficult to increase RAM to high levels. However, PCs are better than Macs at running different programs at the same time. Market surveys consistently prove that creative workers are more productive and more profitable on Macs than on PCs. For the digital photographer, control over color is hugely important: on the Mac, color management is mature and well supported; on the PC, it is rudimentary. While nearly everybody worldwide uses PC-compatibles, the majority of people producing material for books, magazines, and advertising are still Mac users.

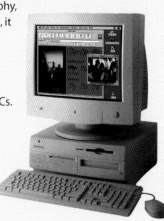

The digital camera

Imagine that your eyes are connected to a device capable of measuring the electrical impulses generated by your retina – the light-sensitive layer of the eye. You could, in theory, construct images from the pattern of impulses they generate. A digital camera works in a similar way. An electronic processor in the camera reconstructs the image by measuring the electrical impulses from each element of a light-sensitive sensor. The resulting image is then written in a digital form onto memory, ready for transfer from the camera to a computer or printer.

There are four main types of digital camera, not counting specialized scientific instruments. The most basic has a fixed lens, only built-in memory, and uses a direct-vision viewfinder. Most digital cameras are a grade up from this. They have an autofocusing lens, which may be a single focal length or a zoom, use removable media (storage you can take out of the camera), and frame pictures using a direct-vision viewfinder and/or use a small LCD screen to show the view through the lens. A few higher-priced cameras are single lens reflex (SLR) models, which allow you to look through the lens via a mirror to see the actual view encompassed by the lens. The image quality from the most expensive cameras of this type is very high indeed. The fourth type of digital camera is devoted to studio use by professional photographers. While they produce extremely high-quality images, they must be tethered to a computer and are slow to use since they scan the images.

Digital photographs can also be produced by digital video camcorders. These do allow you to make large numbers of images easily, but the quality of each one is only on par with the cheapest digital still cameras.

Parts of a digital camera

Sensor Most sensors in use are of the CCD type, so they may be referred to simply as CCDs. Typical specifications will read 1280 x 960, meaning 1280 pixels along the width and 960 pixels across the depth. This delivers more than a million pixels, which should be enough for a photo-quality print size of about 5 x 4in (12 x 10cm). A specification of 1280 x 1024 is marginally better, but 640 x 480 gives inferior results. Ensure that the figures quoted are the actual sensor size and not the picture size, which may be artificially inflated (*see pp.136–7*).

△ *Typical CCD sensor.*

Lens The quoted focal length of a lens tells you whether it has a fixed focal length (such as 45mm) or it is a zoom (such as 28–70mm). From the focal length figure you know what the field of view of the lens is. A short focal length, or wide-angle lens, takes in a broad swathe of a scene, while a long focal length, or telephoto lens, takes in less of a scene but gives you a higher magnification.

Some confusion is caused by the fact that the field of view for a given focal length varies with the size of the sensor, and sensors for digital cameras come in many sizes. The general practice is to quote the equivalent for the standard 35mm format. Typically, a fixed focal length digital camera has a lens equivalent to a 35mm focal length, and zoom lenses cover the range equivalent to about 30–80mm. It is extremely difficult to obtain truly wide-angle results, since CCDs are very small. However, most digital camera lenses can focus very close up indeed – to have a petal nearly touching the lens, when the center of the flower is sharp, is not uncommon.

Viewfinder You need to see what you are shooting. The simplest and most common viewfinder is an optical viewfinder. With this, you look directly at the subject through a glass window to see a bright, but usually tiny, image. When framing is critical, this is not the ideal system. Some expensive cameras use a single lens reflex design, that allows you to view the subject through the lens itself.

LCD screens are often used to supplement a direct-vision viewfinder, but in some cases they are the only solution. An LCD is a tiny monitor on the back of the camera or on a rotating flap, which shows what is reaching the CCD. When used as a live-action viewfinder, LCD screens can be slow to "refresh" – update the image – and all use a lot of battery power. However, an LCD is essential for framing close-ups on cameras with direct-vision viewfinders.

Flash This uses up battery power quickly. Nearly all digital cameras have a built-in flash adequate only for occasional use with close subjects.

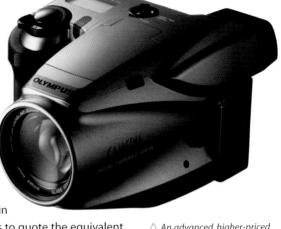

△ *An advanced, higher-priced single lens reflex type digital camera – as you look at the image through the lens it is good for accurate composition.*

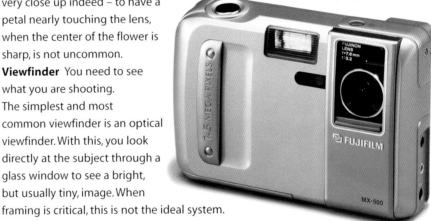

▽ *A direct-vision camera. It has simple controls but is able to give fair-quality results.*

▽ *Some cameras record the image directly onto standard floppy discs; this is convenient but the required mechanism makes this camera bulkier than usual.*

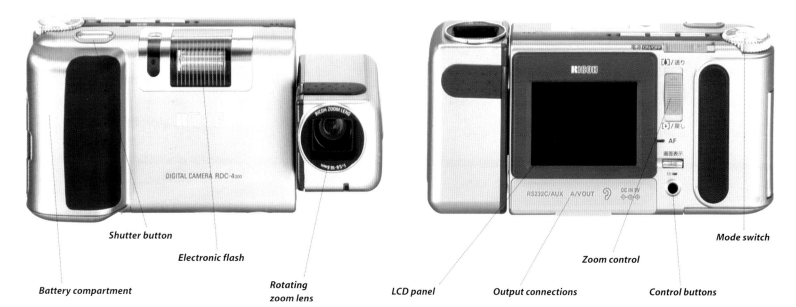

Shutter button

Electronic flash

Battery compartment

Rotating zoom lens

LCD panel

Output connections

Control buttons

Zoom control

Mode switch

Controls Digital camera controls vary considerably from model to model. In general, the more features a camera has the more complicated it is to use. However, some cameras with a only a few features can also be difficult to use. Camera controls are examined in detail on page 18.

Storage The storage medium is the digital camera's equivalent to film. Models differ in having either fixed, internal memory, removable memory, or a combination of both. Cameras with fixed, internal memory offer the cheapest option, but once you fill up the memory you must download the images to your computer in order to make room for more. Cameras offering removable memory

▽ Digital photography has changed ideas about how cameras should look; this elegant example, capable of good results, is shown nearly life-size.

use magnetic, or flash memory to store images. If you have more than one card, all you need do is swap an empty card for a full one and carry on shooting. There are several types of cards, each with its own merits.

Other features Some cameras have the ability to record sound along with the images, giving you a novel way of making notes. You could, for example, mention any details not apparent in the image, or give a map reference.

Scripting is a feature through which the writer of a script can help anybody using the camera. For example, cameras being used to document the environment can be scripted to remind users of a checklist of data needed. This could include the date, time, location, weather conditions, and so on of each shot. The script can be programmed to flash up prompts on the LCD display.

Increasing numbers of digital cameras are modular in construction and allow you to upgrade their capabilities by attaching accessories. Many cameras can download new software via the Internet to improve control over their functions.

Software Strictly speaking, this is not part of the camera, but a digital camera is nothing without software to allow a computer to work with it. The quality of software varies. It may be sufficient simply to transfer picture files from the camera to a computer. Other software will help you with such tasks as setting up the camera, cataloging files, and aspects of basic image correction. Software called "stand-alone" works by itself, whereas "plug-in" software works from within another software application, such as Adobe Photoshop.

△ Digital cameras share many features with conventional cameras with the addition of controls for viewing and deleting images and controlling the digital functions. These controls may be very small buttons requiring a logical mind to operate them; if you can, check them out before you buy.

▽ The digital camera storage media shown here are (from the top): a PCMCIA card, a SmartMedia card and adaptor, and a CompactFlash card (see Glossary, pages 145–55).

Camera controls

Photographers should find digital cameras easy to use, since the picture-taking controls on all but professional-grade models are just like those of point and shoot cameras. Anybody can pick up a digital camera and start taking pictures right away. What requires time to come to terms with, however, are the controls specific to the digital side of operations.

What they offer

With so many digital cameras now available, not all models have precisely the same controls or use the same terminology. The following is a checklist of basic controls and a description of what they do, as well as some of the more useful features that you may want to ensure any camera has before you make a purchase.

Power-on Switches, sliding covers, and buttons are used on different models to turn the camera on. Some cameras can take more than 15 seconds to power up; others are ready far quicker. Look for a camera that has a power-on control that is difficult to activate accidentally, but one that powers up quickly.

Labeling It may seem a simple thing, but some cameras use hard-to-remember symbols and make you press combinations of buttons to access certain functions. The more you have to remember, the greater the chance of missing out on picture opportunities. Opt for a camera with clearly labeled, easy-to-use function buttons.

Quality options Most cameras let you decide the quality level at which an image is to be stored. You may want to keep an image at full resolution – in which case that picture file will be comparatively large. Or you may want to store it as a compressed file and so accept some loss of quality. The smaller the file size, the greater this loss of quality will be. (*For more on image compression, see page 54.*) On some cameras, selecting the quality option is simply a matter of pressing a button, while on others you have to access a preferences menu.

Image capacity The number of shots you can take depends both on the quality options you select, which may change as you shoot, and on how much storage you have. Most digital cameras will calculate the number of remaining shots for you – the figure displayed should change if you select a different quality option.

Review options One of the best features of digital photography is that you can review an image on the camera's LCD screen as soon as you have taken it. Most cameras allow you to view images one at a time or several at once. Since screens on digital cameras measure only about 1½–2in (3.8cm) across, much detail is inevitably lost. Some cameras give you the option of zooming in and scrolling an image, much like a word processor document, so that pictures larger than the screen can in effect be

displayed. Screen quality varies greatly. Good-quality screens are a bonus but you often pay the price of slower screen-refresh rates. Slow refresh rates are a particular issue when the LCD panel is used as a live viewfinder, since any subject movement will appear jerky.

Connection options A digital camera never loses its umbilical cord to the computer. A computer link allows you to download images directly from the camera. Check that the connector provided with the camera fits your computer. If it does not, a simple adaptor will usually suffice to make the match. Many cameras have a direct video out, which allows you to see the image on your TV screen without the need for an intervening computer.

Power supply An AC adaptor allows you to run your camera without wasting batteries. If one is not supplied with your camera, buy it as an accessory. Use the adaptor whenever you are working on the computer or viewing images on your TV screen. At the same time, you can be recharging the batteries.

△ Digital cameras use a combination of standard camera controls, which will be familiar to users of conventional camera, as well as new controls for digital capture. As yet, there is little standardization of symbols or controls, so you may have to learn new aspects of camera handling.

▽ The LCD control panel for the Kodak DC520.

Choosing a camera

There are nearly as many types of digital cameras on the market as conventional ones. What you decide to buy is as much governed by the depth of your pocket as it is by the breadth of your ambitions. There are, however, many affordable cameras that give good results. Paying more does not necessarily guarantee better picture quality, but the convenience features and photographic controls should improve. As much as price, what you actually want to do with the camera should determine the model you choose. Note that most digital cameras are "dual platform", meaning that they work with both PCs and Apple Macs. A few are PC-only, so check before you buy.

Basic work

A camera suitable for producing pictures for the Internet, small inserts for newsletters, or small stand-alone prints can be had on a tight budget. A digital camera with 640 x 480 pixel (i.e., VGA) resolution should do the job. To keep the price down, you will have to sacrifice an LCD screen and zoom lens, but it is best not to sacrifice

△ The Panasonic DSC-F1 is a basic VGA camera with an LCD monitor.

removable storage. Even at a very low price point, equivalent to the cost of a well-featured conventional compact with fixed lens, many digital cameras offer autofocus.

Flexible option

If you are looking for better-quality newsletter or enprint-sized pictures but are on a small budget, you will have to forgo some convenience features. Cameras with 1024 x 768 (i.e., XGA) or 1152 x 864 resolution meet the quality requirement, and those without a zoom lens and with very

▽ The Nikon Coolpix 600 is a basic XGA camera.

little or no internal memory hold down the cost – equivalent to the price of a conventional compact with a zoom lens. Make sure you have a good LCD screen and that the camera is easy to use.

Serious work

If the camera is to be used for desktop publishing or for producing A5-sized ink-jet prints, and you have a medium-to-high budget, then look for a model offering resolutions of 1280 x 1024 or 1536 x 1024 pixels or similar. A camera such as this will be ideal for serious documentation, such as recording an expedition or producing a detailed records of collections and objects for insurance purposes. To give the quality needed for A5 prints, you should select a truly megapixel camera. With a medium budget – equivalent to an average-priced conventional SLR camera – you can expect to get an LCD screen, removable storage, some camera controls, and possibly a zoom lens. With a higher budget – equivalent to an SLR plus zoom – you should get all of the above plus a zoom and a good software bundle (*see below*).

Professional quality

To achieve reproduction-quality pictures up to A5 size, or A4-sized ink-jet prints, you will have to spend as much on a digital camera as you would on a top-quality professional SLR camera body. At the time of writing, you would obtain resolutions of 1280 x 1000 to 1600 x 1200 pixels, but only with direct-vision viewfinders and fixed focal length lenses. You will get more features for your money as prices start to fall.

Software bundles

Many cameras bundle extra software in addition to that needed for downloading image files. What is bundled can make a big difference to your budget. Very capable software, such as MGI Photosuite or Adobe PhotoDeluxe, can meet most image-manipulation needs. Others offer photo-cataloging software. If everything about the choice of cameras appears equal, it can pay to choose by the software offered.

△ The Agfa ePhoto was one of the first cameras to feature a swiveling lens mount giving flexibility in capturing images. An inexpensive megapixel (i.e., the sensor has a million or more pixels) camera, it is capable of useful work.

▽ The Kodak DCS-315 (based on a Nikon Pronea camera) bridges the large gap between amateur and professional cameras with its adequate image quality combined with a full feature set.

Survival guide

While digital photography is not difficult and is a lot of fun to do, it would be wrong to imply that nothing ever goes wrong with the process. Digital photography is different from working conventionally in that the many steps in the chain from image capture to how images are used and stored are absolutely critical – and if just one part fails, the whole chain could collapse. For example, if the software becomes corrupted, you cannot download images to the computer, and so the images are unavailable until you replace the software. Here are some hints on how to keep your digital photography show on the road and running smoothly.

• Without power, you merely have a pretty plastic box in your hands. Always keep a spare set of batteries, preferably the high-power alkaline type, in your camera bag for emergencies. Use rechargeable batteries as often as possible. NiMH batteries are more expensive than the more common NiCd types, but they are easier to use and have better staying power. In normal use, you should be recharging a set at least once a week. Whenever you are working at your desk, power the camera from an electrical using the camera's approved AC adaptor.

What really uses up power quickly is the LCD monitor screen –so on cold days or on long trips, avoid using the screen when the camera is being powered by its batteries.

• Most users of photographic and computer equipment will ignore this advice, but it is important to give it anyway. Read the instruction manual carefully – if only to check that what you guessed is the right button is indeed the one you want. Unless you read the manual you could miss features of the camera you never realize you had. Sometimes, for example, a camera will not operate unless you set the time and date, or until you format the removable storage, and you could waste time and photo opportunities thinking you have a faulty camera.

• When you install the software that drives the camera from the computer, do not ignore the instructions to turn off all virus-protection software, whether you are working on a Mac or a PC. On a Mac, it might be worthwhile turning off all the extensions, apart from the CD-ROM player, before inserting the software CD – but generally you should not have a problem. On a PC, you are more likely to encounter a software conflict, but you will probably find that somebody else has already come up against the same problem and that there is a fix for it somewhere on the Internet. Visit the web-site for the camera manufacturer as your first step and check for any updates to the software that are designed to resolve the problem you have encountered.

• The wires in modern connecting leads are incredibly fine, so treat all leads with care. Do not bend them, knot them, or fold them tightly. In theory, leads should be attached to the computer only when not powered, apart from USB connectors, which are designed to be "hot-pluggable". In practice, however, you can get away with plugging serial leads in while the machine is on – though you still run a risk of damage.

WARNING: Do not ever plug SCSI leads into equipment that is powered up or you could destroy your computer.

• Digital cameras are high-precision pieces of electronic equipment and are not as robust as conventional cameras. They are more prone to damage from dampness, dust, and cold. All parts, especially any removable media, should be treated carefully – the contacts and tolerances are so fine that it takes very little to distort a part and ruin the contact. Many digital cameras have rotating parts – any moving part is more fragile than a fixed one, so again care is needed.

• If your camera has removable memory storage, such as CompactFlash or SmartMedia, it always pays to buy and keep another card, if only as a standby. It is like having an spare emergency roll of film: you never know when you might need it. Don't put yourself in the position of regretting to the end of your days that an attempt to economize you missed out on that shot of a lifetime.

◁ *Batteries are your camera's blood and life – keep them charged up and always have spares readily available. Change all the batteries in a set at the same time. An old battery left behind will rapidly deplete the new ones you put in or, worse, it could cause overheating. If you use non-rechargeable batteries, you may find that batteries which are insufficient to power a camera may still be suitable for use in a personal stereo player or clock. Battery testers, two types of which are shown here, make useful accessories.*

◁ *Computers most commonly "talk" to digital cameras using delicate, high-precision electrical leads to carry the signals. Any damage or break in a lead will degrade the signal or, most often, cause a complete failure. When you attach leads, it is safest to ensure that the equipment is turned off. Always use a light touch when connecting leads, lining up the pins as accurately as possible before pushing them in.*

DIGITAL SHOOTING

Making the transition

The good news is that if you are in any way familiar with conventional photography, you can transfer all your skills to shooting with a digital camera. The not-so-bad news is that digital technology does not solve all the problems associated with conventional photography. What it does bring to the fray, however, are easier ways to deal with some of the traditional difficulties.

Practical considerations

Although the picture-taking controls on digital cameras are much the same as those found on conventional cameras, your method of working needs to be adapted to take account of the way images are recorded.

Exposure control A CCD sensor needs more accurate exposure than does conventional film. The range of brightness the majority of the sensors can record is comparable to that of color slide film, which is much less than that of color negative film. However, most digital cameras give you little control over exposure settings. The result is that you need to attune your eyes to the brightness ranges of different scenes – if they will not look good on slide film, they will not look good in digital. And no amount of digital manipulation afterwards can fully compensate.

Aperture control It follows from the lack of exposure control that there is not much chance of controlling the lens aperture settings in order to manipulate such effects as the depth of field. Even if you had this option, with most digital cameras small changes in lens aperture will have little impact on the visible depth of field since the subtleties of blur are lost in the low resolution of the image when you print it out.

Sensor "speed" Sensors in digital cameras are just like film in that they have a "speed" – an indicator of the light levels the recording medium requires in order to produce an acceptable image quality. For good results, sensors need lots of light, which brings down their sensitivity, or speed.

Most digital cameras offer a nominal speed of about ISO 100. Some cameras allow you to set different speeds from shot to shot – something that would require changing films in a conventional camera. However, the loss in quality of a "faster" – more sensitive – sensor is not quite like that of faster film: the resolution of the sensor remains the same but there is more "noise". This means that there are more pixels present whose values are not derived directly from the scene. Photographers who are accustomed to balancing a desire for film speed with image quality will readily understand this aspect of digital photography.

Flash lighting While built-in electronic flash is standard equipment on digital cameras for enthusiasts, only a few can take you beyond the most basic flash lighting controls, and very few models offer a separate flash contact. The result is that, when working in low light, you need to take care to prevent the lighting of all shots looking the same, which is the effect of using direct flash. The easiest solution is to avoid using flash whenever possible. Bear in mind also that using flash quickly exhausts the camera's batteries.

Composition Digital photography requires you to use all your skills, and more, when it comes to composing individual pictures. The reason for this is that you cannot fall back on the visual effects associated with super-wide-angle lenses or ultra-long telephotos. Most digital cameras simply do not have that type of optical firepower. Fortunately, the hybrid nature of digital photography means that, when needed, you can use a conventional camera and lenses and then scan the resulting images in order to work on them digitally.

Feed-back Unlike conventional photography, digital photography gives you the chance to review results instantly by referring to the camera's LCD monitor screen (if provided). You can check on the spot whether or not you caught the smile you wanted, and ensure that the horizon is level or that the exposure is accurate. Some cameras also give you a warning if the exposure will lead to poor results. Furthermore, the screen gives others a chance to see what you are doing. In parts of the world where cameras are uncommon, showing subjects their image on the screen can help to break the ice and help you to gain their trust. The screen alone can change the way you work.

▽ *Apart from the effects of the sensor used to record the image, the optical aspects of working in digital are the same as conventional photography. The extremely small size of sensors limits the field of view as well as depth of field, and it also places great strains on the resolving power of the lens. Problems of lens flare (from light reflecting inside the optics) also remain. The end result is that none of your photographic skills need be lost.*

📷 *Kodak DCS 315 digital camera with Micro-Zoom Nikkor 70–180mm lens @ 150mm.*

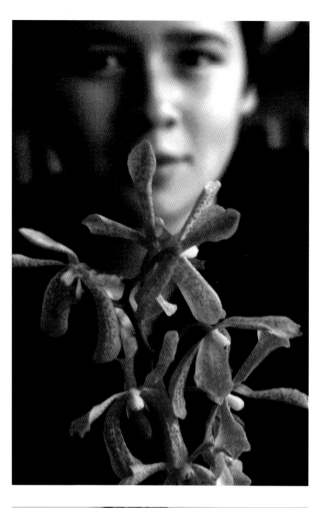

◁ Control over the lens aperture is generally very limited with lower-cost digital cameras: here I could set a wide aperture on a relatively long focal length to blur the face behind the orchids, but the camera I used cost more than $5,000.

📷 *Kodak DCS 315 digital camera with IX Nikkor 24–70mm lens @ 70mm.*

△ A "film speed" setting of ISO 400 (normal is ISO 100) for the digital camera sensor improves low-light abilities, so there is less need for flash, but the cost is more digital "noise". In this image it can be seen by blue specks in the black.

📷 *Kodak DCS 315 digital camera with IX Nikkor 24–70mm lens @ 70mm.*

▽ The small sensor size and resulting short focal lengths needed mean that digital cameras are easily designed for convenient close-up photography. For this work, the usual design that places a flash near the lens is an advantage as supplementary lighting is usually needed for close-up work.

📷 *Kodak DCS 315 digital camera with IX Nikkor 24–70mm lens @ 70mm.*

△ On-camera flash always produces flat lighting and low contrast. Also, shadows produced by direct flash are rarely flattering.

📷 *Kodak DCS 315 digital camera with IX Nikkor 24–70mm lens @ 70mm.*

Portraits: Lighting

The main technical problem when using a digital camera for portraiture is controlling the light. This can be particularly difficult if, like many photographers, you prefer to use daylight. The secret to success is to use to the full whatever natural illumination is available.

Working indoors, try positioning your subject close to a window for the main light, and then open curtains or a door on the shadow side to allow some light to reach the darker parts of the face. When shooting in black and white, with a normal or digital camera, you can use domestic lights as a supplement without fear of color casts.

Working outdoors is trickier. A common problem is not a lack of balanced lighting, but that the lighting is not neutral in color. This happens when, for example, light is filtered through tree foliage. The dappled effect may look promising, but skin tones could easily be spoiled by a green cast. Similarly, in an attempt to avoid bright sunlight you may be tempted to place your subject in the shade, but here you are still affected by the source of the light. If that source is a blue sky, skin tones may appear bluish.

When localized shadows are a problem outdoors, you can always use flash to provide some extra light (*see pages 32–3*), but it is nearly always best to work with the naturally available illumination. Observe how the light shapes a face: the shadows it casts around the eyes, for example. In the pictures of a Samburu girl in Kenya, below and opposite, overhead sun has cast heavy shadows over her eyes. But it has also brought out the shape of her nose and lips, as well as bringing her necklaces to life. As the great photographer Ernst Has said: "All light is good light." The mark of a versatile photographer – conventional or digital – is that they make the best use of whatever they are presented with.

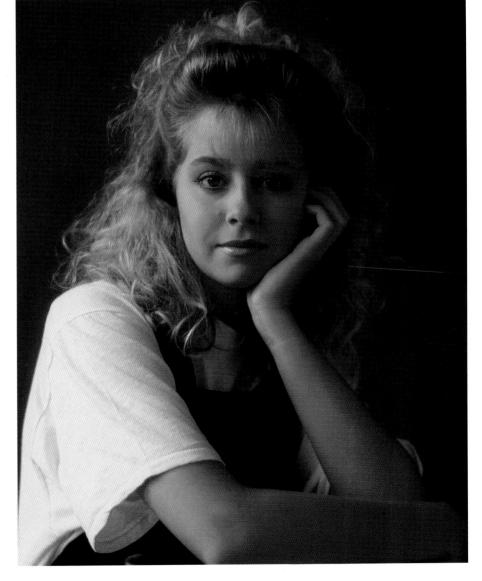

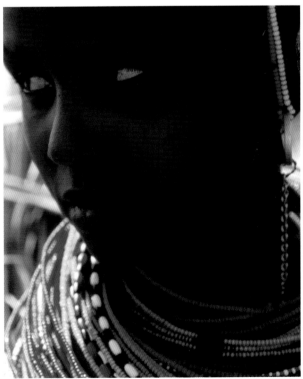

◁ *To achieve balanced lighting, the difference between dark and light is always less than you might expect. Here, although the lighting varies across the subject's face, all details are fully visible. Texture is good in her white top, and enough detail has been recorded in the darker parts of her hair.*

📷 *Leica R-6 with 80mm lens; f/2 at $\frac{1}{60}$ sec; ISO 50 film. Shot in daylight with the camera on a tripod.*

▽ *Clever composition can triumph over lighting difficulties. Nearly black skin under the high, equatorial, midday sun of Kenya is nearly impossible to expose for and hold detail satisfactorily. This is the first attempt, but the background is too busy and the overall shape is poor.*

📷 *Canon F-1n with 135mm lens; f/8 at $\frac{1}{125}$ sec; ISO 100 film. Shot in daylight with no flash. Exposure spot metered from the beads.*

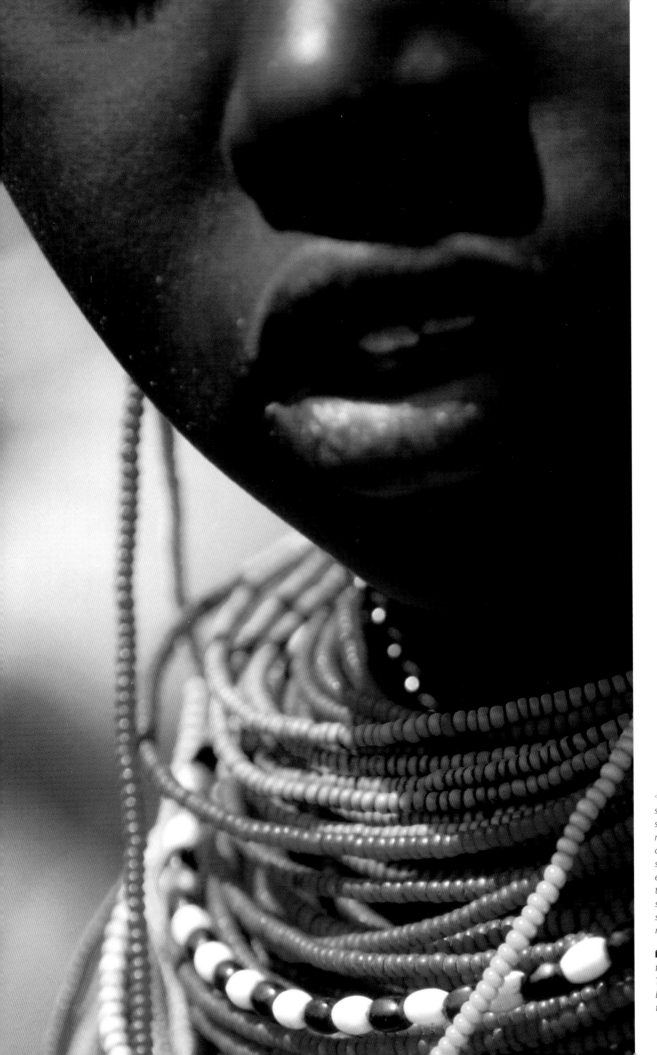

◁ For this version, I reframed the shot to emphasize the strong shapes of the girl's nose and mouth and enhance the brilliant colors of her necklaces. This second composition avoids exposure problems by exploiting the effect of harsh light on dark skin. The same shot taken in softer, more diffused light would not be as dramatic.

📷 Canon F-1n with 135mm lens; f/8 at $^1/_{125}$ sec; ISO 100 film. Taken in daylight without flash. Exposure spot metered from the beads.

Portraits: Perspective

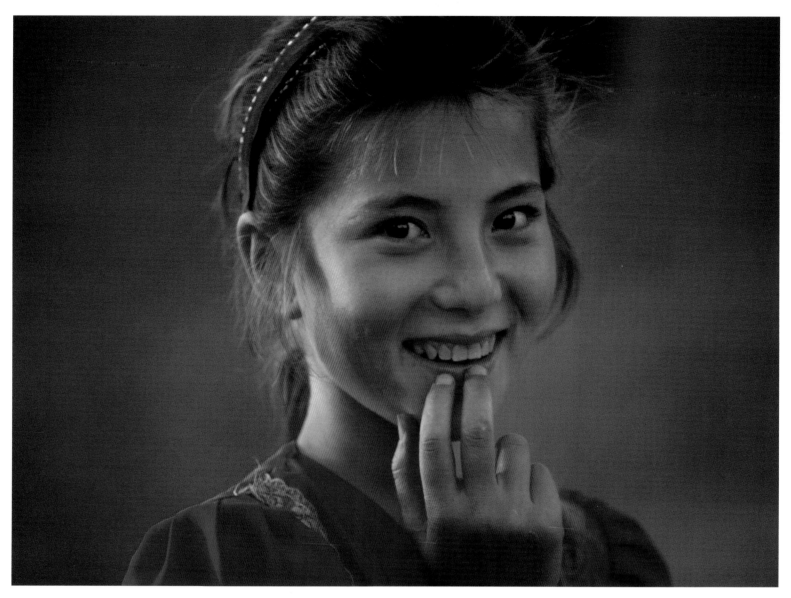

A portrait tells a viewer about what the subject looks like, but it also often reveals clues about a subtext – the relationship between the subject and the photographer. The information for this comes partly from the perspective used by the photographer. If you take the portrait from a close-up perspective, the resulting image will tend to feel more intimate than if you take it from farther away. But things are not so simple. The complication of focal length comes into the equation at this point since how much you see of a subject from any given focusing distance depends on the focal length of the lens.

If you are close to your subject using a longer focal length lens you will see a smaller portion of, for example, a face in the viewfinder than a shorter focal length would produce, but you will see it at a higher magnification. A shorter focal length may, therefore, give you a full face from

close up because of its wider angle view. But there is a disadvantage: objects close to the lens look much larger than objects farther away. Typically, the nose, which is closest to the lens, looks big compared with the rest of the face if you get too close using a shorter focal length.

In practice, photographers find that a 35mm equivalent focal length between 75mm and 90mm gives the best balance between a more intimate perspective or approach to the subject without causing distortions. It follows that if you have to use a shorter focal length, say 50mm, then you should keep your distance – at least 3ft (1m). Using digital techniques, it is very easy to crop away excess image areas to give the impression that you actually used a longer focal length lens. Digital cameras with fixed focal length lenses generally have a slightly wide-angle lens – equivalent to between 32mm and 45mm on the 35mm format – so

△ *This young girl had waited all afternoon to have her portrait taken while I was photographing in a cotton field in Uzbekistan. When she finally ventured nervously into the evening light she placed herself perfectly in a dimming pool of sunshine. Low light and a distracting background meant that an open-aperture option was best. It is hard to believe that behind her were trees and several people.*

📷 *Canon EOS-1n with 70–200mm lens @ 200mm; f/2.8 at $^{1}/_{125}$ sec; ISO 100 film.*

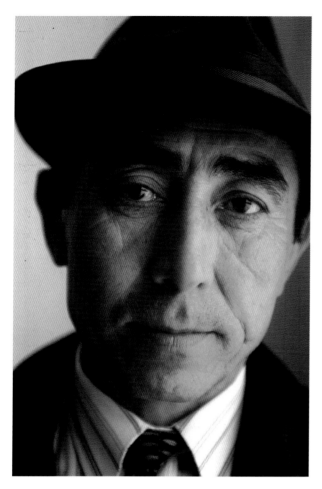

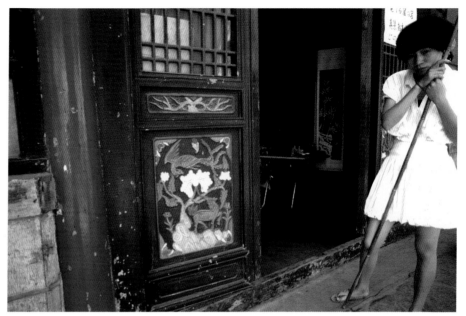

△ An extreme wide-angle lens often produces distortion at the edges of the frame – here it looks as if the face of the shopkeeper in the Forbidden City, Beijing, has been stretched in two directions. The effect disappears if you look at the print from very close up, which means that extreme wide-angle portraits tend to work best when they are greatly enlarged. With most digital cameras, however, extreme wide-angle effects are impossible to achieve, so you will be spared this particular problem.

 Leica R-6 with 21mm lens; f/8 at ¹/₆₀ sec; ISO 100 film.

△ A standard lens is a generally useful optic, but certainly not for close-up portraits, as you can see here. In order to fill the frame, I approached too close with a 50mm macro lens, which has exaggerated the severity of this man's appearance.

 Canon EOS-1n with 50mm macro lens; f/5.6 at ¹/₁₂₅ sec; ISO 100 film.

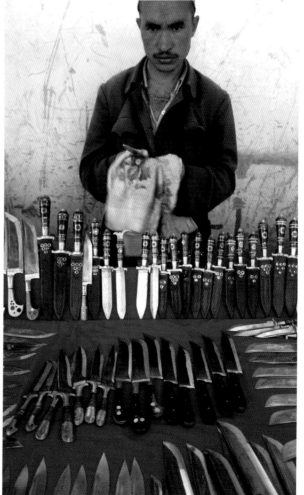

◁ A moderate wide-angle lens catches this knife-seller and his wares all in one shot. A small lens aperture was needed to keep everything in the frame sharp, and this resulted in a relatively slow shutter speed – evident in the movement recorded as he polishes one of his knives. A careful choice of position – needing a tiny shift sideways – ensured that the sparkle from the knives was caught.

 Leica R-6 with 35mm lens; f/11 at ¹/₁₅ sec; ISO 100 film.

close-up portraits that flatter a face are difficult to achieve. When you use a digital camera with a zoom lens for portrait pictures, it is generally preferable to use the telephoto end of the lens's range.

Because the face in a portrait is crucial, photographers often minimize potential distractions by showing the background as an out-of-focus blur. The usual technique is to set a large aperture on the lens to reduce depth of field. However, most digital cameras don't have aperture controls. So, in order to produce a blurred background, use the longest focal length your zoom lens offers, since depth of field decreases as the focal length increases. No matter how blurred the background, avoid including bright highlights as these will distract attention from the face.

Wide-angle lenses do have a role to play – their wider angle of view forces you to stand back from your subjects and, therefore, to include more of the environment. However, the wider the angle of view of the lens, the more care you need to take to avoid distortion at the edges of the frame.

Portraits: Color or black and white

Digital photography brings closer to reality the dream of being able to change the "film speed" in the camera at the flick of a switch. With more expensive digital cameras, you can change sensor sensitivity (the digital equivalent to conventional film speed) very simply. As with conventional film, changing sensor sensitivity changes image quality. You can even change from color to black and white effortlessly. You may find it surprising that a black and white option is offered at all: after all, it is easy using image-manipulation software to change a color image into a black and white one. The great advantage of not shooting in color lies in file size – a black and white image file is a third smaller, sometimes even smaller, than its color equivalent.

So, just from the point of view of saving room on your storage media, black and white has many points in its favor. It is a decision you need to make yourself. If the work does not need color – a progress report on a construction site, for example, or the faces of auditioning actors – it makes sense not to use it.

There are factors other than file size, however, that favor working in black and white – sometimes it is simply better than color. We have all seen pictures containing too many hues, too much information. Black and white simplifies and clarifies, pares the subject down to its essentials. The absence of color is particularly effective if you want to concentrate the viewer's attention on the

◁ △ *The limited range of hues in this portrait contrasts with the picture opposite – here they all complement and balance each other. Removing the color information destroys the delicate harmonies and counterpoints between the blocks of light and dark tones, warm hues and high-key areas. Normally I try to avoid having large blocks of very bright, overexposed areas in an image, but here the nearly white area in the top left is balanced by the light on the subject's clothes.*

📷 *Mamiya 645 Pro TL with 75mm lens; f/4 at $1/_{60}$ sec; ISO 100 film.*

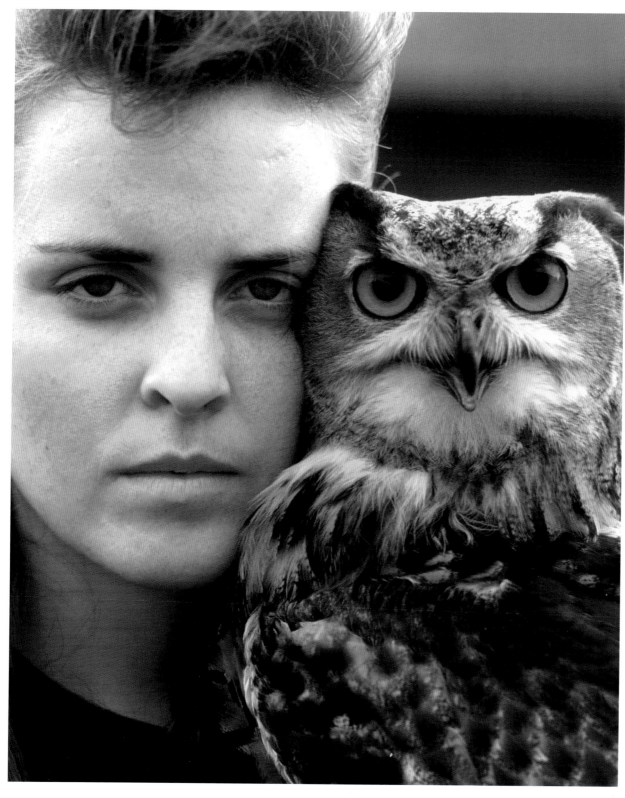

◁ △ *The keeper of a private bird sanctuary had an amazing rapport with her charges: this eagle-owl positively relished contact with her. In color, there is too much going on with the striking colors of the owl's eyes competing with the dark eyes of the keeper, her skin tones contrasting with the owl's feathers. But when seen in black and white, all the elements are balanced so there are no distractions from the fascinating contrasts and similarities between the two faces.*

📷 *Canon F-1n with 135mm lens; f/2.8 at ¹/₁₂₅ sec; ISO 64 film.*

facial features in a portrait or on composition. So, if the lipstick is too red, the necktie over-patterned, the blue of the eyes too piercing, just throw the switch for a black and white photograph. However, as in conventional photography, colors may not translate into black and white in the way you expect. While red is a strong color contrast to green, once they are translated into gray tones, the luminance or brightness information for both colors can be almost identical. Similarly, a blue sky may turn disappointingly dark when translated into a gray tone.

Switching to black and white may also improve image quality. Because the camera's own circuits has less image-processing work to perform, it can use the information from every sensor to give more subject detail.

If you shoot in color you can later change to black and white, using software such as Adobe Photoshop.

Candid and street photography

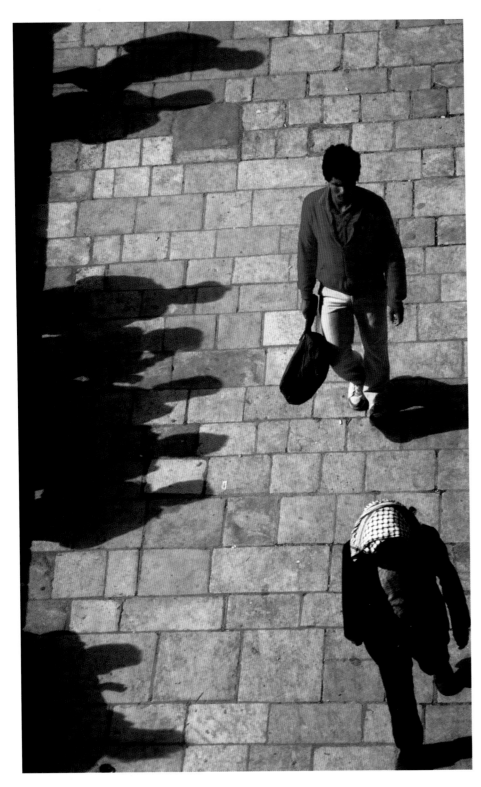

△ A fortuitous line-up of shadows in this picture? And so it is – but I had to spend more than half an hour waiting at Jerusalem's West Gate before the movement of people arranged itself into the picture I wanted … and all the while, the sun was moving across the sky and shadows were shifting.

Minolta Dynax 7i with 28–85mm lens @ 85mm; f/5.6 at $^1/_{125}$ sec; ISO 100 film.

Small-format photography grew up on the streets. It is on the streets that life spills out into the open; it is where much of the world's play, commerce, and human activity go on. Great pioneering photographers, such as Alfred Eisenstaedt, Ernst Haas, and Henri Cartier-Bresson, who taught us how to photograph and what to photograph, were essentially candid and street photographers. Can digital cameras carry on this tradition?

In that digital cameras are simply a convenient device for capturing images, of course they can be used for street photography. However, this pursuit requires quick reflexes from the photographer and equally rapid responses from the camera. Unfortunately, most digital cameras are rather slow to respond after being switched on – most need five to ten seconds, and some much longer. In addition, most digital cameras are relatively slow to take a picture once you press the shutter button. This means that you must adapt your normal technique and plan further ahead if you don't want to keep the camera turned on all the time. You will also have to try and guess what is going to happen in the next 30 seconds, rather than responding to what is happening right in front of your eyes. Using a digital camera at present is similar in some respects to being a good driver – anticipation enables you to see what is happening a hundred yards up the road, not just what is in front of your car. Good anticipation also makes a good photographer.

All the news is not bad, however, since digital cameras bring with them a few useful tricks of their own. Many models have a swinging lens carrier, for example. This means that you don't have to point the camera straight at the subject. Instead, you can hold the camera body one way and have the lens pointing to the side. While you should always ask permission before taking somebody's photograph from a nearby position, the swiveling lens feature can help you take candid shots without the subject being distracted by the knowledge that you are taking their picture. They also make ideal snapshot cameras, since most models operate in almost total silence, without the clunk of the reflex mirror or the whir of the film transport motor that accompany the operation of a conventional camera.

Another advantage to using a digital camera is that they allow you to let strangers see what you are doing: show the LCD screen to a street vendor, for example, and he can see for himself the picture you just took. This is better reassurance than any words could be that your intentions are harmless and that all you want is a picture of, say, his attractive food display. Think how effective instant-picture prints are for eliciting the cooperation of strangers: the LCD screen of a digital camera can be even better. And if

you do want to give prints away, some cameras contain a tiny, built-in printer.

The LCD screen design of some digital cameras offers yet another advantage for candid photography. If the screen is on a rotating flap, you are not limited to peering through the viewfinder – always a giveaway that you are taking a photograph. You can use the screen as a waist-level finder, holding the camera low and looking down at the screen, or rest it on a table while pointing the camera at an unsuspecting subject. But do consider if it is proper to take sneak pictures. You will often obtain better shots by first making friends of those you want to photograph.

The waste rate when shooting digitally can be much lower – nearly zero, in fact – than with a conventional camera. What often spoils a candid shot is a distracting highlight, telegraph wire, or some other feature in the background that you did not notice at the time of shooting. It is a simple matter in digital photography, and largely unobjectionable, to remove the distraction. Furthermore, at any time, you can review shots and erase any that clearly have no future. Be advised, though, that the worse time to picture edit your work is immediately after a shoot – allow a little time to pass. And remember, once you have erased an image, it is gone forever.

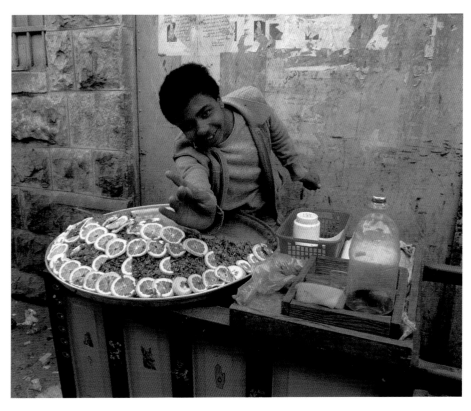

△ People are usually cooperative if you bother to make contact with them, as was this street vendor in Jerusalem's old town. A digital camera allows you to show strangers what you are doing and that you mean no harm. Then you can carry on photographing with either a conventional or digital camera.

📷 Minolta Dynax 7i with 28–85mm lens @ 28mm; f/4.5 at ¹/₆₀ sec; ISO 100 film.

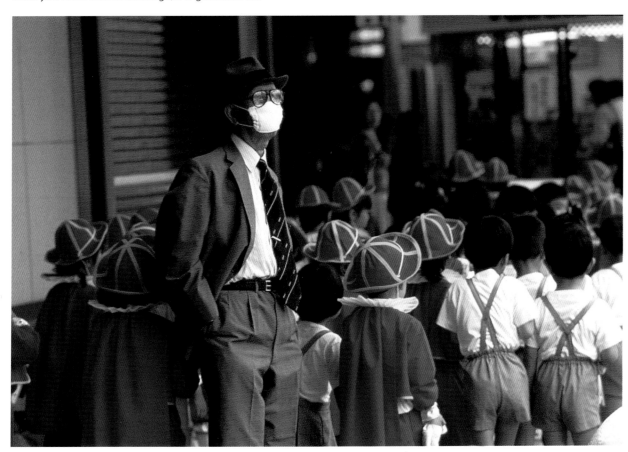

◁ A little anticipation brought together an old man wearing a mask to protect himself from traffic fumes while waiting at a bus stop in Nagasaki, Japan, with a small group of schoolchildren on their way to the train station. Such a picture would be easy to capture on a digital camera.

📷 Canon F-1n with 135mm lens; f/2.8 at ¹/₁₂₅ sec; ISO 100 film.

Flash photography

Just about every digital camera available for general use has a built-in electronic flash. So what is it about flash that makes it so indispensable? For one thing, people do not expect a mere lack of light to impede their photography. Electronic flash is portable sunlight available at your command, providing illumination where and when we need, and in just the right amounts, too. For another, manufacturers set CCD sensors to a sensitivity roughly equivalent to that of ISO 100 film – a fair balance between image quality and speed. However, ISO 100 is fast enough for use outdoors only on a bright, near-cloudless day. Indoors, ISO 100 is too slow for the typically low light levels you will encounter. Added to this, lenses for digital cameras have a long way to go before they have anything like the speed (a measure of a lens's maximum aperture) of conventional lenses. The result is that when using a digital camera you need a flash rather more often than not.

This has two inevitable and unfortunate results. First, lighting from a built-in flash gives flat – i.e., direct – lighting with dull results. Second, using flash rapidly drains the power from the camera's batteries.

The usual method for improving the harsh quality of flash is to bounce its light off the ceiling. This is not possible with built-in flash. You can try to soften its light by wrapping diffusing material, such as semi-translucent plastic or even tissue paper, over the flash window. But not only are these solutions inelegant and impair the hi-tech impression of the system, they also greatly reduce the power of the flash and can damage it.

Another solution is to set a relatively long camera exposure time in conjunction with the flash. In this way, any ambient light has a chance to register so that instead of inky black where the flash does not reach, there is some color and detail in the surroundings. Some manufacturers allow for this technique in the autoexposure programming they provide.

There is another problem associated with built-in flash: "red-eye". Since the light source is very close to the lens, when the flash of light enters through the iris of a subject's eye, it is reflected off the retina and straight back into the lens. Since the back of the retina is full of blood vessels, what you see in the photograph is a spot of bright red in the middle of each pupil. This problem affects conventional camera photography as well, especially at long focal lengths, but it can easily be dealt with in digital photography using image-manipulation software – many applications have "red-eye-remover" tools. Some cameras offer a "red-eye-reduction" feature, which consists of a series of rapid, pre-exposure flashes designed to close down the iris of a subject's eye before the main flash fires and the exposure is made. This, however, uses up a lot of battery power and slows down camera operation.

On balance, it is far better to have built-in flash than not, but when buying a camera look for a model that offers "long-exposure flash" and also allows you to turn the flash off. Finally, it is worth experimenting with diffusers on the flash head to change the quality of light from the usual harsh, direct light into something softer and more flattering.

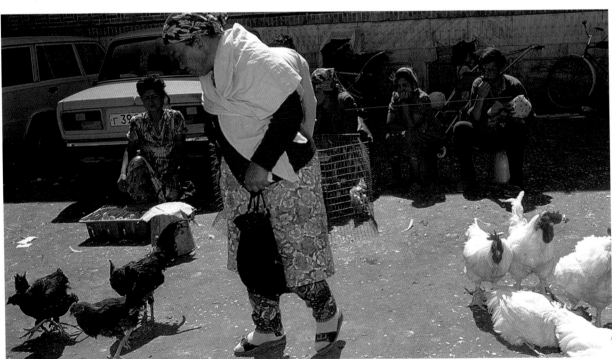

◁ *"Synchro-flash" or "daylight-flash" allows you to put extra illumination into the shadows to improve image contrast. Here, in the great Bazaar, Samarkand, Uzbekistan, electronic flash has filled the heavy shadows and balanced them with the harsh sunlight. Many digital cameras have a synchro-flash feature.*

📷 *Canon EOS-1in with 20mm lens; f/11 at $^1/_{250}$ sec, plus flash; ISO 100 film.*

△ A normal flash exposure in low light underexposed the background – only 2 stops of underexposure is enough to turn it inky black. In this shot, taken in Istanbul, Turkey, the underexposure is more than 4 stops.

📷 Canon EOS-1n with 28–70mm lens @ 28mm; f/4 at ¹/₂₅₀ sec, plus flash; ISO 100 film.

◁ In a long exposure coupled with flash, the shutter is held open to register the ambient light while the flash fires to illuminate anything whin its range. As a result, any movement in the subject is registered as a blur against a sharp outline of the flash-exposed image.

📷 Canon EOS-1n with 28–70mm lens @ 28mm; f/4 at ¹/₈ sec, plus flash; ISO 100 film.

◁ With bright sunlight behind them, these girls waiting to perform a dance in Bishkek, Kyrgyzstan, were effectively in deep shadow. An exposure correct for their faces would completely bleach out the background, but a judicious amount of fill-in flash gave a generally well-balanced result, with just slight overexposure evident in the background.

📷 Canon EOS-1n with 28–70mm lens @ 28mm; f/5.6 at ¹/₂₅₀ sec, plus flash; ISO 100 film.

Tricks with landscapes

When photographing a landscape, ideally you should wait until all elements of the scene are perfect. In reality, you will probably be *en route* somewhere else and so have little control over the timing of the shot, and no control at all over the lighting. If you use conventional film, remember that different films render colors differently. For example, Kodachrome yields colors subtly and softly compared with the bright, saturated hues of Fujichrome. Negative films, too, impose their own color biases, but these are nothing compared with the huge variety in results that can be produced, depending on who prints the negatives and how that person does it.

To achieve precisely the effect you want, shoot the scene when the opportunity arises and then tweak results at home using a scanner and picture-processing software. A key truth about the photographic process is that every time you copy a photograph you can radically alter image quality, so look on scanning (*see pages 46–9*) as just another way of taking a photograph. Once you have scanned the original, you can then warm up its color balance, put color into a pale sky, even remove most of the color to produce a pastel effect.

In fact, when you become comfortable with the notion that you can scan and rework your images at your leisure, you will begin to think, see, and shoot differently. You will realize that you may not need numerous color-correcting filters and that if the lighting is not perfect, and you don't have the time to wait until it is, all is by no means lost.

To give yourself maximum flexibility once you start to manipulate your images, you need plenty of material to work with. One way to do this is by "bracketing" exposures. This involves making two extra exposures – one slightly underexposed, the other slightly overexposed – plus the "correct" one. If the scene has a wide brightness range, as in the view on these pages, you may need to bracket more widely, using a greater number of exposures.

The better exposed and sharper the original image, the better any subsequent reworking will be. Although you can simulate greater sharpness in the computer, it is far better if the original is sharp in the first place.

▽ This image is a manipulated version of the one opposite, showing the Registan Square in Samarkand, Uzbekistan. When I saw the original it was obvious it was slightly underexposed and had failed to capture the warmth of the light. Also, the clouds were too gray. After scanning, it was but a few minutes' work to improve considerably the tonal qualities of the image.

📷 *Canon EOS-1n with 24mm TS lens; f/16 at $^1/_{15}$ sec; ISO 100 film.*

◁ This is what the original scan (and, indeed, the original photograph) looks like. Even if a scene does not look very promising, it is best to take the photograph anyway, just in case – you may never have the chance to go back there again and, even if you do, the light may never be better. The beauty of digital picture processing is that you know you have a chance to turn an image into what you wanted it to be.

◁ You can sometimes adjust the scanner settings to give good results. But you will often have to make further, small, adjustments. Here is the result of using the scanner's automatic adjustment facility, and the effects are not subtle enough.

Levels

Channel: RGB

Input Levels: 0 1.00 255

OK
Cancel
Load...
Save...
Auto

Output Levels: 0 255

☒ Preview

◁ The Levels control, or histogram adjustment, is almost always the first thing to work on when improving a scan. Using this feature you can make fine adjustments to the brightness and contrast of the original by moving the triangular-shaped sliders. This screen-shot shows that the dark values have been "clipped", or do not extend to full black, because of poor scanner settings.

◁ Landscapes most often look better when tones are warmed up. There are several ways of achieving the same result. You can use the color-balance control (available on all picture-processing software), you can change the hue/saturation sliders, you can alter the curves of a color channel (only on professional software), or you can use special-effects software called "plug-ins". This is the "variations" screen, available on most software, that shows you the effect of different settings before you commit to any of them.

Panoramas

Here is a digital technique conventional photography cannot hope to match – seamless panoramas. A panorama, strictly speaking, is obtained by swinging the lens on an axis called the rear node to expose a length of film that is bent on an arc. The result is an image that looks as if you recorded what you saw by swinging your head from side to side. Only very specialized cameras can do this, so it has become common practice to call any image that is long and narrow a "panorama". In fact, most of these are simply top-and-tailed versions of a normal shot.

The alternative method is to take lots of separate shots, swinging the camera slightly between each one, and then pasting the images together. If you simply want an impression of an ultrawide image, then this is fine, but since the edges never blend sufficiently neatly to hide the joins, this technique never gives convincing results.

Digital photography, however, allows you to take many separate shots as with a conventional camera, but then your computer software takes over to stitch them together. Panorama software does its job by searching for pixels with very similar values at the adjacent edges of two images and joins the overlap together. However, the more carefully you take the original shots, the more perfect the stitching can be, and so the less work the software has to do.

While a panorama usually pans horizontally, there is no reason why you should not tilt the camera vertically to create a tall, thin strip of an image. This is suitable for a high-rise building or, more effectively and rather less clichéd, the interior of a cathedral or a dramatically modern atrium.

However, when trying this, remember that the effects of subject scale are much more marked with panoramas. This means that any changes of scale are more obvious because the relative differences between objects near to you and farther away are greater than in, say, a wide shot of a landscape, in which everything that can be seen is far away. You can experiment with zooming in to compensate

△ Six shots were all that was necessary to capture a panoramic view from Trafalgar Square, London. While a seamlessly joined view has its uses, a less formal, imperfect panorama can be more lively and give a truer sense of the visual experience. The individual shots were adjusted for color and density before being joined, and after the image was made, further adjustments were needed – the right-hand corner was too dark and so had to be lightened.

🎥 Kodak DCS315 digital camera with 24–70mm lens @ 50mm; f/8 at $^{1}/_{60}$ sec.

for the parts of the subject that become smaller as they become more distant from the camera position.

Digital photography coupled with virtual-reality technology can go much further than merely producing a static, panoramic image. You could, for example, use your shots to create a virtual space through which a viewer can walk and explore. It lies beyond the scope of this book, however, to detail these exciting possibilities.

It is by no means essential, of course, that panoramas be seamless. There may be times when a blatant mixture of angles and perspectives add interest and produce an interpretation of a scene rather than merely a documentary record of it. However, if you want to produce seamless panoramas, here are some hints:

• For good-quality panoramas there is no substitute for using a tripod with a built-in spirit level. This makes sure that your pan is truly horizontal. For even better results, use a proper panoramic head. This allows you to locate the best point of rotation (called the rear nodal point): when you have it, the resulting image does not appear to move around as you rotate the camera. This gives perfect joins.
• Where there is little detail in a scene, such as blue skies or snowscapes, make overlaps greater. Where there is a lot of detail, such as the branches of tree, you need less.
• The lower the image quality, the smoother the joins.
• If you are using a zoom lens, set the focal length for the middle of its range. The wide-angle end of a zoom is likely to give uneven illumination of the image, making the corners of the image darker than the center. This will make good joins all but impossible to achieve.

▷ Vertical "panoramas", producing tall, slim compositions, provide a dramatic change of view. Here, magnificent storm clouds above a beach in Fiji dwarf the tiny figures on the ground. A normal cropping of the image would diminish the contribution these figures make.

📷 Canon EOS-1n with 17–35mm lens @ 17mm; f/5.6 at ¹/₁₂₅ sec; ISO 100 film.

◁ Try to get away from the usual panoramas of streets scenes or landscapes. This café interior in New Zealand was so full of light and warm colours that it made an appealing subject. Although I was using a wide-angle lens and so had to take only three shots, the changes of perspective are so marked between each shot that perfect joins were impossible.

📷 Kodak DCS520 digital camera with 17–35mm lens @ 24mm; f/5.6 at ¹/₃₀ sec.

Abstract imagery

◁ *Unusual views lend them-selves to abstract treatment. Here, looking straight up into the bare branches of trees gives you a series of patterns within patterns.*

📷 *Canon F-1n with 20mm lens; f/11 at ¹/₃₀ sec; ISO 64 film.*

Nothing comes more naturally to digital photography than abstract imagery. Complicated or rich textures, regular or random colored patterns all fall nicely into the realm of digital imaging. The inherently regular nature of the digital image, made up as it is of an array of square patches, partly accounts for this, but so does the fact that strong subject textures help to disguise the imaging defects of the CCD. Indeed, these same imaging defects may even enhance the sense of texture or pattern.

In practice, just about any texture seems to create an effective digital image – pebbles on a beach, peeling paint, ostrich feathers, textiles, and similar subjects. A subtle problem can arise, however, when shooting fine, regular patterns, such as a close-up of silk. The pattern of the subject and that of the CCD sensor may interact to cause "moiré" effects – irregularly repeating bands of darkness. Unfortunately, you will not see these in the viewfinder, and probably not in the LCD screen either. If you're photographing fine patterns it is best to experiment by varying focusing distances and shooting angles – just small adjustments will normally solve the problem.

For best results, the entire image should be crisply focused. Anything that is out-of-focus creates the impression of depth, whereas the most effective abstracts tend to be two-dimensional. You will also need to make sure that the camera is perfectly square-on to the subject, so that it is parallel to the back of the camera. This is most important if there are any straight lines in the image. Converging lines, or those going off at an angle, will hint at a three-dimensional projection and may spoil the effect.

Flat lighting – illumination that is even, multidirectional, and casts only the softest of shadows – is best for abstract imagery. Cloudy days often provide the perfect lighting conditions, especially since you know that, as a digital photographer, you can easily correct the problem of cold color casts often associated with shooting when the sun is obscured. Where the conventional photographer must screw on color-correcting filters, with unpredictable results, you can ignore all such inconveniences and just take the picture, safe in the knowledge that changes can easily be made on the computer (*see pages 58–9*).

When preparing abstract imagery for use as, say, a background for an Internet web-site, avoid the temptation to give the image the strength of contrast and color it would need as a stand-alone image. Instead, you should tone down the image's contrast and saturation by reducing the vibrancy of colors. As a background, the image should interfere with the page as little possible.

△ Even with attractive subjects, such as pebbles on a beach, it pays to watch for the most effective lighting. When the water is deep, the sunlight refracted by the water does not lace the pebbles with light and shade, as it does in shallow water. When the sun is overhead, it does not produce the sparkle you can see in this shot, taken when the sun was setting.

📷 Canon EOS-1n with 28–105mm lens @ 50mm; f/8 at ¹/₁₂₅ sec; ISO 100 film.

△ In the crowded bustle of a market, it is easy to be enchanted by all the color and movement. However, this close, restricted view of a display of fresh vegetables is more likely to give a satisfying image than any attempt to capture the whole market scene. Sometimes, less is definitely more.

📷 Olympus OM-1n with 85mm lens; f/5.6 at ¹/₃₀ sec; ISO 64 film.

△ A handful of fallen petals collected from a vase of cut flowers that were past their prime provided ample opportunity to create a still-life with an abstract pattern of almost calligraphic-like strokes.

📷 Canon EOS-100 with 28–105mm lens @ 85mm; f/4.5 at ¹/₆₀ sec; ISO 100 film.

Nature photography

△ There is every good reason to make even simple record shots of plant or animal life, perhaps taken as part of a study or research program, as aesthetically pleasing as possible. This elegant composition shows the debris on the jungle floor overlapping a littoral, which receives nourishment from the sea. In the relatively dark conditions under a jungle canopy, it is tempting to use flash, but that should be avoided. If it had been used for this subject, it would have destroyed the soft sidelighting.

📷 Canon EOS-100 with 50mm lens; f/5.6 at 1/15 sec; ISO 100 film.

Digital cameras are ideal for a range of nature applications, such as plant and animal photography or environmental surveys. High-quality images are often not required for simple record shots taken, usually in closeup, as reminders and, occasionally, for identification. A species count of plants in a given area does not call for great plant photography – merely one shot for each of the specimens encountered. A low-resolution digital record of a flower taken up close is often enough to identify it and it costs next to nothing to make. Many camera models allow you to annotate each picture with a voice message, and it is a great boon to have a visual and verbal record locked together so that you know, for example, the date, time, or map reference for each shot.

Digital advantages

Another huge advantage digital cameras have over their conventional cousins for this type of work is the instant nature of the picture results. For example, if you are not sure of the identification of a plant or insect, you can take a shot of the unknown specimen and immediately show it to an expert at base camp, thus eliminating what can be the protracted delay involved in waiting until the expedition is over and then having the film processed.

This emphasis on closeup photography plays to one of the principal strong points of digital cameras. The very short focal length of the lenses fixed to most models makes close-focus work particularly easy. Add to that the capacity to view subjects through the lens via the LCD monitor screen (see page 16) and you have a winning formula for taking effective images of insects, plants, and so on, as well as detailed closeups of parts of subjects – perhaps mineral deposits showing through on a rock face.

When composition and other aesthetic considerations are paramount, the TTL (through-the-lens) autoexposure facilities offered by virtually all digital camera really comes into its own. With the camera's circuitry looking after the technical aspects of "getting it right", you can turn all your attention to the subject itself. For best results, as with conventional photography, hold the camera rock-steady to avoid camera shake – and bear in mind that when you are shooting at close subject distances even the slightest camera movement will be immediately apparent in any resulting images.

Another useful characteristic of most digital cameras is that they are nearly silent in operation. In the field, the digital camera's very simple shutter mechanism and lack of a complicated and noisy reflex mirror system can be an advantage when you are photographing any animals that are sensitive to noise.

Some digital cameras can record a short – say, 5-second – clip of movement. Image quality will be rather low, but for a natural-history project this type of imagery could be invaluable. If the camera is also linked to a remote control unit, then an infrared trigger can be rigged that will allow the subject to take its own picture while the camera is left unattended – wonderful for animal behavioral studies.

For more distant subjects, such as big game or birds, most of the available digital cameras do not take inter-changeable lenses and, therefore, cannot compete with a conventional SLR fitted with an extreme telephoto lens or teleconverter combined with a shorter lens. However, those digital models capable of taking telephoto lenses actually have a slight advantage over conventional cameras. The smaller area of a digital camera's CCD sensor, compared with the area of a frame of film, means that lenses are, effectively, more powerful, giving up to 70 percent greater subject magnification.

The cost factor involved in nature photography is worth emphasizing. Digital record-making can work out much cheaper than using film. Image storage, too, is easier than with film, and copy images can be cheaply produced without harm to the original files.

And, finally, botanical images have all the properties to make fine composite or mosaic images – their colors can be vibrant, they are composed of strong and varied geometrical forms, and their complicated shapes and patterns meld easily.

△ Top left: A crayfish caught by a skin-diver off the coral reef. Top right: A reef heron startled by a boat launches itself off its favorite palm-tree perch. Above left: The colors of ferns at the forest edge appear deepened by overcast and diffused light. Above right: A golden orb spider spins webs up to 6ft (2m) across, but a telephoto lens was needed for good subject magnification.

📷 Canon EOS-1n. Top left: 50mm f/2.5 lens. Top right: 300mm f/4 lens. Above right: 17–35mm lens. Above right: 300mm f/4 lens. ISO 100 film.

Travel photography

If there is one area of working that does not lend itself ideally to digital cameras, it is travel photography. When you are abroad, far from home and with no electrical and telecommunications plugs readily to hand, the last thing you want is a camera that might have to be linked to a computer, needs this or that cable to work, and, worse still, is too delicate to tolerate dusty, freezing, or hot conditions. Conventional cameras shine when it comes to travel photography: they are relatively robust, are restricted in the number of pictures they can take only by the amount of film you are prepared to carry, and use up very few batteries, even on a long journey. But do not give up on digital photography when you are traveling. Digital cameras will not supplant ordinary cameras in this area of activity for a long time, but they do complement conventional photography very effectively.

First, there may be many aspects of your trip that would make pleasant memories, or may even be necessary to record. But do you really need to commit them to your precious top-quality conventional film? The fun times on the beach, the cutely amusing street signs you come across, or the people you meet along the way are all possible examples of this type of situation. Far better to record your drunken revelries digitally so that you can censor them or

delete the uselessly blurred shots later when you can make a more reasoned decision. Since image quality is not a priority for these types of pictures, you can record them at compression ratios that would easily allow you to hold 40 to 60 images on a digital camera.

Second, as has already been discussed in relation to candid and street photography (*see pages 30–1*), digital technology is a valuable aid in putting strangers at their ease in front of the camera. The LCD monitor screen will show people instantly what you have just photographed – but unless your model has a built-in mini-printer, you will not be able to give them a print.

Digital travel photography, however, is not only about what type of camera you have with you. You will use a conventional camera differently and see things in a new light when you know that the film original is only the starting point in creating an image, not the end product. Time can be of the essence when you are traveling, and often there is no time to wait for a car to move before you photograph an attractive street or to find a shooting angle that does not show loops of ugly telegraph wires. With digital photography, you can take the shot anyway knowing that if the resulting image warrants it, you can remove the obstruction with little effort in the computer.

◁ When a shot demands precision timing, it is best either to avoid using a digital camera, because of the time-lag between pressing the shutter and actual exposure, or else learn to anticipate exactly when the camera will take the picture. River taxis in Bangkok travel at breakneck speeds, and it is not easy to catch a view of them in which they can be clearly seen, without them merging with the river bank or other distractions.

📷 Canon F-1n with 80–200mm lens @ 200mm; f/4.5 at $^{1}/_{250}$ sec; ISO 100 film.

◁ Picture composition can help overcome the limitations of lenses. This view of a fisherman in Hong Kong looks, at first glance, as if it were taken with a wide-angle lens thanks to the sweeping lines of the stream. In fact, it was taken with a standard lens. This is evident in the lack of distortion of the figure, even though he is in the extreme corner of the image. A small aperture was set to ensure the maximum depth of field.

◉ Nikon F2 with 50mm lens; f/16 at ¹/₁₅ sec; ISO 64 film.

◁ Avoid pictorial clichés. An otherwise obvious sunset shot on a beach in Madeira is transformed by its reflection in a pool into an atmospheric, airy composition of silhouettes. For this type of image, conventional photography is ideal since it can hold the quality in the sky's tones. With a digital camera, turn off compression (see page 18 under Quality options), if possible, and save the resulting file at the highest quality setting.

◉ Canon EOS-1n with 20mm lens; f/5.6 at ¹/₃₀ sec ; ISO 100 film.

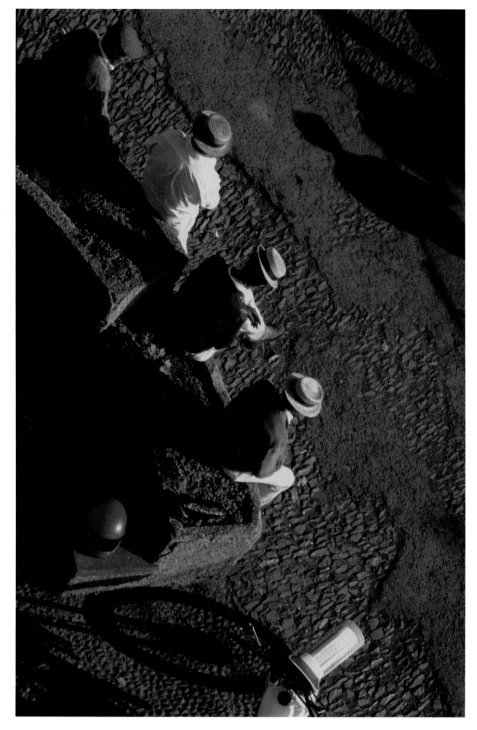

△ *Brightly lit and colorful scenes, such as this group in Madeira, are ideal candidates for travel photography, whether you use a digital or conventional camera. Subjects that are busy with detail and receiving contrasty lighting can be effectively captured by lower-cost digital cameras because the irregular patterns and rough textures help conceal the tell-tale signs of a low-resolution digital image. To ensure you don't miss such opportunities, your camera must be in good working order, with clean optics and fully powered with batteries; you should also have ample quantities of either film or "digital film" – the memory cards for digital cameras.*

📷 *Canon F-1n with 135mm lens; f/5.6 at $^1/_{250}$ sec; ISO 100 film.*

Survival guide

Here are some useful tips for ensuring trouble-free travel photography with your digital camera:

• Before you leave home, make sure that all equipment is working properly. Check the entire process, from capture to print-out. Take some pictures, download them into your computer, and check images at high magnification for any obvious defects. Then resize the images and print them out. If you do not realize that something is wrong with a piece of equipment before arriving at your destination, you may get home to find no recorded images.

• Take a battery charger and travel plug adaptor with you. If a power supply is not available, take lots of spare batteries. Consider buying a solar-powered battery charger for long trips to remote areas.

• Take as much spare memory with you as you can. Try to keep one (preformatted) memory card safe and empty as an emergency reserve. Check that it works with your camera first – sometimes cameras reject a memory card for no discernible reason.

• Wrap everything in double plastic bags if conditions are dusty, and don't subject equipment to extreme changes in temperature without sealing it in a case or an air-tight bag. If you take a camera from an air-conditioned room directly into tropical heat, condensation will form on the lens and camera body. Moving equipment from a warm environment into a very cold one, without giving it time to adapt, may damage it.

• Never leave a camera for a long time in high temperatures, such as in a car's glove compartment.

• Keep all optical surfaces clean. Blow dust, sand, or other loose debris off the lens and eyepiece optics before cleaning away marks. Use the inside surface of a clean double-tissue as a cleaning cloth. You can breathe on lenses and eyepieces and then carefully wipe off the water condensation. Don't scrub at the lens surface as if it were a car windshield.

• Batteries cause more malfunctions than anything else. If the camera will not work, first check that you have correctly installed the batteries. Then clean and check the contacts, if the camera still will not work they may have been distorted or bent out of shape. And, finally, check that all the batteries are equally fresh. Even one flat battery in a set of three good ones may give sufficient cause for the camera to complain. If you use rechargeable batteries, take at least one spare – five batteries, for example, if your camera takes four.

• Take a small tool kit with you. The handiest tool is a jeweler's screwdriver. Many cameras have up to ten tiny exposed screws, which could work loose after a lot of traveling. Check regularly and tighten them if necessary.

WARNING: Any repairs beyond this may invalidate your camera's guarantee.

REVITALIZING EXISTING IMAGES

Suitable images

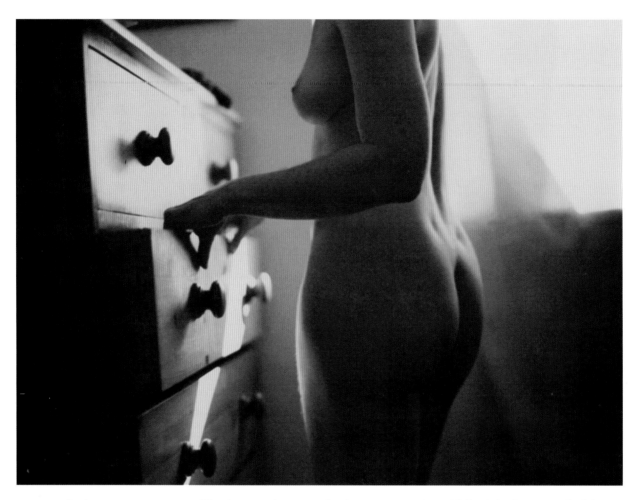

◁ ▽ *Strong morning light filtering through curtains caused the camera's light meter to produce the underexposed original image you can see below. The scan resulting from this thin original was very "noisy" due to the lack of detail, a problem that was particularly pronounced in the very dark shadow areas in the lower part of the image. Changing the image into a duotone helped, but more work was still needed and defects in the highlights of the scanned version had to be replaced by copying color from other areas. Other features of the software were utilized to give the shadows more substance without disturbing the rest of the image.*

📷 *Mamiya 645 Pro TL with 75mm lens; f/2.8 at $^1/_{125}$ sec; ISO 400 film; machine processed in T-Max.*

Whether or not you are a prolific photographer, the chances are that over the years you have built up drawers full of photographs, slides, and negatives, many of which could be enjoying a new lease of life. With the advanced digital technologies readily available on your desktop, it is an easy matter to start revitalizing the worthier examples from your archive. This chapter outlines the basic steps to take, from choosing suitable pictures for scanning, the scanning process itself, and the essential repair jobs, through to the storage and cataloging of the resulting digital files.

The best images for scanning (*see also pages 48–9*) are those that are technically of a high quality. Well-exposed and well-developed pictures will produce better scans than underexposed or overexposed ones, or those that have been poorly processed. Another point to look for is the focus and sharpness of the image you intend to work on. While digital image manipulation can improve a picture, the better the original is in the first place, the better the digital result inevitably will be. Don't think that image manipulation can work miracles; the software cannot pull out information from an image if it is not there to be seen

by the scanner. Having said that, it is always worthwhile attempting to rescue an image, especially an important one, and the only way to find out what can be done is to scan it and see.

Making a selection

Here are some hints to make sure that you achieve the best results when handling or choosing material for scanning:
• Well-exposed, well-developed film of any type is best to work on. Films that make the worse scans are overdeveloped black and white or underexposed transparency (slide) films.
• For color scans, color negative film (for color prints) is the easiest to work with.
• For prints, glossy papers work best. Avoid paper that has a pronounced texture. Prints with kinks and folds are very difficult to flatten out on the scanner bed.
• Carefully remove any dust, hair, or other loose material from the film using compressed canned air before scanning. Finger marks should be cleaned carefully away using a film-cleaning fluid.
• Do not use glass-mounted slides since the glass will interfere with the scanning.

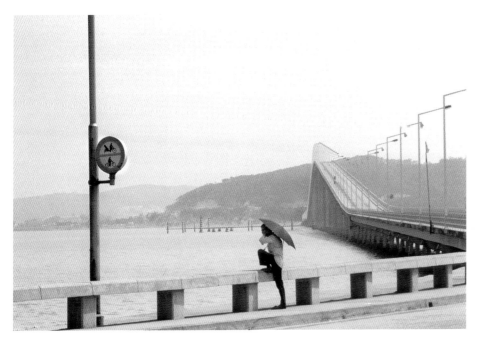

◁ △ This shot (above) was taken on a dull day, which led to a dull image and, not surprisingly, a poor scan. However, the potential of the shapes and composition of the original made it worth a rescue attempt. A lot of work on adjusting individual color channels brought back some of the colors (left), even if they do not relate strongly to those of the real scene.

📷 Nikon F2 with 135mm lens; f/4 at ¹/₆₀ sec; ISO 64 film.

What you can achieve

You do not need the most sophisticated photo-retouching software for the majority of image-manipulation jobs, but it helps. In fact, the simpler tasks tend to work best on better-quality software. So, what are the repairs and improvements you can realistically expect to be able to achieve at home?

• With a little practice you can clean up pictures heavily marked with such things as dust particles, small hairs, and scratches in about half an hour.

• Within limits, set by the quality of the original picture, you can improve subject contrast and brightness. Ironically, the better the original picture, the more you can manipulate contrast and brightness.

• The extent to which you can improve color balance depends on the software you use. Adobe Photoshop is currently the best, especially when helped by Extensis Intellihance or Test Strip, but other software, such as PhotoSuite and DeBabelizer, also work well.

• Repairing torn or missing parts of an image calls for a lot of skill since you need to copy, or clone, parts of the existing image into the missing areas.

Keeping tabs

Once you have built up a large collection of scanned images, you will soon discover the need for a system that keep tabs on them all. The most convenient method of doing this is by using cataloging applications (*see page 54*) – the digital equivalent of the ubiquitous office card index. Once you have turned your computer on, you can quickly and easily search for the details of a specific image, and take a look at the details of all the work you carried out on it and any notes you made, all without having to search out the original image.

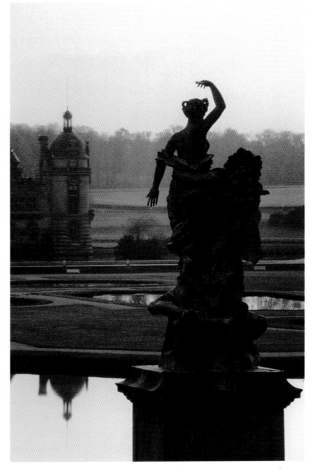

📷 Canon F-1n with 200mm lens; f/5.6 at ¹/₁₅ sec; ISO 100 film. Camera mounted on a tripod.

△ To the eye at the time of shooting, there was plenty of detail to be seen in this magnificent ornamental garden, but since I was photographing against the light, the film could not record it. Other exposures rendered the garden well but burned out the sky. Choosing the version with a fairly good sky (above right) yielded this scan (above) – too dark for the grounds but containing color information in the light areas. A little work improved detail in the shadow, as well as the mid-tones, although with some loss in the highlights. Details in the mid-tones are not as good as they would have been if properly exposed, but this is now a usable picture.

Working with flat-bed scanners

One excellent approach to using a flat-bed scanner is to use it simply as another type of camera – one that takes pictures in a completely different way. Because of this, it has special abilities – but also some peculiar foibles. Once you start to think of a scanner in this way, rather than as a high-tech computer peripheral, it can be great fun to use. All of a sudden, many jobs for which you would normally need a camera or an enlarger can simply be taken to your desktop. Flat-bed scanners are, in fact, digital photography's own studio camera.

Copying a print or document

Even if a print or document is too big to be encompassed by a single scan, it is easy to merge, or stitch, different scans together to make up the whole image, although quality may suffer as a result. And there is no reason why, in addition to prints or documents, you should not place any dry, flat object on the glass to be scanned. It is even possible to make a scan of your face or hands. You can also produce your own contact prints, like those reproduced below.

Bear in mind, however, that your flat-bed scanner is a precision instrument. Take commonsense precautions when scanning anything out of the ordinary:
• Do not scan anything that is damp or wet.
• Take care to avoid contaminating the glass bed with anything acid or corrosive, such as the perspiration on your fingers or food or drink.
• Take great care to avoid scratching the glass. In particular, be extremely careful if you are scanning such objects as jewelry or pebbles, which may be harder than glass.
• Do not force the lid down on an object in order to flatten it. This will strain the hinges, which are usually rather weak. Flatten the object before placing it on the scanner bed.

◁ Many scanners allow you to scan a batch, i.e., a number of photographs, at once. This not only greatly improves your working efficiency, it also means you can easily scan the entire batch as a single image. This is like making a contact sheet in normal photography, but can be far more useful in digital form: not only can you view all the images at once, but the "contact sheet" can be cataloged and its individual images can even be lifted off and used in their own right, whenever you need small, low resolution files.

📷 Canon EOS-1n with various lenses and exposure settings; ISO 100 film.

As with taking pictures on a normal camera, the more carefully you make the scan the better will be the quality of everything else that follows. All scanners offer you a pre-scan image that represents the final scan but without all the details. This gives you a chance to adjust the colors and tones of the pre-scan. You should adjust this image to match, as closely as possible, the original image before you make the final scan. Modern scanners and their "drivers" – the software that controls them – can produce outstanding results. However, there are things you can do to make sure that it (and you) work efficiently and to the best quality:

• Scan to produce an image that is the size you want to print out. For example, suppose you are scanning a print that is 5 x 4" (12 x 10cm) but you need the image to print out to 9 x 6" (23 x 15cm). It is better to make all these settings on the scanner and let it carry out all the calculations for you than scan at some other size, and subsequently make changes in your image manipulation software. First, it saves time to have the right size image straight out of the scanner rather than having to make adjustments after scanning. Second, if you increase the size of a scanned image you will probably lose out on quality compared to scanning it to the right size in the first place.

• Always keep the scanner glasses spotlessly clean.

• Check that the colors you see on the pre-scan match those of the final scan (*see pages 138–9*).
• Be systematic about your filing and the names you give your images.
• Ensure that you save your images to the file format that is easiest for your software to use. It is a waste of time having to change file formats more than is necessary. Image quality can suffer, too, if you do.
• Allow the scanner to warm up for at least half an hour if you want to make the best-quality scans.
• Line up originals carefully on the glass. Rotating an image after scanning to square it up can degrade image quality, especially that of black and white artwork.

Interpolation and exaggeration
When you buy a flat-bed scanner you will be presented with resolution figures. Certain manufacturers exploit a lack of knowledge concerning the difference between interpolated and optical resolution. Interpolated resolution invents data, while optical resolution is what the scanner can actually see. Interpolated resolutions can make a scanner look good: "4800 ppi for less than the cost of a computer" sounds like the greatest bargain in digital photography, and so that may be quoted instead of the optical figure of 600 pixels per inch (ppi). For photographic work, 600–1000 ppi will give very good service.

◁ △ You can create an image entirely on a flat-bed scanner using quite ordinary objects. I first scanned in all the individual elements shown above, such as a Russian lacquerware box, skull, and the various flowers. These scans were then combined in the computer after a great deal of experimenting with layering effects (see pages 64–5) and color adjustments. For example, the white flowers were turned into pink and blue ones. Not everything I scanned ended up in the final image, which was inspired by Pushkin's tale of a sleigh ride through a snowstorm at night.

Resolution and results

◁ It would be a pity to lose the beautiful sunset sky of the Aegean, here over the island of Chios, with a low-resolution scan. The film grain gives texture to the sky, without which it would be too polished and unreal looking. An insufficiently high-resolution scan would lose the film structure and substitute an unsatisfactory pixellation. The original 35mm slide was scanned at 2700 dpi for this reproduction.

📷 Canon EOS-1n with 17–35mm lens @ 17mm; f/8 at $^1/_{125}$ sec; ISO 100 film.

Even imaging professionals find this subject confusing, and space in a general book such as this permits only an outline discussion. For the present, note that there are two different meanings for the term "resolution".

First, when applied to input, such as that from a scanner, resolution is a measure of how much detail can be recorded by the device in question and should be quoted in pixels per inch (ppi). Second, when applied to output resolution, such as that from an ink-jet printer, it is a measure of how much detail can be seen in the print produced by that machine, and is quoted in lines per inch (lpi). Beware of confusing output resolution with yet another type of resolution – the printer's resolution – which is always higher than true output resolution (see also pages 140–1).

In practical terms, the easiest approach is simply to ask yourself some practical questions. "What am I going to do with this scan?" "Just what is going to be the final output?" "Will it be a greeting card no larger than a certain size, an image for the World Wide Web, or a large-format, exhibition-quality print?"

From the answers to these questions, everything else flows. If you know the output needed will be a large, high-quality poster, then a high-resolution scan will be needed and this will entail a very large file. If your demands are less ambitious, a lower-resolution scan, with a resulting small file, will be fine. So the question you will have to ask yourself before you start your scan is: "What is the best resolution I need?" Always aim for the optimum file size for the output's intended use. Most scanner software will tell you the file sizes that will be produced by the resolution settings.

Irrespective of the size of the original – whether it is an APS (Advanced Photo System) negative or a 10 x 8in (25 x 20cm) print – the largest basic finished file size you are likely to work with is 20–25MB. This is enough for a good-quality magazine reproduction to around A4 in size, but you can comfortably print up to A2 with an ink-jet printer without too much degradation of image quality.

A smaller output size, such as A5, can be provided by a file size in the region of 6–8MB. This is much more manageable. Now, if you print on an ink-jet printer, where the print quality may not be as high as that in a magazine, you may find that the difference in image quality between a 25MB file and a 6MB file is surprisingly little. At the other end of the scale, a half-size image for the Internet may be only about 50KB. More examples are in the table (see right), in which "Optimum" means optimized for file size – the best balance between a small file and requisite quality. These are not figures optimized for quality alone.

Optimum file sizes

Ink-jet prints

A3	20.8MB
A4 full	10.4MB
A5	5.2MB
6 x 4in photo (15 x 10cm)	2.7MB
A6	2.6MB

Images for web pages (in pixels)

960 x 640	1.75MB
768 x 512	1.12MB
640 x 480	0.90MB
480 x 320	0.45MB

Book/magazine prints

A4	18.6MB
10 x 8in (25 x 20cm)	13.6MB
A5	9.3MB
7 x 5in (18 x 12.5cm)	6.7MB

△ ▽ The grain structure of fast film is irregular, with rapid jumps between bright and dark, giving a speckled effect (above). At very high magnifications you can see that the image is made up of individual "dye-clouds" – the photochemical equivalents of pixels. Individual dye-clouds are red, green, or yellow and vary greatly in size, as well as in appearance according to how deep they are in the emulsion. The pixel structure of a digital image, however, at 800% magnification (below) is marked by the regularity of the component pixels – both in size and arrangement – with relatively few sudden leaps in values. Such a view is called "pixelated".

Sufficient pixels?

What do you do if the file you have is too small for the use you have in mind for the output? You could, perhaps, simply print it out to the size you want and hope for the best. At worst, you will see that the output is "pixelated", meaning that you can see the individual pixels that make up the image.

One way to avoid this often unsatisfactory result is to reduce the size of the individual pixels. This has the effect of increasing the file size, yet, of course, it cannot increase the amount of detail in the image itself – it simply is not there. The process used is called interpolation. This pads out the file by creating new pixels based on the values of nearby ones. Scanners also directly use interpolation, and for the same purpose – to pad out the information to make it appear as if there is more detail present than was actually recorded. It is worth experimenting to see if interpolation produced directly by the scanner gives a better result than interpolation carried out by your image-manipulation software.

△ Taken on extremely fast film in order to create a grainy rendering, this original actually appears smoother if a low-resolution scan is used. This can be good, or not, depending on your intentions. While very high resolution is needed to capture the true grain structure, that is arguably a waste of time. A low-resolution scan can work just as well.

📷 Olympus OM-2n with 85mm lens; f/2 at $^1/_{1000}$ sec; ISO 1000 film.

More efficient scanning

• Collect all your originals together, and plan what you want to do with them.
• Use a naming convention that others can understand, e.g., "girl rocks blue sea sky" can be more widely understood than "kristina chios".
• Scan all the landscape-shaped pictures separately from portrait-shaped ones. This saves you rotating pre-scans, and it helps if you classify originals by the final file size or resolution.

• Always scan images to the lowest resolution that you need. This gives you the smallest practical file size, which, in turn, makes image manipulation faster, takes up less storage space, and is quicker for you to access and move the file around.
• Consider whether you should make your output image very slightly larger (say, 5 percent) than the final size. Sometimes this is essential – when you want your image to "bleed", or extend to the very edge of the paper, for example.

△ The original digital camera shot of a Papua New Guinean looks sharp here. But its pixel structure makes it more difficult to enlarge greatly compared with the grain structure of film. Thus, while two images can be equally acceptable at low magnification, the digital image may be less tolerant of enlargement.

📷 Nikon Coolpix 900S digital camera, at 50mm focal length.

Tidy scans

△ ▽ *Scratches once ruined many a photograph, but no more. The long scratch on the original (below) was easily removed and the loss of contrast and desaturation of color caused by shooting through an airplane window were also corrected after scanning and applying simple manipulations.*

📷 *Canon F-1n with 50mm lens; f/8 at ¹/₂₅₀ sec; ISO 100 film.*

Once you have made your scan, you should make sure that the resulting file is as good as it can be before undertaking any manipulation work on it. The first task is to crop any unnecessary image in order to reduce its file size. Often you will set a slightly generous crop at the pre-scan on the basis that it is better to have too much than too little image. Removing even a small part of the image can save you a great deal of time and trouble since smaller files are always easier to deal with than larger ones.

Next, you may need to adjust the color balance and the tone reproduction. All image-manipulation software allows you to correct imbalances of color, such as the orange-red cast caused by tungsten-filament lighting recorded by daylight-balanced film. Another color problem is the blue cast often seen in shadows of shots taken outdoors on bright, cloudless days. To deal with this, open the color-balance control of your software, where you will see a dialog box with slider controls. Now, think about the image. What is its problem? Is it too red, too blue, and so on? Fortunately, unlike color printing, with digital photography you can experiment with different settings and see the results immediately on the screen. When it looks right, just hit the "return" key (*see also pages 58–9*).

All image-manipulation software allows you to set the overall brightness and contrast of an image. But this is a relatively crude control. Good software will allow you to manipulate the exact relationship between the light and dark parts of the image through the "Curves" control, which is a graphic representation of any changes you make to the existing tonal relationships. You do not have to worry about how this control actually works. Just experiment with the curves, watch what happens, and, when the image looks right, hit "return". This is the beauty and strength of digital photography: there is no need to commit yourself until you are sure the changes are exactly what you want them to be. If your software does not offer "Curves", it may give you "Levels" instead. Again, just experiment with this control, trying out the different settings until you like what you see on the screen (*see also pages 60–1*).

You need to bear in mind that the accuracy of your software's tone and color balance settings depends on how well your monitor is set up. More details on this are given on pages 138–9.

Overcoming problems

Even if you are not naturally tidy in your non-computing habits, you may be surprised just how satisfying cleaning and tidying up scans can be.

The essential technique for cleaning scans is to cover up the defect with a piece of the good image. A speck of dust in a sky almost always has a patch of perfectly clean sky next to it. By cloning, you copy that bit of clean sky (the source) and paste it on top of the speck of dust (the target) in order to obliterate it. The result is an invisible

Good habits

• Save the file regularly, and certainly after completing every element of a repair.
• Don't work at the monitor for more than an hour without taking at least a five-minute break. After several hours of work, give yourself increasingly longer breaks and, perhaps, some gentle exercise, such as forward bends.
• Use keyboard short-cuts to minimize strain on your wrists from using the mouse.
• Keep your working area clean, and drinks, etc., far away from slides and the scanner.
• Back up all that day's important work before shutting down the computer.

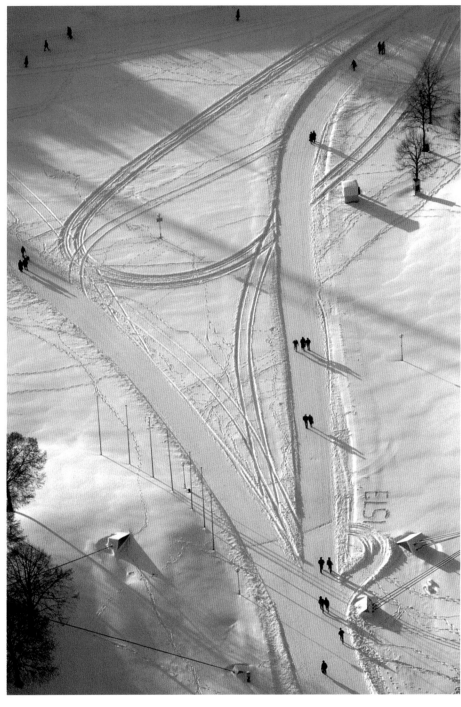

◁ The original view (near left) from Munich's television tower was too green from being shot through a pane of glass, and that was the first element to be corrected. And for my taste, there are too many details. Removing a number of people and lamp posts helped (far left), as did enhancing the tonal rendering by increasing contrast and saturation.

📷 Olympus OM-2 with 85mm lens, f/4 at ¹/₁₂₅ sec; ISO 100 film.

◁ △ Order was brought from the chaos of the original picture (left), showing gulls feeding off Brighton Pier, England. The first step was to remove some gulls, changing the position of others, and duplicating one or two into positions that improved the overall composition, taking care not to make the end result appear contrived. With a busy background of the water, it is easy to move elements around. However, close inspection shows you must be careful to match, say, the reflections of the gulls in the water to the birds above. And if you remove a gull, its reflection must also go. There are also subtle changes of hue and contrast in the water, and these must be matched to each gull's position.

📷 Contax S2 with 135mm lens; f/4 at ¹/₂₅₀ sec ; ISO 100 film.

repair. If you are working on a very dirty scan, start from the top left of the image since it is easier to clone systematically from cleaned areas to dirty ones. If you set the clone tool to "Aligned", the source will always be just to one side of the target area.

With defects larger than a speck of dust, you may be tempted to work too quickly. If you do so, there is a risk of creating new problems, such as streaky patterns or areas of excessive smoothness. To prevent this, select a smaller brush tool, dabbing at the area being repaired and checking results constantly before applying new strokes. Alternatively, it may be easier to copy over a large area all at once. This is usually possible only if you have large areas

of identical values to copy, such as an even sky. You need to make a selection that is "feathered", in which the border of the selection is unsharp so that it blends seamlessly into its new position.

When you have a lot of work to do on an area, it can become smoothed out because of all the feathering. This polishes away the look of film grain. To correct this, select the region you are working on and then add "noise", which will simulate the appearance of the film grain.

Damage to prints or film can almost always be repaired in the computer. The easiest ones to remove are scratches or other small, distinct marks. Large, blurred marks, such as water stains, can be very time-consuming to correct.

Storage and cataloging

You do not have to work long in digital photography to realize that a little activity produces a quantity of data far in excess of anything else you are likely to have encountered. Here are some simple strategies to prevent the mass of data overwhelming you:

• The most effective but hardest strategy to implement is using the smallest possible file size. Most people use files much larger than that required by the output in the mistaken belief that excess data is needed for quality results. If a high-resolution file is a must, then keep it solely as the source and make smaller working files from it as they are required. This is the thinking behind such systems as the Photo CD, which keep "proxies" of each file at different resolutions. Don't forget that the beauty of digital photography is that you can make as many copies of the original as you like without degrading it or worrying about the quality of the second-generation copy.

• Use the computer's hard disk as a permanent store only for your software applications, and for work-in-progress.

Software such as Adobe Photoshop needs lots of space on your hard disk to spread its files around while it works. So, apart from having the largest hard disk you can afford, you will also need to purchase removable storage media. Generally, the more data a disk accommodates the more cost effective it is. While 100MB disks are much cheaper than 2GB ones, and the drives themselves are also cheaper, the 2GB disk is far less costly per MB of data. Standards change with time, and you need to keep abreast of the most popular types of media, especially if you want to exchange disks with other digital

photographers. For early exchange with others, and for backup and archiving, a CD-writer (*see page 14*) is an excellent option.

• An important strategy is to use cataloging software right from the beginning. There is no point in clogging your brain with details to memorize when there is software available to do the same job more efficiently and reliably.

Cataloging applications work by making a record, just like a card index. Some specialize in images, while others will track all your digital assets. For example, if you point Extensis Portfolio at a folder containing dozens of images, within minutes it will create a catalog of the folder by collecting "thumbnail" images of every image contained. You can also add key words, such as dates, names of locations, or subject matter, so that at any time you will be able search for a particular record by entering a key word. You can use this catalog whenever you want: opening it up and checking through the thumbnail images is immeasurably easier and far faster than scrambling for individual disks – faster even than opening a folder already on the computer. Once you have the catalog, you can even publish it over a network or on the Internet.

• Another type of cataloging software is simpler but can be extremely useful by keeping track of all the files you have on all the disks you use. Thus, you can look up the contents of a disk at your computer without first having to mount the disk. Iomega's FindIt utility is a good example of this. You will find it preferable to identify your disks by numbers or dates rather than by names.

File compression

One way to save file space is to compress your files: this does not squeeze files physically, but stores them in an efficient way. Just as it is useful to have your papers scattered on your desk for working, but more efficient if piled for storage, so your image files need to be organized accordingly. The best compression is LZW: it works on TIFF, the commonest file format, and does not lose any data although its files are not the smallest possible. JPEG compresses to different levels according to the level of acceptable loss of detail: JPEG reduces files to a quarter of the original with very little loss, or if some defects are acceptable, files can be more than 75 times smaller.

70-71 paris gray 387K blue duo 608K purple duo 595K subtle duo 665K wacky duo 667K 01 2721K boy silh001 1034K Iyabi boy 4186K

Iyabi boy copy 7773K other boy001 2138K roof001 2136K -spiky flow001 18872K -spikyflowr ex1 1569K -spikyflowr fra 2767K -spikyflowr vrt 2077K spikyflowr 2934K

spikyflowr diff 3161K spikyflowr extr 1627K spikyflowr frac 3569K spikyflowr hi-b 2808K spikyflowr stnd 922K spikyflowr Terr 3021K spikyflowr twir 3037K spikyflowr vrtx 2325K

◁ *This is a typical "thumbnails" view of a catalog of some of the images used in this book. You can see at the glance how many images you have and whether there are any unnecessary duplicates, as well as look up such details as file size, file name, and so on. From within the cataloging program you may be able to do useful tasks, such as change a file's name without having to hunt down the original file – provided that the program can find the file on local disks or network. This screen shot is from Extensis Portfolio.*

PICTURE PROCESSING

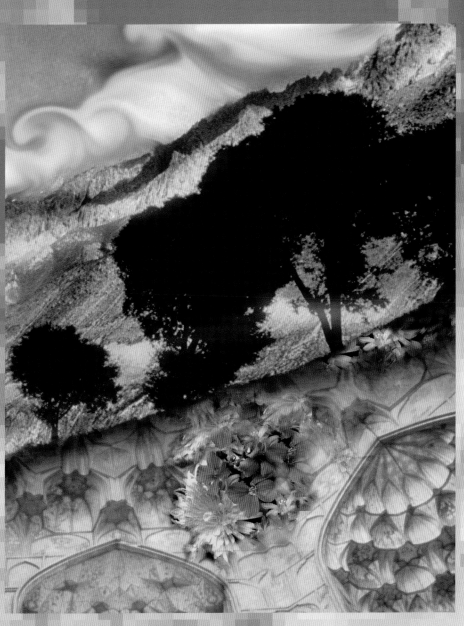

Making a start

I t is easy to be bewildered by the variety of digital effects that can be applied to an image. When you are first introduced to digital photography, it is natural to try out every effect, control, and filter on offer. But the fact is, as you will see in Master Class (*see pages 73–98*), most professionals use only a few of these effects and controls for any given project. If you are a photographer you may not wish to compromise your original image. Digital photography offers you the choice to stay as close to the original as you wish or to deviate from it as far as you wish.

You need to deal with picture processing systematically. For a start, there are the global color and tone controls, which affect the overall appearance of the image. The next most common process is the combination of images, or compositing – using cloning and copying techniques. Compositing in most applications places objects in their own virtual space or layer, rather like one transparent sheet over another; this gives us another element of control – the interaction between layers (*see pages 64-5*).

Most filters produce effects rather like the special-effects filters used on camera lenses, allowing you to distort, add textures or produce kaleidoscope-like effects. Since most digital filters are inspired by optical ones, it is unsurprising that they mimic known photographic effects.

The difference is that in digital processing you can precisely control the strength of the effect before applying it to the image. Note, however, that filter effects are now generally so powerful that the one-click types can easily submerge a picture's subject matter. This makes images that have filters applied to them all look pretty much the same – mere copies of each other.

Another fascinating area of digital processing uses the original picture as the basis for an altogether different class of image – such as digital paintings, "natural-media" images, or animations. One particularly popular simulation for many photographers is the duo-tone or tri-tone, which mimics darkroom toning effects. A close second come such painterly effects as pointillism.

A variety of electronic "tools" is used to control all of these effects. Some of them have overall image application, such as the zoom control to view the image at different magnifications, making and moving selections, etc. Some use symbols, such as a brush, to indicate their function and imply the effect they control; others may be less easy to understand until you use them. Keep in mind that tools are different from effects: you use tools in order to control effects. Generally speaking, tools are used to apply effects to small or local areas of the image in a controlled fashion.

◁ ▽ *Taking inspiration from printing processes that reduce the color palette as well as add liveliness of texture, I first inverted the colors of the original scene from rural Somerset, England (below). This turns both color and lightness values upside-down (left). I then adjusted individual color channels, to return the image as close as possible to the original, and then added a lot of noise and grain. More adjustments were needed to balance the tones and lighten or darken areas as needed. It sounds like a lot of work, but it actually took less than 30 minutes from start to finish.*

📷 *Leica R-4s with 180mm; f/8 at $^1/_{15}$ sec; ISO 100 film. Camera mounted on a tripod.*

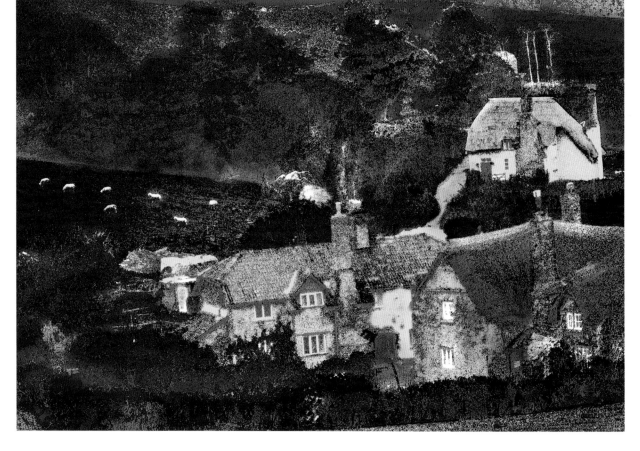

◁ △ *The original image of a picturesque corner of Prague (above) called out both for the removal of the unattractive car and a heightening of colors to Art Deco levels. A few minutes' cloning work removed the car by using portions from other parts of the image. Then I used the saturation controls to increase the color content. This tends to lighten tone overall, which was corrected using Levels and then Curves. Local saturation was also heavily and liberally applied, as you can see in the windows at the top to bring out the blue, as well as burning-in to darken slightly the pale wall on the left. The result is beginning to look like an enthusiastically hand-painted postcard of the type sold to tourists, which was the intention.*

📷 *Canon EOS-1n with 28–70mm lens @ 28mm; f/8 at $^1/_{30}$ sec; ISO 100 film.*

Avoiding problems

Digital picture processing is littered with little traps for the unwary. Here are a few to hints to help you avoid the more common pitfalls:

• Practice on a small file, say 300KB, when first using filters. Then you can learn most of what you need to know without having to wait ages for the effect to be applied to a large file. If your computer memory is limited, save a copy of your file, change its size to something smaller, and work on that version. When you have the exact effect you want, note the settings and apply them to the larger file.

• Work only on a copy of an important file, never the original file itself. A good habit is to duplicate a file even before you open it.

• Allocate to your program as much memory as possible, and do not run other programs at the same time if you can help it. Always make sure that your image-manipulation program is the first one you launch.

• Keep at least 15 percent of your hard disk free for the computer to use. The more free space it has, the better.

• Allow time for playing around. You will learn more from experimenting with settings than by trying to duplicate somebody else's effects.

• If you find that applying an effect or control seems to make no difference to your image, it may be that you have inadvertently selected a small section of the image and the changes are being applied only to that selection. De-select or press the "escape" key, and try again.

Controlling color

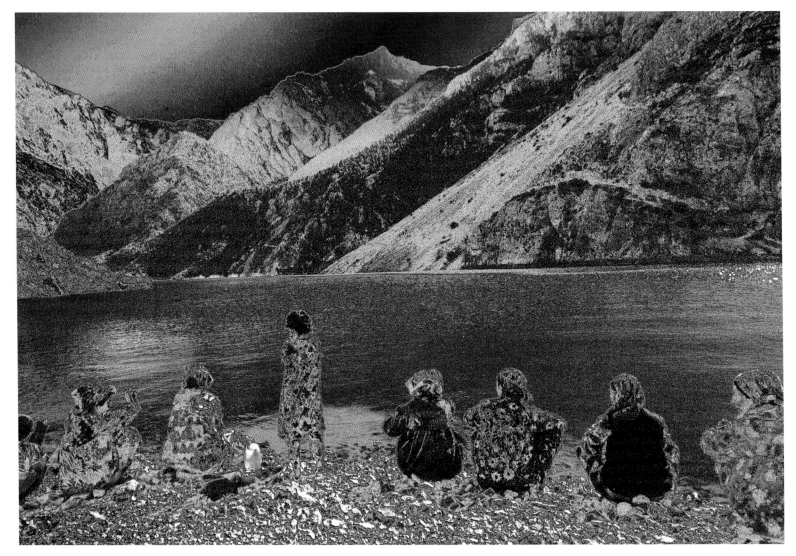

Digital photography gives you unprecedented control over the color content of images. It is safe to say that any color problem can be solved with ingenuity and knowledge. There is one drawback, however: you must recognize that different color-reproduction systems cannot, ever, be matched perfectly to each other. For example, your printer uses inks that are laid on paper, whereas a computer monitor uses phosphors that glow or give out colored light, while slide film uses dyes that filter out light. Each of these is a color-reproduction system, and while there is a certain amount of common ground, such as colors that match across the systems, there is a significant portion that simply will never match. Unfortunately, it is the bright, eye-catching colors that are the most difficult to match from one system to another and, more to the point, from our real-life experiences to any reproduction system. The subtle pastel hues may also be difficult to match.

How best to tackle this problem is the science of color management, covered later in this book (*see pages 138–9*). Our solution at this stage is to operate at the lowest common denominator – for most digital photographers, this means the range of colors that can be printed on paper by an ink-jet printer. All you need to do, therefore, is adjust your monitor so that the screen image looks similar to a print of the same image produced by your printer. You can use either your monitor's built-in controls or such software as Gamma Control in Adobe Photoshop.

As any darkroom worker knows, settings on the enlarger must be matched to suit the paper and chemistry being used. The usual darkroom test strip is a procedure that calibrates the whole system, and you have to perform the equivalent task for your computer. Your printer, therefore, can be thought of as a color enlarger. If you change its inks or use a different paper you may find that you need a different color balance to produce an accurate, color-

△ *While this peaceful scene by Lake Shakhimardan, Uzbekistan, makes a perfectly satisfactory picture, the strong shapes suggested other possibilities too. Changing the image from the usual color space of RGB (which describes colors with reference to amounts of red, green, or blue) to LAB space (which describes colors by their lightness 'L' and positions on color "wheels" 'A' and 'B'), I experimented with the lightness element and discovered that colors were affected in unexpected ways. The curves for this image are similar to the one for the LAB mode on the opposite page.*

📷 *Canon EOS-1n with 20mm lens; f/11 at 1/125 sec; ISO 100 film.*

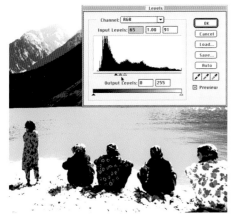

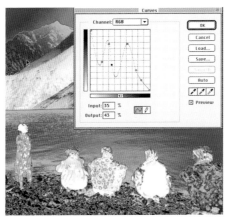

△ *Curves gives you tremendous control over image color. From the original scan (top left) you can exaggerate tonal values (above left) or create wild colors (above right). The other image (top right) shows a curve similar to that which created the main image on the opposite page. Note that it took only minute adjustments to create very different effects. Compare, for example, the mountain in the two versions.*

📷 *Canon EOS-1n with 20mm lens; f/11 at ¹/₁₂₅ sec; ISO 100 film.*

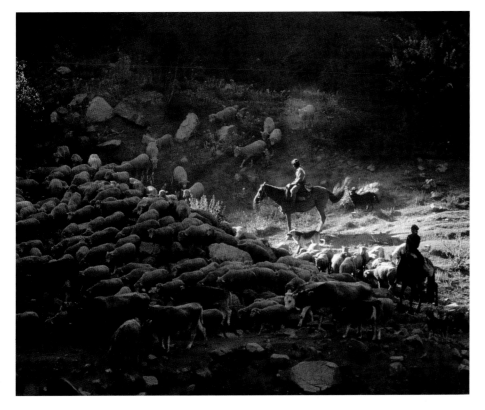

matched record. Similarly, you may need to calibrate your monitor screen from time to time.

Once the setting up is out of the way, you can turn your attention to individual images. The easiest way to control the overall color of an image is through the color-balance control, which is available on all image-manipulation software. Depending on how the control has been designed, you may have sliders, operated by the mouse, and the chance to see the effect of changes on your image before committing to it. If you have worked in a color darkroom you will probably be comfortable using these controls: you will know, for example, that decreasing the green and blue by equal amounts is the same as increasing the red, and so on. But if you have never dealt with color before, the best thing about working digitally is that you can move the sliders and just see what happens. Most software offers an automatic adjustment, which usually produces standard, satisfactory results.

Another approach is to use specialist software, such as Extensis Intellihance or Test Strip, that "plug-in" and work from within the Adobe Photoshop software program. The former analyzes the content of your image and automatically makes corrections for you, or you can set it to suit your particular tastes and preferences. Test Strip takes a different approach by offering visual feedback of any changes you make before you commit to them. Its best feature is that it can simulate the effects of using conventional color-correcting or color-balancing filters.

As you gain more experience with the software, you may want to start experimenting with the Curves control (*see left*). Curves gives you more control by allowing you, for example, to adjust colors in the shadows without affecting the colors in the highlights. And as you can see from the examples here, Curves can produce highly anomalous results, producing pictures that actually define a new type of imagery. These effects are purely digital in that it would be impossible to duplicate most of them in the darkroom. For those who enjoy visual stimulation, playing around with the Curves control using different color channels can bring hours of pleasure.

◁ ▽ *Cloudless days always give a mixture of lighting – warm colors from the sun's direct rays and cold colors in the shadows lit by the blue sky. In the original shot (below), taken near Lake Issyk-Kul, Kyrgyzstan, the shadows are too cold. Using the Curves control and choosing the blue channel (left), I reduced the middle-to-dark tones to raise the yellow (or minus-blue) content in the shadows to warm them a little.*

📷 *Canon EOS-1n with 300mm lens, plus 1.4x teleconverter; f/5.6 at ¹/₆₀ sec; ISO 100 film. Camera mounted on a tripod.*

Controlling tone

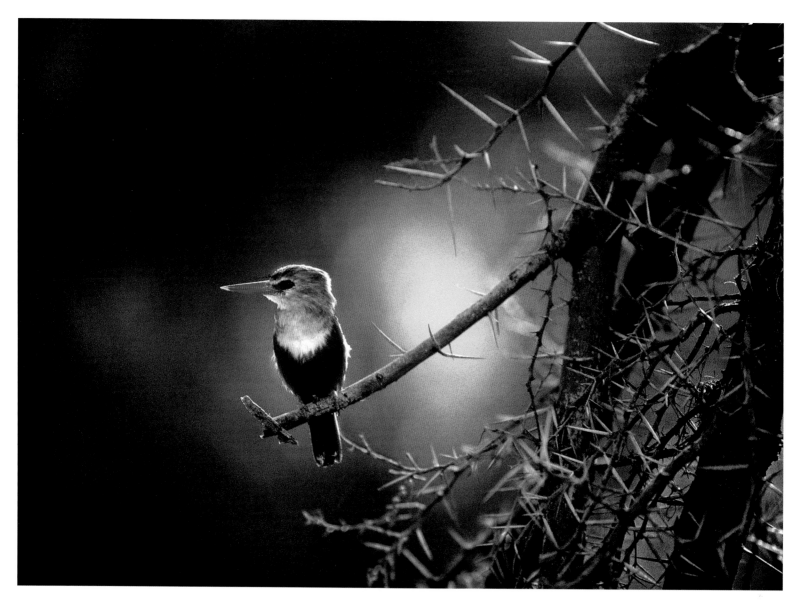

The ability to control tone reproduction is the hallmark of a good photographer. In black and white, tonal control is achieved by technical factors, such as film exposure and development, as well as the exposure and development of prints. In color photography, tone control is largely the result of standards set by the film- and print-processing industry, leaving only exposure and lighting for photographers – unless they have their own darkroom facilities. While the need for tone control is just as crucial in digital photography as it is in conventional work, the old restrictions have been thrown aside.

Conveniently at your desktop, digital photography allows you to turn a picture into high-key, low-key, posterized, high-contrast, or low-contrast result – and all within seconds. And better still, there is not a drop of chemical or scrap of paper in sight.

Different approaches

Image-manipulation software provides you with a number of approaches to controlling image tones.

Brightness This is a crude control that raises or lowers the brightness levels of every pixel by the same amount. Using this control causes a loss of image data.

Contrast Another crude control that changes contrast by clipping (reducing) or increasing the brightest and lightest pixels. This feature will also result in a loss of image data.

Levels Although the control is implemented in slightly different ways in different software applications, essentially it allows you to map the current brightest, average (or middle), and darkest pixels to new values by moving a series of slider controls on the screen. The Levels feature in more advanced software allows you to set the white point and black point. Setting the white point to just a little

△ *The light on this tiny kingfisher in Kenya was excellent but not perfect; a bright pool of light in the lower right-hand corner was distracting. This picture was taken before digital photography reached the desktop and for years I've wanted to reduce that distraction. I have now applied gradients on a layer, i.e., smooth transitions from dark to light, like the edge of a shadow, and combined it as "color burn" (see pages 64–7) to darken strongly without losing tonality.*

📷 *Canon F-1n with 300mm lens; f/2.8 at $^1/_{125}$ sec; ISO 100 film.*

down from its uppermost value improves highlight detail (by putting a little ink into otherwise blank areas); setting the black point to just a little less than maximum black improves shadows (it also saves on ink).

Curves This is the secret weapon in the arsenal of controls offered in digital photography. Curves can give you total control over not only the tonal reproduction of an image, but, where the software provides It, also over the way each colour component is reproduced. The Curves control takes Levels one step further by giving you infinitely more control over individual tone values.

The main purpose of tone reproduction is to match an image's overall tone values to what you think they should look like. On some occasions your aim may be to re-create, as closely as possible, the original scene's tonality. At other times, however, the tonality of the original scene may be only the jumping-off point for something altogether different. Whatever your intentions, digital manipulation allows you to experiment without committing anything to print. It usually helps, however, to have some idea of what you want to achieve before you start experimenting – but don't discount the value of unexpected results.

For quick, overall adjustments you may decide to use the brightness and contrast controls, but this is not recommended. If you have a Levels control, use that instead. One way of working is to start by adjusting Levels and then turn to Curves for more precise work and color balancing. The usual profile for good results – with increased mid-tone contrast and more detail in the shadows and highlights – is bow-shaped.

▽ *There is a limit to what digital manipulation can do. An overcast day in Prague resulted in the top image in the sequence below. The best that could be done with it is shown in the center. It does have improved colors and contrast, but it looks like a poorly printed postcard. It is no match for the brilliance of the same view, unretouched, taken on a bright day, shown at the bottom.*

📷 *Kodak DCS 210 digital camera @ 29mm focal length setting; ISO 100 film.*

▷ *Automatic tone correction has its limits. This shot of a restored portico in Athens (top) is too dark since I used exposure settings to to record details in the well-lit building opposite. Good transparency film can hold information that, although not obvious to the eye, can be extracted by a good-quality film scanner, but details lost in highlights are gone forever. Applying automated correction in software, such as Intellihance, may give a bright but too brilliant result (center). Here, the shadow values are overbright and colors are too saturated. In some programs, you can tone down an effect by degrees, as shown here (bottom). For this version, the Fade control was used, which adjusts the degree of mix of the original image and the new, altered one. A setting of 100 on the Fade control gives the full effect of the change, while 0 eliminated the change; I experimented with different settings and settled on 70 as giving the best balance between the over-correction and the too-dark original.*

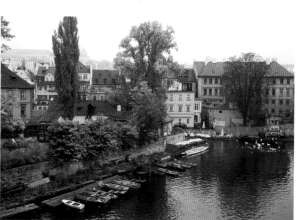

📷 *Canon EOS-1n with 17–35mm zoom lens @ 17mm; f/8 at ¹/₃₀ sec; ISO 100 film.*

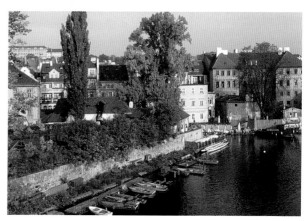

Creating a new image

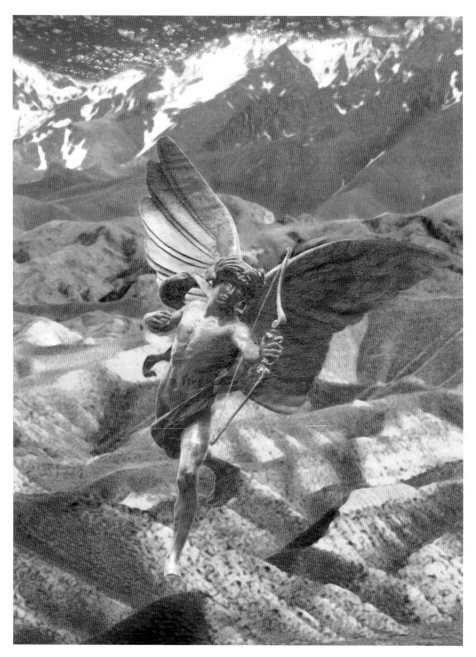

△ This image combines a sky from France, a landscape from Tajikistan, and a black and white Eros from London (right). But there is more – the colour for Eros comes from a canal in Brussels. Once the basic image was decided on, most of the work came from the need to make neat joins, as well as subtler details, to ensure a realistic blend between the elements. I put extra glints of gold, for example, on the Eros statue in order to suggest that it was picking up color from the desert.

📷 Sky: Olympus OM-2n with 21mm lens; f/8 at ¹/₈ sec; ISO 64 film. Desert: Leica R-6 with 80–200mm lens @ 200mm; f/4 at ¹/₆₀ sec; ISO 50 film. Eros statue: Canon EOS-1n with 80–200mm @ 180mm; f/4 at ¹/₂₅₀ sec; ISO 400 film.

Digital photography's ability to join seamlessly, blend, and mix numerous images into each other to create a completely new picture is one of the most exciting developments in the history of photography. Not only does this technique, called "compositing" (the making of composites), challenge the formerly unique and primary nature of the image, it alters forever the relationship between separate images. Now it is simple to take any part of any image and place it, perfectly blended and joined, into another to create an entirely new one.

The basic technique involves copying and pasting – a portion or all of a source image is copied over to, and pasted on top of, the target image. With simpler image-manipulation software, the new elements are placed directly on to the target image. With other software, the new elements can be placed onto a layer above the target image. This has the appearance of a drawing on a transparent sheet held above the target image. However, with digital imaging you can alter the ways in which the top layer interacts with the bottom one. Ordinarily, the top layer would simply add color to or darken the layer or base below it. But in the computer you can make the top layer brighten the lower one, create new color relationships (by, for example, making a blend of blue and red produce brilliant green rather than the dark brown you might expect), and so on.

In advanced techniques, you can use graduated masks to blend one layer softly and smoothly with another and outline shapes to allow a layer to show through. The images on these pages illustrate the variations possible using basically the same simple techniques. First, the figure of Eros was photographed in black and white. I then "lifted off" the original picture by selecting the statue using a combination of the Magic Wand tool in Adobe Photoshop, which joins up pixels with like values, and the Lasso selection tool. The unwanted background was then erased.

Next, the various backgrounds were worked on. The one requiring most work was the desert scene. The original shot had a dull sky, and one with more interest had to be blended in. A meteorologist might suspect that the sky came from the sea, not mountainous terrain. The blend was created simply by placing the new sky below the layer containing the desert and erasing unwanted sky from the desert scene.

To give the Eros some color, a photograph of water was copied and its colors changed until it had the golden hue you see here. It was then placed as a layer above the background image. At this stage, the golden layer completely masked the background. The role of the Eros figure is to allow the golden layer to show, but only

through the figure itself, and this is achieved by setting a "clipping path" relationship between the two layers. This means that the golden layer is masked where there are no pixels below it, and is allowed to show through where pixels are present, the strength of the color being dependent on the values of the pixels present. This is an excellent example of what software can achieve that is impossible by physical masking.

The most complicated-looking image, of the Eroses flying around Nelson's Column in London's Trafalgar Square, was in fact the easiest. I made numerous copies of the same basic Eros and transformed each with variations of size and orientation. To help give a sense of movement, some of their wings were blurred.

Hints for better compositing

• If you match your source image, in terms of sharpness, color balance, tonal quality, and lighting direction, with the target image, composites are usually more effective – unless you expressly want a mismatch.

• Don't leave stray black or white or sharply defined pixels along the edges of your selection since these will give away the effect. Some software allows you to "shrink" a selection by a few pixels to remove such clues. A careful blurring of the edge is a very effective correction.

• A few well-chosen and well-placed elements are almost always more effective than a medley of only vaguely relevant elements.

◁ △ *A very misty shot of the Palace of Westminster complex in central London was turned to good use as the basis for this version. Grain and exaggerated colors (screen shot left) were used to create a silhouette of the buildings, the gull was really there, and Eros is the same as the others on these pages.*

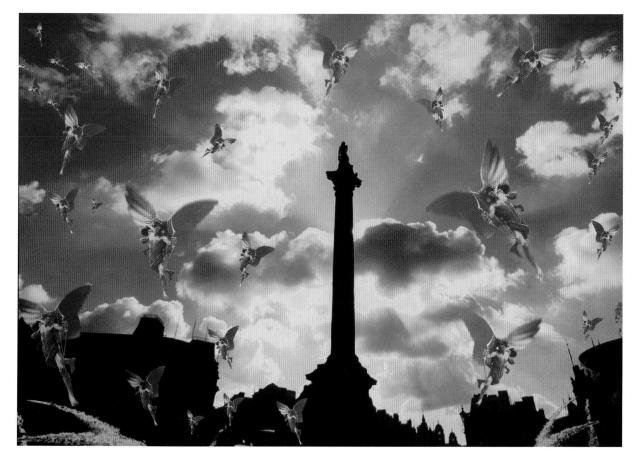

◁ ▽ *The Eroses flying around Nelson's Column in London was very easy to create, given one good shot of the Column. The individual statues were all clones from the same black and white image, but each has been scaled, turned, flipped over, or made lighter or darker to give a sense of them being at different distances. Some of the wings were blurred, too. The color for the statues came from a simple colored layer, which lay above the statues. The technique was to turn the Eros layer into a clipping path (screen shot below).*

Layer effects

The concept of layers is central to compositing techniques. Layers can be likened to the use of cels in motion-picture animation. Each cel carries a different part of the scene – the slowly changing background or the different positions of the character, for example. But layers go much further: instead of the simple obliteration of detail in a lower layer by one positioned on top, layers can interact or blend in a number of ways. Bear in mind that layers in digital photography are virtual layers – they do not exist in reality – so they can digitally interact with each other. This means that layers can be blended in any way the software permits.

The normal blend effect, or mode, in Adobe Photoshop, for example, defines the interaction simply as "replacement": the top layer replaces pixel information in the lower one. Another simple example is to define the interaction to be an addition of values – add the RGB (red, green, blue) values of corresponding pixels in the upper and lower layers. This results in a brighter layer and, thus, a much brighter image overall. Another example might compare the two values of corresponding pixels in the upper and lower layers, and set

a new value that is the lower of the two values. In other words, this layer interaction darkens where the upper layer is dark, but those parts of the lower image are left alone where they are already darker than the upper one.

On such programs as Adobe Photoshop you not only have a wide choice of blend modes – up to 19, depending on the version – but you can also adjust opacity. This controls the extent to which the upper layer covers or affects the lower layer. Think of it as controlling the "strength" of the upper layer. Equally, it controls the mixture of the two layers. Furthermore, if you have more than two layers, what you do on any one layer may affect the interactions in layers both above and below. It is truly a recipe for endless experimentation with different visual effects.

If you don't have a basic understanding of how layers work you may spend a lot of time trying out settings without any idea of how to achieve specific results. The examples here show some of the blend modes and variations for two layers but in different orders. For some blend modes you can obtain identical effects as using a different mode simply by reversing the order of the layers.

△ Layer-blending modes need not be complicated to be effective. Here, three images were combined and faded together, with two of the images reflected down the middle to create a strongly symmetrical design. The blending mode was "hard light" in the top two layers.

▣ Sheep: Canon EOS-1n with 80–200mm lens @ 200mm @ f/8, $1/125$ sec. Building: Canon EOS-1n with 20mm lens @ f/8, 4 sec. Tracks: Canon EOS-1n with 80–200mm lens @ 100mm @ f/4, $1/250$ sec.; all on ISO 100 film.

The sequence on the left shows the result of blending the images on the right in a variety of different modes and with one or the other layer on top, or "active".

◁ **Screen mode** *Imagine you have two projectors and are shining the image of the sheep's skull and the leafy grass (right) on to the same spot. The image would look rather confused (far left). The top, or active, layer is in screen mode, the lower is on normal. Swap the order of layers around and it will look the same. However, if you then change the lower layer to color dodge, the result is quite different (left), with only hints of the skull visible.*

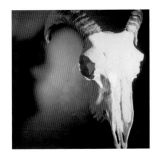

◁ **Color burn mode** *This is like a global burn tool – it darkens all it touches – but its effect is selective and it has more impact where there is already some darkness. In other words, color burn increases contrast, and does so very dramatically (far left). Swapping layers has no effect, but you can achieve a softer blend by pulling the leafy grass layer on top, and then changing the bottom, skull layer to soft light (left). Once you gain an understanding of how the layers interact, you can use local dodging and burning tools (to alter contrast) to touch up the image and produce a more convincing rendition.*

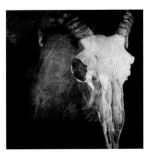

◁ **Color mode** *Using this mode mixes the hue and saturation information of the active layer with the brightness information (luminance channel) of the lower one. So you would expect radically different results depending on which image is active. With the skull layer active, its limited range of colors has the effect of toning down the colors in the underlying layer (far left). If you now place the leafy grass layer over the skull, you can see that only the strongest colors can overcome the strong density of the lower image (left). Adjusting the opacity of the active layer gives you great control over the final effect.*

◙ *Top: Nikon Coolpix 900 digital camera @ 50mm focal length setting. Above: Nikon F2 with 50mm lens; f/11 at 2 sec; ISO 64 film. Camera mounted on a tripod.*

◁ **Overlay** *This is in the same family as the soft light and hard light modes, in that they all screen or multiply a color, depending on the base color (lighter colors in the lower layer stand a better chance of showing through than darker ones). The overlay mode blends image detail without too much loss of detail in either layer. As you can see, changing the active layers makes a great deal of difference. With the skull above the grass (far left) only enough detail shows through to leave a ghostly outline of the skull. With the grass image above the skull (left), the lighter-colored pixels of the skull all show strongly through.*

◁ **Saturation** *If you are looking for a subtler effect, this one may interest you. In this mode, the saturation values – those that measure the strength of the colors – of the active layer are added to the underlying layer. The effect is clearest (far left) where the highly saturated colors of the skull have enhanced the colors of the grass and made them unnaturally brilliant. Reverse the situation (left), and the weaker colors of the grass have only a patchy effect on the skull, but they do leave a subtle pattern. To make local adjustments, the saturation tool is the one to use.*

◁ **Unpredictable results** *With the skull above the grass (far left) in difference mode and the underlying grass layer in color burn mode, the result is to invert the skull image to give a negative-like image. Difference mode inverts the values of underlying pixels according to the brightness of the active layer – the brighter the active-layer pixel, the more inverted becomes the corresponding lower pixel. Inversion means making a pixel bright if it is dark, or vice versa, and making it red if it is green, yellow if it is blue, and so on. The result you normally achieve is also shown when the underlying layer is set to normal mode (left).*

Filtering influences

Being able, at a touch of a button, to create the most fantastic visual effects without effort and after only a minimal delay is, at first experience, the most alluring feature of digital photography. But it soon pales. Fantastic filter effects on images are in themselves just that: effects. They amaze and impress for a short time, but they seldom lift themselves above sheer gimmickry.

Filter effects are, however, an excellent supplement to the more general, more photographic controls already seen. Their judicious use can lift a normal image into the extraordinary. Overuse of the more garish examples can be tamed only by good taste. However, not all filter effects are garish: some, such as unsharp masking, is a standard tool, although even that can be used too frequently.

Effects and uses

Since the variety of filter effects can be bewildering, it helps to classify them into broad groups.

Sharpness and blur filters These uniformly affect the image, or parts of it. They look at the edges to increase differences – to sharpen them – or decrease differences – to soften them.

Distortion filters The effects of these filters vary according to the selected area's distance from a certain point or axis. Their effect is to change the shape of the image.

Art materials filters These simulate such effects as charcoal drawing or painting brush strokes by using the image information and combining it with effects based on an analysis of artists' materials.

Stylizing filters Similar in operation to art materials filters, but they use geometric shapes, such as bricks, or greatly exaggerate a feature, such as edges, rather than using artists' materials as the model for the effect. Filters creating textures fall into this category.

Rendering filters These take their name from three-dimensional programs where the effect and the base image have a complicated, but controllable, relationship, such as lighting effects that simulate a light shining on an image. These effects make heavy demands on the computer, and you may find that large files cannot be processed at all if your computer is underpowered.

Noise and pixelation filters These break up the image with random patterns that simulate, say, photographic grain or the patterns from mechanical printing processes.

How filters work

It may spoil the mystique to learn that filters are essentially a series of repeated mathematical operations – repeated a truly enormous number of times – many of which are as basic as adding and subtracting. Some filters work by operating on small parts of your image at a time; others need to "see" the entire image all at once. For example, the "unsharp mask" filter looks at blocks of up to 64 pixels square at a time. But the "rendering" filter must load the entire image into memory because all of it is needed at once for the calculation. A simple filter effect to understand is distortion. Here, the filter moves the position of a pixel (actually it shunts the value of one pixel to another pixel) according to where it is. Suppose you want a "spherize" effect: in order to pull a rectangular shape into a spherical one, you must move pixels toward the center of the image by varying amounts, depending on how far away they are. Those that are distant from the center must move a greater distance than those nearer the center, which hardly move at all. Add all these moves together, and you will achieve a spherical distortion.

◁ This is an excellent candidate for filter effects (far left) because it has a strong, simple shape and lively colors. The filters most often reached for are those producing sharpening and blurring effects. You can apply some filters repeatedly to cumulative effect (left). You can see that the original shot has been sharpened more and more. As a result, even the out-of-focus part of the image has been enhanced. Note, too, that the film grain now shows up clearly and the flower has higher contrast.

◁ One of the most powerful filter effects is the lighting controls, and different software offers different versions. MetaCreations Painter, for example, has extremely powerful and versatile lighting tools. In Adobe Photoshop, the effects are still useful. Here (far left), a strong blue light has been applied off-center to the right with metallic surfaces and textures added to the green channel. In contrast, you can also produce a simple charcoal-and-chalk rendering of the image (left) – very useful for simplifying a subject while keeping the subject matter identifiable.

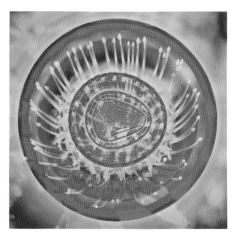

◁ You can see (far left) an image produced by KPT Fractal Explorer. A fractal is a complex curve which reveals more and more detail as you zoom into it: in image manipulation different fractals can produce stunning images very quckly. KPT works from within Adobe Photoshop. If, however, you want a pointillize effect, then this, too can be catered for (left). I posterized the pointillize effect to just three levels per channel, thus simplifying the range of colors to just three per color channel.

◁ It is best not to take tonal control for granted even though most filters leave the overall tonal balance alone. Here the solarize filter was used. The filter effect delivered by the system is shown first (far left). It is dark as this filter works by cutting off all pixels brighter than the mid-point, so all values are mid-point or darker. After being put through the Levels control (left), it is a much livelier, better-integrated image .

◁ Blurs can create useful patterns very quickly. Radial blur (far left) concentrates the blurring effect in a radial direction to give an effect very similar to zooming a lens while the shutter is held open during a long exposure. You do not expect a blur filter to produce patterns (left), but some do this very effectively. Here, a wavy blur has been applied to the basic image.

◁ The power of an application such as Adobe Photoshop is increased tremendously by using "plug-in" software. Once added to the application, plug-ins operate as if they are part of the basic program. KPT is one example, and another is Terrazo, the effects of which you can see at work here (far left and left). Xaos Tool's Terrazo makes repeating tiles out of a small portion of the image, and is both effective and quick. Better still, it is often bundled free with applications.

Natural media

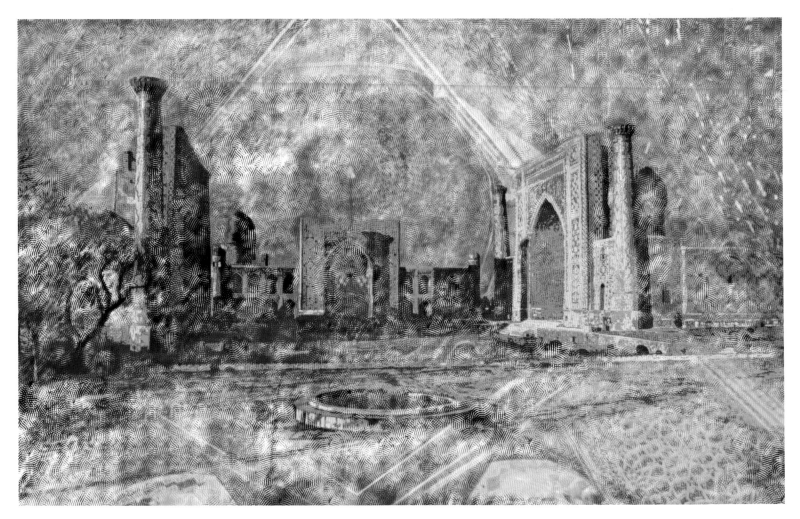

The natural step up from filters, which apply effects over the entire image in an indiscriminate way, is to apply the effects selectively. The programming skills that allow you to do this are nothing short of amazing – thanks to them you can stroke a line across your monitor screen and, instead of seeing a boring black line, you have a broad brush stroke, like that from a bristle brush heavily loaded with oils. The colors can even be mixed – as if you had dipped the brush into two or three colors – and the

colors can vary along the stroke. If digital photography causes some conventional workers to feel threatened, then natural-media programs could affect some painters in much the same way. But what is interesting is how to apply natural-media painting programs to photography.

The examples you see here do not even begin to scratch the surface of those available – natural-media effects deserve a book to themselves. For the photographer, the most useful technique is natural-media cloning.

◁ △ *The photograph of the Registan Square in Samarkand, seen on page 34, was used as the basis for this image (above). I reconstructed the image using a "pencil", working on a cross-hatched texture. As this process tends to reduce the strength of colors, I also reinforced the colors by using the Curves control (far left). However, this image lacked a center, so I blended in a new image (left) of another building in Samarkand.*

📷 *Far left: Canon EOS-1n with 24mm lens; f/16 at 1/15 sec; ISO 100 film. Left: Canon EOS-1n with 20mm lens; f/16 at 1/2 sec; ISO 100 film.*

◁ △ *A standard view of Notre Dame Cathedral, Paris (above), can be turned quickly into a pseudo-Impressionist sketch (left) using cloning and a suitable brush tool – one that does not lay down a single stroke but many smaller ones at once. With normal colors the effect was too washed out, so I strengthened the hues of the original and then posterized the image – reduced the steps of color to four per channel. Some parts of the "Impressionist" sketch were given colors not taken from the original image to liven up the darker parts, such as the foreground.*

📷 *Olympus OM-2n with 21mm lens; f/8 at 1/30 sec; ISO 64 film. Exposure was taken from the cathedral.*

Taking the Painter program as our example, you construct the cloned image, using the original source image data as usual, but the difference is that the source directs far more complicated effects. Each stroke is, in effect, like a little filter, so you build up an image by adding together lots of small filter effects, each based on a small area of the source image. The Impressionist-inspired sketch above is an example. The clone color was used to color the brush strokes, which were laid as flecks shaped like rice grains. The program automatically and randomly altered saturation and hue within a set limit as it laid the strokes, thus giving variety to the treatment. In Painter version 5, some of the filter effects actually include distortion as well as the more usual painterly ones.

You will find that the most effective images for natural-media effects are very simple ones, those with clear outlines and subject matter as well as strong colors, particularly if the image is to be used at a small size. As with filter effects, you will save yourself a great deal of time if you experiment with different effects on a small file. This takes the computer less time to process the effects, and so the work will feel far more responsive. Although you may have to wait several seconds to see the effect you have applied appear on the monitor screen, if you do not like what you see it can immediately be undone.

Should you wish to explore natural-media effects further, an essential purchase will be a graphics tablet. Working with a stylus and a tablet gives you something no mouse ever can – variations in pressure to produce variations in the width of stroke or the strength of color. Graphics tablets come in various sizes, the most practical being A5. This is large enough to do serious work but not so large that it swamps your work space. You will find it indispensable for all image-manipulation work, not just natural-media painting. Costs are approximately five or more times higher than a good-quality mouse.

Use natural-media effects when you need a change of style and pace. Because they are unusual and they also compress very well, they are excellent for Web pages. It is easy to get carried away with the effects, however, so when you have worked on an image, stand back and bear in mind that, in art, less is often more.

Duo-tones

Of all the digital image-manipulation techniques that are currently available, one of the most subtle and, at the same time, rewarding is the duo-tone. Its subtlety comes from the fact that, at its best, the duo-tone relies on nuance and quiet effects for its impact, which is always soft and easy on the eye. And working digitally with duo-tones is rewarding because the influence that you exert over the image's final appearance is almost miraculously controllable.

So, what exactly are duo-tones? In the printing industry, they are used to improve the rendition of blacks and to give the impression of a greater range of tones in an image. In order to achieve this, two different inks are used: one is the normal black, while the second is a colored ink, which can vary in intensity from very light to very dark. The most often-used second ink color is a warm- or yellowish-colored black. The use of two inks gives rise to the term "duo-tone"; if three inks are used,

the correct term is "tri-tone". When you work digitally, you replicate the printing industry effects by using all the inks at the disposal of your color printer. Fortunately, you can leave the complicated color calculations to the image software. The most powerful, yet easiest, software to use for creating duo-tone effects is Adobe Photoshop – version 5 of this application allows you, for the first time, to see instantly the effects of any of the changes you make.

For example, you were to put some dark brown ink on top of the black, it would deepen the black by filling in much of what little white space was left in the first printing. Furthermore, you can allow some of the second ink to tone the mid-tones: usually this is confined to the lower mid-tones. The result is to enrich the whole visual experience of the printing. The subtle separation of hues in the low to lower mid-tones from those in the highlights has the effect of producing the appearance of a wider range of tones than is actually the case.

△ *This picture was taken in soft morning light with the lens at full aperture. It was obvious to me at the time I took the shot that it should not be printed as an ordinary black and white image. The softness of the tone it contains complements the softness of the focus.*

📷 *Mamiya 645s with 75mm lens; f/2.8 at $^1/_{30}$ sec; ISO 400 film. The film was developed in ID-11 1+1, and the image was scanned from the negative.*

△ A black and white negative of a bedroom scene was scanned and then turned into a duo-tone using a blue second ink. This lowered the overall contrast of the image, so some of the highlights were exaggerated by applying some local dodging.

📷 Mamiya 645s with 75mm lens; f/5.6 at ¹/₁₅ sec; ISO 400 film. The film was developed in ID-11 1+1 and the Image was scanned from negative.

Creating a duo-tone

You can start from any image file, even a color one. First, whatever the type of image file you have, turn it into a gray-scale image in the Image > Mode menu of Adobe Photoshop. This means discarding all color information forever – so make a copy of any color file as an initial step. Once you have done this, access the duo-tone mode (again under the Image > Mode menu). From here, select duo-tone from the menu in the dialogue box. You now have a choice of going it alone or loading one of the preset duo-tones. If you are not familiar with duo-tones, use the Duo-tone Presets, usually found in the Adobe Photoshop folder in the "Goodies" folder. Double-click on any one and see the result. Trying just a few experiments is likely to give you a pleasing result.

Clicking on the colored square in the dialog box allows you to change the color of the second ink. A bright red could give you the effect of gold toning; a dark brown ink can give a sepia-toned result. You can see how powerful this feature is – in an instant, the toning of any image varies without you having to go through the bother, mess, and expense of mixing chemicals, which start to deteriorate immediately after you have made them up.

If you click on the lower of the little graph symbols, you will see a curve. This tells you how the second ink is placed – manipulate the shape of the curve and you change the effect of the ink. You may choose to have a lot of the second ink in the highlights, in which case all the upper tones will be tinted. Or you may choose to create a wavy curve, in which case the result will be an image looking like it has been posterized.

In the latest version of Adobe Photoshop, you can choose Previews, which allows you to see any changes you make without having to apply the effect to the image. If you have a lot of spare RAM, the updates will be rapid; otherwise not. But an update, even if slow, is better than none at all. This issue is important since there is no substitute for seeing the effect of small changes to test the effectiveness of the duo-tone on your image.

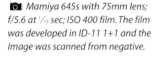

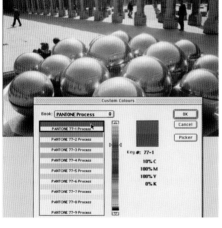

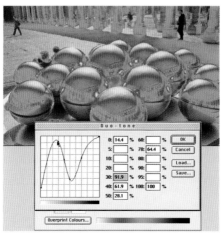

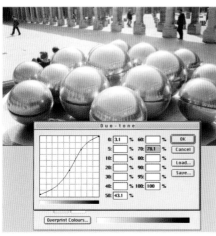

◁ The first choice of color was a blue (top far left), with a curve that put a lot of color in the shadows. The second shot (top left) shows a choice of brown-red. When that color is taken and an anomalous curve is drawn, the result is a posterized, metallic effect (bottom far left). This is increased by removing the color and increasing the contrast. The use of a gentler curve (bottom left) results in a subtler hint of sepia in the shadows and mid-tones. The original scan is shown below.

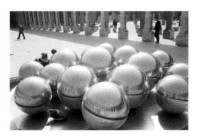

📷 Leica M-6 with 35mm lens; f/8 at ¹/₁₂₅ sec; ISO 400 film. Film developed in ID-11 1+1.

Framing images

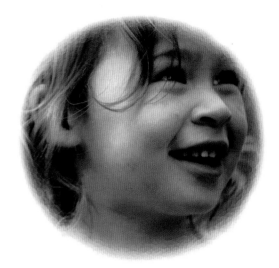

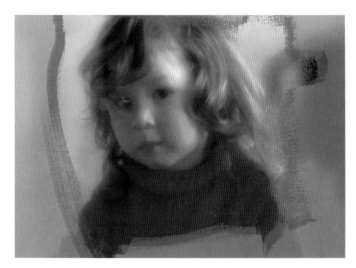

The square or rectangular, sharp-edged frame is not the only way to present an image. Many cultures incorporate the irregular outlines of the support material being used, be it tree bark, leather, or a rock wall, into the image itself. However, the way we most often present images is within the confines of a regular frame – on the printed page, for example, or a sheet of printing paper – and so anything less formal in terms of image appearance can look untidy. One way around this dilemma is to accept the basic rectangular format but to make the edges varied and less strict in order to create a more fluid junction between the image and its surroundings.

This development lends itself perfectly to digital-manipulation techniques, since you can easily produce a series of frames useable with any number or type of images. Frames can have a paintbrush effect, for example, with ragged and torn edges, or you can try geometrically patterned edges, or frames created with different lighting effects. All of these, and many more, are easy and quick to produce on your computer.

The usual approach to creating frames is to use a plug-in filter. Although the plug-in is a program in its own right, it can only operate from within another program, such as Photoshop. As a first step, open your digital image and then start the plug-in – this has its own dialogue box where you can set all the parameters you need, such as the width and blending mode or the transparency of the frame. By using some plug-ins, you are able to simulate the appearance of a bevelled and grooved wooden frame, but there is such an overwhelming choice of framing software, via extra CD-ROMs or downloadable from the Internet, that it is impossible to even begin to list them all.

Another approach is the drop-shadow. This is a popular graphic design device that gives the impression that the image is floating above the printed page. This is achieved by creating a softly blurred shadow partially hidden by the object. Its position relative to the object, its colour, and how blurred it is all give the viewer information about the lighting and how "close" the object is to the paper's surface. There is an art to the drop-shadow: when quietly and subtly produced it can contribute to the overall effect; otherwise it will dramatically reduce the image's impact. Drop-shadows can be created using any image-manipulation software that has a Layers facility.

◁ *Flexibility with frames, as seen here, given by the Photoframes plug-in for Photoshop is far greater and easier using digital techniques than conventional processes. You can choose effects from a wide and growing choice (from CD-ROMs or the Internet), apply colors, different layer-blending modes, or create your own frames.*

MASTER CLASS

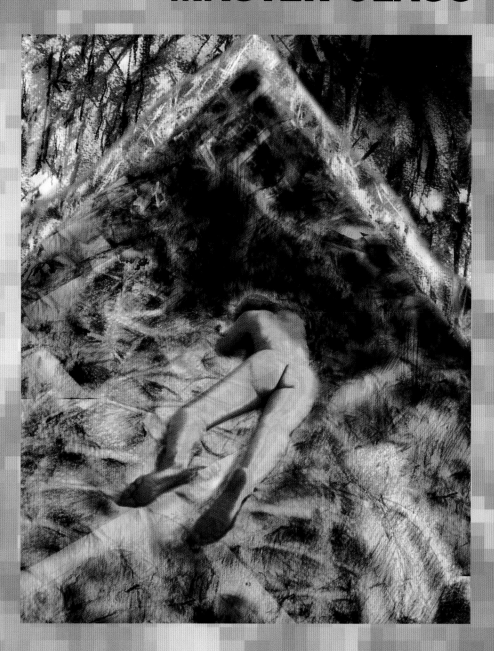

A multi-discipline approach

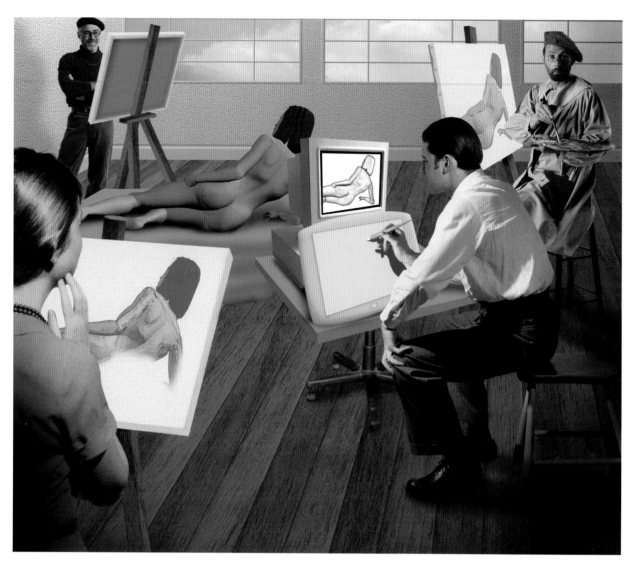

◁ To illustrate an article on graphics tablets, commissioned by PC Format magazine, digital pro Steve Caplin had to bring together a range of skills and tap into diverse sources of imagery. The room was drawn entirely digitally once most of the elements were in place – it was easier to match a perspective to the available elements rather than force the component parts of the image into any type of fixed perspective. The artists were taken from a CD-ROM collection but the nude model was drawn in the computer, using Poser software. The graphics tablet itself had to be drawn from scratch. Finally, Caplin had to keep the design considerations firmly in mind – the lower right part of the image had to be dark to carry reversed-out type. Note some of his clever touches, such as the hand position of the artist using the graphics tablet and eye contact with one of the artists. It is this type of detail that enlivens an image and shows a real master at work.

Battle lines have long been drawn between art and photography, largely on the grounds that art is somehow better because of the greater element of human skill and interpretation involved in producing an image, while photography is simply a mechanical process, too literal. And since the introduction of digital cameras, a line now seems to have been drawn between digital and conventional practitioners. Digital imaging, the complaint goes, is too far removed from the "truth" of the scene or situation recorded because of the interposition of the computer and by the need to learn how to use various application programs. Some of this ill-will may simply be resistance to letting go of hard-won darkroom skills.

Indeed, digital photography calls for a new breed of generalist practitioner. For many years, a photographer could get away with knowing only how to operate a camera, lens, and exposure meter. All other aspects of picture-making could be left to technicians. Today, digital photographers need to be masters not only of the camera, they must also be computer literate. Further, they need a good understanding of the printing processes, without which achieving specific color results becomes a matter of luck rather than judgement. For good measure, as the worldwide web becomes increasingly important as a showcase for the work of both aspiring and established photographers, competence in web design becomes more of a factor.

As a result, modern masters of digital photography need to adopt a multi-discipline approach – not only visually aware and photographically talented, but also comfortable with the computer, a variety of programs, and printing processes. In short, there are very few masters. There are plenty of technical wizards who simply do not understand the subtle nuances that separate good imagery from bad, just as there are many talented photographers whose command of the computer might well embarrass the average teenager.

The needs of the image

In this section of the book, you will have the opportunity to look at examples of work from a range of expert digital photographers, whose material takes in everything from the mystical to the commercial, including documentation, cultural commentary, and the irreverently critical.

The work presented should not be thought of as the result of any aimless experimentation, even though step-by-step details of how the photographers arrived at any particular image are not given. This is because good photography is driven by the image, not by the processes involved in getting there. If, for example, you learn a process, such as how to manipulate layer masking, there is no guarantee that applying that process will ever create an image that satisfies you.

Suppose you experiment with the different filters and effects of various blending modes and discover that a certain combination of settings gives you an interesting result, which then becomes your new image. If you work in this way, then it is the program leading you to the end result, rather than your own ideas being the driving force. This is, in fact, the common experience for many people starting out on digital image manipulation. Certainly you need to experiment in order to learn how the software works, but the sooner you turn the situation around, so that you continually try to make the software produce the result you want to see, the better.

Even a quick glance at the techniques in this chapter may show you something you find surprising – professionals often use only a very small part of their available repertoire.

First, they all use the basic adjustments of levels, curves, hue, and saturation – but the contrast and brightness controls are really too crude for professional consideration. Cloning and selection with copying controls rank next in terms of frequency of use, which brings in layers and their blending modes. To touch up and balance the overall image, the burn, dodge, and saturation tools are favored. So where are all the filter effects? Perhaps the sharpen and the blur filters will occasionally be applied, but most of the time the rest will lie unused. The fewer elements of the software you use the more likely it is that those you do use will become an extension of your thinking.

Apart from the fact that professionals often work with bigger files than do non-professionals, the work you see in this chapter can all be done on any modern computer and with relatively modest photographic equipment. Furthermore, every effect or technique you learn about can be scaled down to smaller, lower-resolution files. It is this "scalability" that is one of the less obvious hallmarks of digital work, while conventional photography is often shackled to specific film formats and the availability of set sizes of printing paper. You may be encouraged to know that none of the artists featured on these pages uses the latest or the fastest computers.

Good digital photographers, like their conventional counterparts, can come from any type of background, and the good news is that the need for talented digital workers is growing far faster than the available supply. If you can combine technical skills with artistry and a visual creativity, you have every chance of becoming a success.

Career advice

What are the key requirements for a successful career in digital photography? Assuming that you have the desire and motivation, then what you need above all else is a wide portfolio of skills:

• You need to be a competent photographer – to understand lighting, exposure, composition, and the nature of film. All the photographers featured in this chapter demonstrate this understanding in large measure, even if they have not been formally trained as photographers.

• You need to be comfortable with computers and able to work with diverse pieces of hardware to get the most out of them.

• You need to be competent working with software. This means more than being able to use standard software. You need to be able to obtain the results you want rapidly so that your thinking and creative processes are not hampered by the software.

• It helps if you can draw, although this is not essential. Most of the people featured in this chapter are more than competent draughtsmen and -women.

• You need to understand how to translate the abstract into a visually led product, such as a poster, editorial illustration, or product label. Much of today's professional work is the creation of a visual solution to a conceptual or communication problem – for example, producing an image to express the passage of time, or illustrating the tactics used by politicians to appeal to young voters.

• You need good business sense or access to good advice, as well as a desire to commit yourself to working to the highest standards.

• You need to be professional in all aspects of your career, and to take all your commitments seriously. This includes always meeting deadlines. Working as a professional means you may be dealing with commercial enterprises that cannot afford to be let down by the late arrival of your artwork, no matter how good the reason.

• You will discover that it is particularly helpful to have a base in visual and contemporary culture, as well as an awareness of art history. Such a background provides you with a rich resource of ideas and, at the same time, may help you to avoid obvious examples of visual cliché.

Catherine McIntyre

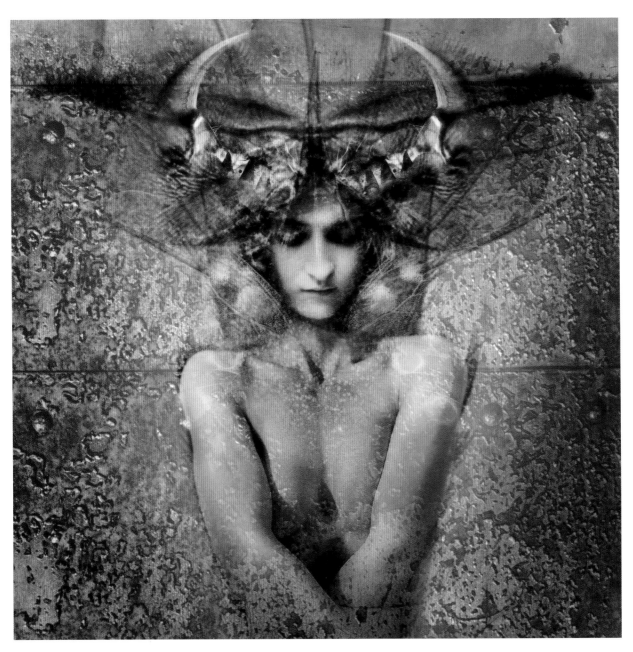

◁ Chrysalid, *appropriately enough, is an image that, as Catherine McIntyre explains, "grew by itself and did not have an agenda to start with." However, as she worked on it, her concepts of metamorphosis and Woman as Nature began to clarify. The figure comprises several layers of the same image in different modes – a luminosity layer at around 50 percent underneath, followed by another layer to give it strength, and a further one to lift the highlights. The "horns" are, in fact, a spider's fangs taken from a late 19th-century encyclopedia. Other components in this image include a closeup of a fly's foot, a pale butterfly, and, for the background, an old, rusted door photographed at a factory in Dundee, Scotland, the colors of which have not been altered.*

Catherine McIntyre's roots are photographic, although her background is in illustration. The photographic influence is evident in the "feel" of her images, which definitely belongs to the photographic print. McIntyre works with closeups of texture – crazed porcelain, the surface of papers, the fineness of feathers – but she uses them at a variety of different scales so that their surface qualities complement or contrast with the smooth beauty of the human forms she places with them.

McIntyre began her formal studies in the life studio – a traditional start for many artists. McIntyre says it gave her a sound understanding of form, light, and proportion. One consequence of this training is that she has an abiding fascination with anatomy, the mechanics and moods of the body and its movement as well as its measurement.

While working for a Master's in photography, she found herself preoccupied once more with the nude. Like many digital photographers, she had experimented with collage but found working with pieces of paper restricting in terms of scale and color. Furthermore, the mechanical limitations of sticking the objects and their lack of translucency were frustrating her expression. When she discovered Adobe Photoshop, she also discovered the power of digital or virtual layers. It was a liberation, and a revelation. McIntyre found that she could combine all her interests in the nude, collage, and photography into a single, seamless operation.

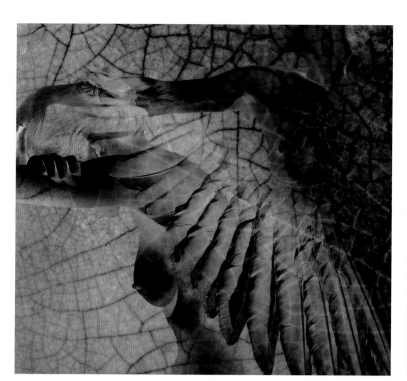

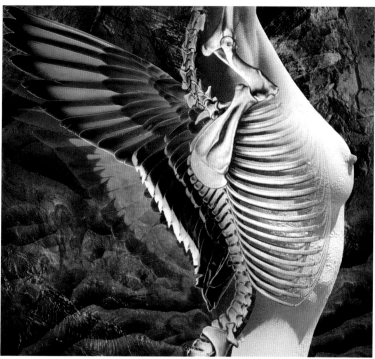

△ Above left: Black Angel *is the title of a personal piece about depression. Three layers of a dead pigeon's wing, a directly scanned plate, plus the image of a nude are the components here, which were all blended in Difference mode to deliver a heavy, dark effect. The image was used as a CD cover for Carl Weingarten and Joe Venegoni's* Silent Night/God Rest Ye Merry Gentlemen, *which was published in 1998.*

Above right: Victory *is a striking image that expresses the exaltation of survival and winning out against the odds. It is composed of numerous layers and components, including a rock, some sand, fossil fish, a wall, bones copied from a 19th-century etching, a duck's wings, a horse's neck, and a nude figure. The nude was placed as the top layer, using Blend in the Luminosity mode. This way, the lightness values of the nude are maintained but they are mixed with the colors from the lower layers.*

◁ The Act of Not Writing *is an image dealing with absence. The absence of communication creates negativity and the darkness of isolation, while the trapped figure reaches out to connect with the outside world. Various envelopes from an auction catalog for a stamp sale were used, blended as Difference and Luminosity mode layers. The nude was first inverted (its bright values darkened and dark ones lightened) and then sandwiched between the layers of envelopes as a Difference layer. The inversion was needed because Difference tends to darken light values.*

Workshop 1: Catherine McIntyre

◁ *The concept underlying this image, entitled* Past, *is the way history, either personal or global, always seems to haunt and influence the present. The background for the image consists of a simple merge of two different shots of a peeling wall, plus a shot of a lion's skull, and a scan of photographs of child victims from the Holocaust. Technically, it is very straightforward, and the image's strength comes from careful composition, the sparing use of emotive elements, and subtle tonal control.*

Catherine McIntyre's studio setup is an excellent reminder that it is not the newest, most-expensive equipment that produces the brightest and best work. McIntyre works on a relatively old Apple PowerMac 8600 running at 250MHz, with an extra 32MB of RAM to take her total to just 64MB. Surprisingly, she uses a mouse in her work, varying the air-brush pressure and other parameters from the options palette. She says that she cannot get on with a graphics tablet. Her scanners are widely used industry standards – the early version of the Nikon CoolScan and a Umax Astra 1200S flat-bed scanner. For backing-up files, which she does in a very organized fashion, she uses a Yamaha Prowrite CD-ROM writer.

Her exquisite prints are output on the Epson Photo EX. For the photographic side of her work, McIntyre prefers a Minolta X300, which she finds easier to focus on textures or larger elements, such as the skull seen above, compared with her other camera, a Nikon F401. The Nikon is equipped with a 28–80mm zoom; the Minolta with a 28–70mm zoom. She also uses an early Bronica medium format camera for some elements, such as her nudes (*see pages 80–1*), as well as close-ups, using an 80mm lens. Agfapan 100 is her choice for black and white, while she uses Fuji for transparencies and Agfa for color negatives.

Deliquescence, a monograph of her work, was published by Pohlmann Press in 1999.

△ Part of a photograph of a wall, taken on color negative film, scanned and slightly enhanced. This was merged with the photograph of the wall below to increase the complexity of the textures and also to give a graduated range of colors.

△ A lion's skull, borrowed from a local museum, was taken to a beach to be photographed. It was important that the direction of the lighting on the skull matched that on the walls, and that the shadows fell to their intended position, below the skull.

△ The lighting on this wall had more light and contrast than that of the one above, so care was needed when blending them. Masks were used to fade one wall (to make it more transparent) in order to allow the other to show through. You can see in the final image that the blue, for example, does not extend right across the image.

△ This image was scanned from a book illustrating the Holocaust. It was added to the main image in Lighten mode. In this, the software compares the brightness of each pixel on one layer with the underlying image: if the upper pixel is lighter than the lower one, that is the final value of the pixel; otherwise the lower pixel value is adopted.

Workshop 2: Catherine McIntyre

◁ *This image, entitled* It Looks Still, *is constructed from five layers. The background is a combination of pictures of tree bark placed over a shot of a pastel-coloured wall. The drawing of a molecular structure, created with graphics software, was carried in another layer. These layers were blended in Luminosity mode, in which the brightness of the lower layer is kept but is coloured by the layer above. The final two layers are represented by the nude body and the handwritten text.*

Catherine McIntyre's image of a figure emerging from a wall like an unfinished Michelangelo sculpture is, the artist says, about travel: "It's the travelling through time of genetic information and it is also about the fact that physical and psychological travel requires future contemplation to be fully assimilated." Part of her thinking behind the work involves the clichéd metaphor of the journey through life being an inward movement, which she symbolizes here with the helical arrangement of the molecule, a shape echoed by and contained within the nude figure caught in a twisting, struggling pose.

In its construction, the image is not complicated, and in terms of composition it is conventional. What makes it so interesting, however, is the thinking behind its conception. That, in turn, brought in the variety of textures seen, ranging from the peeling, decaying wall surface and the smooth sensuality of the body to the hard, polished nuclei of the atomic model. The handwriting is the finishing touch. Its suggestion of being graffiti gives scale and context to the texture, as well as a philosophical insight. As it turns out, the painter Georges Braque is one of McIntyre's inspirations, so we have here a homage, too.

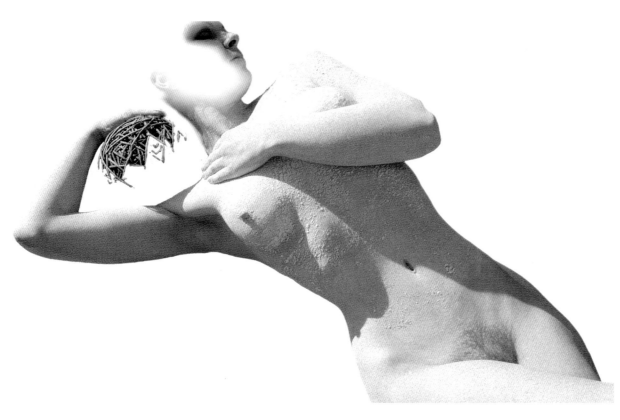

◁ *The nude was photographed originally for a different purpose. For this image, parts of the body were erased and it was rotated to an upright position. The medium format negative was printed conventionally and the resulting print was digitized on a flat-bed scanner. This route was easier than scanning the negative directly, since a very high-resolution image was not needed for the finished work.*

📷 *Zenza Bronica with 80mm lens; f/8 at ¹/₆₀ sec; ISO 100 film. Studio flash was used to light the figure.*

△ *The rich, organically varied textures of tree bark offers many possibilities for use as a background. However, it takes experience to catch the right level of detail, sharpness, and contrast to ensure that the background complements, rather than competes, with the main image. McIntyre's technique here is to have the tree bark colorized by another texture – that of the pastel-coloured walls. The two layers are seen here, combined.*

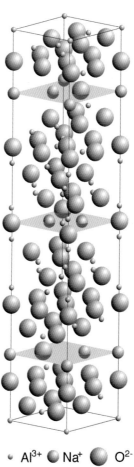

△ *Braque's handwriting was scanned and applied in Difference mode. It reads:*
Une chose ne peut être à deux places à la fois. On ne peut pas l'avoir en tête et sous les yeux.
This translates as:
A thing cannot be in two places at once. One cannot have it both in one's mind and before one's eyes.

◁ *The molecular structure was first drawn in a graphics program, which produces a vector image – a type of file that can be printed at whatever resolution can be handled by an output device. To be used in Adobe Photoshop it first had to be translated into a bit-mapped image.*

• Al^{3+} ⬤ Na^+ ⬤ O^{2-}

Steve Caplin

This piece was commissioned by lager manufacturer Stella Artois to coincide with a tennis tournament. The original idea was to display this, and the image below, on a billboard with moving panels. The intention was that it should look almost animated – as if the crowd were looking alternately left and right. Twenty-four models were individually photographed in the studio and in groups by the advertising photographer Malcolm Veuville, with Caplin supervising. The image was created in Adobe Photoshop version 2; as Layers had not yet been introduced, working on such a complicated image proved extremely tricky.

Steve Caplin is at heart a prankster who likes to draw cartoons. He describes himself as a satirical graphic artist. That he chooses digital imaging as his technique reveals another side to his character – a technophile with an encyclopedic knowledge of computing and magazine publishing, particularly on the Apple Macintosh. In fact, he is also well known as a contributing editor to a leading computer journal. He writes features on design and image applications, and on publishing, as well as reviewing digital cameras, and new software.

Caplin's background is a mix of wine-bar piano-playing and philosophy, which led to publishing when the owner of the wine bar left to start a magazine. When the owner became bored with publishing, Caplin took over, and he has been in publishing ever since. In 1987 he launched the UK's first consumer publication – *The Truth* – to be produced using desktop publishing, which won both *MacUser* and PIRA awards for desktop publishing. One of his prizes was for an early application for digital image manipulation.

Caplin used this application to produce images that he showed to the editor of the satirical magazine *Punch*. Impressed, the editor asked for a caricature of the Queen for a feature on the opening of Parliament (*see pages 84–5 for a recent version of this same topic*) and, from there, Caplin produced a weekly cartoon. On the strength of this excellent showcase, *The Guardian* newspaper started to commission him on a regular basis, and now his photo-montage images appear regularly in many magazines and newspapers, including *The Sunday Telegraph*, as well as in numerous press advertisements and on billboards.

The distortion of the faces was accomplished laboriously and carefully within Adobe Photoshop by using Distortion and the Smudge tool. This image was created in the days before applications such as MetaCreations Goo, which would have made short work of the caricature creations. Caplin was given a free hand with the image by the advertising agency Lowe Howard Spink. The image was displayed for just two weeks, but it won several awards and thus fully accomplished the client's objectives.

◁ Far left: Commissioned by PC Direct *magazine to illustrate a feature on future education, a future in which the teachers never change, this image was taken from a royalty-free catalog. The children are Caplin's own, the various images on the blackboard are from CDs, and the wire-frame image of a glass was specially created for the job.*

◁ Left: Commissioned by The Guardian *newspaper when news broke of the failure of Prince Charles's architecture magazine and his unhappy Institute of Architecture, the crumbling Greek monuments (made up from various historic sites) had obvious references. The Prince was shown in armor to represent his defense of all things "truly British".*

◁ Another Guardian *commission, this image was used to illustrate a feature on why politicians fail to appeal to the young and the idea that politics is the new Rock 'n' Roll. This gave all the clues needed. Clothing was scanned from mail-order catalogs, the guitar was drawn, and the portraits of the main British party political leaders at the time – Paddy Ashdown, Tony Blair, and John Major – were provided by the newspaper. Caplin explains: "Cartoonists usually build up towards a character from nothing; I start with the whole person and try to get away from them."*

▽ To illustrate a story about desktop editing for PC Format *magazine, what could be more appropriate than to show an editor at work on a desktop? The editor came from a CD of American retro images, but most of the rest of the image is drawn in Adobe Photoshop. The key to making the image acceptable as something that could be real, Caplin explains, is to put in small details, such as the crease in the newspaper and the flare from the desk lamp.*

Workshop 3: Steve Caplin

Speed of response and total reliability are the key qualities needed when working with newspapers. To produce this front page image illustrating the "updating" of the House of Lords – the historic figure Black Rod had knocked on the doors of the House of Commons wearing trousers, not hose, for the first time in hundreds of years – Steve Caplin had no more than three hours from being briefed to delivery of the final image.

He was supplied with key images – pictures of the Queen, Prince Philip, and the throne – but the rest was up to him. His first try was to dress the Lords in ordinary clothes, but then they did not look like Lords. A front-page image must be instantly readable, and few things are more recognizable than a picture of the Queen.

To produce this image, four different sources were used: scanned images, the Internet, a royalty-free CD-ROM, and a digital camera. The CD-ROM image was in black and white, so Caplin colorized it using an"action" that he created. An "action" in Adobe Photoshop allows the user to record the steps required to produce a specific result and save the sequence for later use. Caplin's action turns a gray scale image into a color one, to colorize with a flesh tone, and adjust Curves so that there is less color in the highlights and more in the shadows. Once the basic color is added, Caplin adjusts it by hand as necessary.

The final image was used on the front-page, very large. If he had been unable to produce the image in time, the newspaper would have been left with a disastrously large hole. Steve spells it out:"Speed and reliability are paramount in newspaper work. You just do not miss deadlines."

Caplin says he never works at resolutions higher than 200dpi, and for newspapers at not more than 175dpi. He uses an Apple Power Mac 8600 with its original processor replaced by a 300MHz G3 chip. His computer carries 416MB of RAM, his scanner is an Epson GT9000, and he makes good of use of his Nikon Coolpix 900 camera and Nikon CoolScan film scanner. In addition to the usual array of Jaz, Zip, and Syquest drives he has installed an ISDN (Integrated Services Distributed Network) line, which is a fast digital link for rapid communications with his clients, who are in the main newspapers. He sends his files as JPEGs. When the technicians at the newspapers receive this compressed file format, they can then convert it for color reproduction on newsprint.

While his mainstay program is Adobe Photoshop, he also uses Illustrator, Dimensions, Poser, and After Effects to create graphics, 3-D models, and manipulate video images. MetaCreations Poser is a program that draws animal and human figures that can be posed or positioned at will, allowing Caplin to produce a range of different poses.

◁ The photograph of the throne was provided by the newspaper, but there was not enough carpet below the picture for the intended design. Carpet from another image was copied, turned into a pattern, and added to make it look like a step. A CD-ROM of images was the source of the body for the Queen (her face was supplied in a picture from the newspaper's archive) after the figure of the kneeling man had been deleted. To add color to the black and white image, Steve Caplin used an automated process in Adobe Photoshop called "actions" to give realistic-looking flesh tones. Color was also added to the clothes and the overall contrast adjusted to match that of the throne image.

◁ Once the Queen was comfortably settled on the throne, the next problem was how to depict Prince Philip. What could be more casual than using a picture of the artist himself? Using a Nikon CoolPix 900 digital camera, which has a good flash facility, provides excellent image quality, and has a swivelling lens (allowing him to monitor his own pose on the LCD screen). Caplin took a few shots of himself using the self-timer.

◁ Caplin's pose with his fist supporting his face (above) fitted well with the Prince's usual glum expression (left), but the legs from that image were too long to fit, so those from another were used. The image of Prince Philip, supplied by the newspaper, was scanned and then composited with the digital camera image. At this stage, the face obscures the hand, so parts of his face had to be erased to allow the hand to show through.

◁ For pictures of the crown, sceptre, and orb, Steve Caplin entered the Internet (far left). He typed in key words such as "queen", "crown", "throne", in a standard search engine (an application that examines databases of the World Wide Web), and found everything he needed. Caplin then "screen-grabbed" the images he wanted (i.e., he used a utility program that captures the images shown on screen), then dropped the crown, scepter and orb into the composition.

Sandy Gardner

◁ In creating Forgotten Dreams Sandy Gardner explains that she was trying to represent the state of dreaming, showing the girl's dreams swirling around her, with the dark center to the image representing the black hole down which hopes and aspirations are lost. It is a simple composition with the girl framed by twines, flowers, and figures, which were scanned in, manipulated as separate layers, and merged by varying the opacities of each layer. They were then placed against a background of one of Gardner's abstract paintings.

Sandy Gardner approaches digital imaging with the eye of a designer. While her photography is well controlled and accomplished, the texture of her work is essentially not photographic. It is organized around space and composition; its principal sources are the classical traditions of painting. With her free use of disjointed scale (normally small objects are placed in far space and large ones are placed close to the viewer) she creates a fluid sense of solidity.

Gardner tries, in her own words, to create "evocative imagery, hoping this will inspire the viewer to find some kind of personal narrative". But underlying this is a finely honed sense of what is tonally acceptable.

After earning her degree at Loughborough University, Leicestershire, Gardner felt lost and uninspired, but as her attraction to photography grew she spent her evenings in the darkroom experimenting with such nonstandard techniques as solarization and printing multiple negatives, while becoming increasingly frustrated by never quite achieving the results she wanted.

Gardner had had to use Adobe Photoshop to help make the separations for some silk-screen prints. She then learned more about the program and discovered that many of the effects she had been trying to achieve in the darkroom could be done in Adobe Photoshop. However, her time in the darkroom shows to good effect in her imagery.

Despite living in splendid wind-blown isolation in the Lake District of northern England, Gardner has worked extensively for many commercial clients, including Amnesty International.

The image of seahorses (far left) was inspired by a pair of the little creatures Sandy Gardner bought in a shop in New York that specializes in bizarre animal remains and skeletons. The crab (left) she discovered dead on a beach near her home. When found, it had only two of its legs and one pincer remaining, so the rest she re-created from the surviving parts by cloning and copying. Gardner also added some distortion to make them look different and more realistic. The overall color and the presence of the autumn leaves are simply reminders of the season in which the image was created.

This image, entitled Beauties Divide, features a claw from a dead bird Gardner found by the side of the road. The hair was the artist's own, spread on the flat-bed scanner. Other elements consist of a nude model and some shrivelled snowdrop flowers, as well as images containing the small details, such as bubbles and bells. The difficulty in bringing an image like this to fruition lies in controlling all the elements in order to retain the clarity and depth of the original perception. This Gardner has achieved through the subtle use of Blending modes. She has done this so successfully that the image won the 1998 Adobe Calendar Competition.

Workshop 4: Sandy Gardner

Sandy Gardner works with a Wacom Art-Z Tablet and a Pentium II computer running at 300MHz equipped with 256MB of RAM, and she views her work on a 17in (43cm) monitor. For scanning, she uses a Nikon CoolScan II and an Epson flat-bed scanner. Gardner counts her Hewlett Packard CD writer as one of her key pieces of equipment, producing CDs of all her scans and storage for working files. Files are usually at least 100MB in size, and these are saved without "flattening" (in order to keep all the layers separate). She uses another Pentium computer, running at 266MHz, which is dedicated to printing out on her Epson Stylus 3000 and Hewlett Packard laser printer.

Her photographic equipment is inspiringly modest – a venerable Pentax Spotmatic 35mm SLR backed up by a Praktica BX40, both loaded with Kodak Gold negative film. Any nude models are photographed in the studio.

For the images, *Memories and Regrets*, featured on this spread, Gardner used her whole range of imaging tools – scanners, cameras, and an eagle eye ready to spot the smallest potential of an object, such as the wooden house and horse she found in a friend's antique shop.

△ ▷ *A border was first designed on the computer and then printed on to paper. The paper was distressed by being crumpled and torn, then scanned on a flat-bed scanner. The resulting scan was colored using warm tones. Other elements, such as the flower and jewelry, were also scanned directly. Used in this fashion, a scanner acts like a closeup camera, taking life-size digital "photographs" of objects.*

◁ ▽ *The background images for this work, entitled* Memories and Regrets, *are shown below. These included the paper crumpled up, distressed, colored, and then scanned. The decorative border had first been designed (see opposite). All the other items used are everyday household items or those that could easily be found in an antique or junk shop. They were all either photographed or scanned directly. The central flowers look completely different from either originals because the layer blend mode was Difference, which inverts color and tone values to dramatic effect.*

Workshop 5: Sandy Gardner

◁ Igneous Passion *is a rich tapestry of textures, which could have been created by painting techniques. Working on it via the computer, however, is wholly more controllable and easier. The panels were created simultaneously, and the whole image took a couple of days to complete. The process was a mixture of experimentation – checking the outcome of applying a certain filter – and direct work on the image with a brushed-on effect. The handwriting in the image was carefully made just too difficult to read, with the intention of injecting an extra element of mystery into the image.*

To begin with, the computer controlled Sandy Gardner, as she explained: "I started with a concept but then I'd apply a filter and the results were unexpected and didn't follow my original idea. My concept had gone and the computer had created a new one. Much of my early work was shallow and superficial. Now I know exactly how to achieve specific effects, whereas before I was allowing the program to dictate the direction of my work."

The images on these pages were inspired by a lecture Gardner attended by the designer and graphics guru Dave McKean, which may account for the dark and foreboding atmosphere reminiscent of the *Sandman* graphic novels created by McKean with Neil Gaiman. Gardner's image was made as part of a major project for her degree show, and it is one of her favourites. The photographs of Gardner were taken by photographer Paul Landon, while other elements either were photographed or were placed on the scanner and captured directly.

The four interlocked and interrelated panels tell a story of passion through the symbols used. Extensive use of layering effects was made to create a rich brew of images, deep colors, and mysterious half-detail in the shadows.

△ *Above far left and middle left:
Remnants from a meal were put to
good use. The bones of a small bird
and chicken were photographed
and scanned in. They were then
used with the colors changed
as necessary, and the unwanted
parts were removed.
Above right: The model's skin was
covered in baby oil and then she
was photographed in a makeshift
studio by the intense illumination
given off by a halogen security
light. This produced the glistening
effect on the body.*

△ *To create this effect, Gardner
used the scanner, placing her hair
directly on the glass. Before doing
this, she intertwined her auburn-
colored hair with that from a
blonde wig.*

△ *The hands were "photographed" by placing them directly on a scanner,
with a book covering them. But the "book" seen here is actually a small
clasp from a necklace. It was scanned directly, and a copy of it was made
and flipped over to form the other side of the "cover". The two halves were
finally joined to form a convincing image of a book. The real book was
erased and replaced with the new one. The colors were intensified using
the Curves control (see pages 58–9).*

◁ *More organic textures came
from the kitchen. Here, a piece of
melon provided color as well as a
repeating pattern.*

Tania Joyce

◁ *This image, entitled* In the Beginning, *is part of a series called* The Enchanted Journey. *It attempts to represent the initial impressions of a child imagining that its whole world is a very small and protected place. The tree symbolizes the Tree of Life with the child's parents standing below it. The grass was created from a much smaller patch of grass by using the Rubber Stamp tool to clone selected areas of an image to produce an enhanced perspective. The flowers were copied and scaled in various sizes to add to the distorted perspective. The repeated clouds were created through cloning as a surreal element in an already unreal world. Finally, the colors were greatly enhanced to an extremely high degree of saturation.*

Tania Joyce comes to digital imaging with two considerable advantages. First, she is an excellent draughtswoman – some of the pages of her workbooks are ravishing creations in their own right. Second, she is an accomplished scientific photographer, working as she does as photographer and digital designer in the Department of Biology, Imperial College, London. This brings certain privileges not available to others – access to very specialized imaging devices, such as a scanning electron microscope, for example.

Joyce's digital style has evolved from an academic background in art, design, and photography, and she has made full use of her finely honed talents. These are evident in her meticulous drafting ability – both in design and photography – combined with her eye for detail. While shooting the composite elements for her digital art, Joyce draws inspiration from diverse sources, often making use of both macro- and microphotography to capture surreal views of the natural world. For example, a scanning electron microscopic image of the surface of a leaf will transform the ordinary into an alien landscape, thus creating a fantasy world with truly photographic realism – but none constructed using a computer program.

While studying public art and design at Chelsea College of Art and Design, London, Joyce developed her skills in painting and mosaic-making, using photography as the source material for her work. While her painting explored closeup and obscure visions of plant life (still a continuing theme in her work), her mosaic-making was the starting point for an interest in creating composite imagery – a process akin to a mosaic worker's use of small pieces of ceramic tile and mixed media to create a finished piece.

Later she realized a passion for computer-based art at the University of Westminster, London, where she studied for a degree in Photography and Multimedia, graduating with first-class honors. At the university she specialized in using Adobe Photoshop to manipulate her original photographs, creating digital images with a distinctive mythological theme. What appeared to be an eclectic approach to the study of fine art was slowly turning into a fully developed means of creating contemporary art by the synthesis of the traditional with the modern.

△ The Fall of Icarus *is part of a series reworking ancient myths in modern dress. The male subject was photographed from below as he jumped down from a platform – it took numerous jumps before Joyce caught the right range of poses to represent the fall. The wings, which came from photographs she had taken of pigeons alighting, were composited together against a sky background on which Joyce used a lens flare filter to give the sense of a blindingly hot sun.*

△ Caught in the Eye of a Fly, *as this image is called, is part of Tania Joyce's* The Enchanted Journey *series. The fly was photographed using a scanning electron microscope (at approximately 1000X magnification) and represents a demon or monster of childhood nightmares. The child's face was copied into each facet of the fly's compound eye to show that she had been caught under the gaze of this creature. The fly's eye was shot on 35mm black and white negative film, scanned on to a Kodak Photo CD and then colored.*

◁ *To create* Ladybirdland *a scanning electron microscope was again used, this time to show the hidden detail on the surface of a leaf. The image also shows a leaf hair (lower left) and a gaping hole (right), where a hair has broken off, revealing the cells underneath the surface of the leaf. Electron micrographs do not contain color, so Joyce had to add this very carefully. The ladybirds were photographed in daylight using a Nikon F3 and a Micro Nikkor 55mm f/2.8 lens. It was then a simple matter to place the beetles in various positions on the leaf's surface.*

Workshop 6: Tania Joyce

The image featured on these pages, *Medusa*, is one of a series of seven that reinterprets ancient myths and legends using modern idioms and a digital medium. Tania Joyce adapted the ideas from an old book, *The Treasure Casket* by Zita Mulder, which she found in the attic of her house. The initial work started with rough sketches of a powerful woman with writhing snakes for hair. This was developed, through the use of photography and digital manipulation, into a fantasy image with graphic realism.

All the composite elements were photographed on 35mm film. The portrait of the model was photographed outdoors on a late spring afternoon, when the sun imparted a subtle golden glow to her skin. She was then photographed lying on the floor with her hair wound into snake-like shapes placed in a fan-shape arrangement.

Tania Joyce continues the story:"At work, I asked if anyone had a snake I could borrow. The next day someone brought in an 8ft (2.5m) boa constrictor called Alice on an ordinary commuter train. Alice wasn't what I was expecting, but she turned out to be a beautiful model – although I didn't want to be left alone with her! I set up studio flash and a black velvet background but the snake decided to explore the studio. So I ended up following her around with a camera and hand-held flash."

Once all the films were processed, Joyce composed a mock-up in her sketchbook to give her a rough impression of how the images would fit together. All the negatives and transparencies were scanned onto Kodak Photo CD before she started work on the computer – an NT workstation with dual Pentium II 450MHz processors and 256MB of RAM.

△ To add the finishing touches, Tania Joyce created clothing for Medusa's shoulders by cloning a piece of black velvet. The edges of the snakes and hair were cleaned up with the Eraser tool and subtly blurred to give a more realistic impression, and she increased the contrast of the image overall to give it extra impact. Originally Joyce had intended to create a background scene behind Medusa, showing people turned to stone, but she found the final portrait didn't require any such complicated background. Instead, a stormy sky with white clouds provided a suitably strong and simple backdrop for the figure.

◁ The model was photographed on color negative film using natural daylight for illumination. Since the model's hair was long and plaited, it was ideal for Joyce's purposes. She positioned the model on the floor and then spread her hair out, into snake-like shapes fanning outward. She then photographed this arrangement from various angles, using electronic flash in order to heighten contrast and add sparkle to the subject's black hair.

◁ Beginning with a white background, Joyce had to isolate the model's head and shoulders and erase most of her hair. In stages, she added selected coils of hair, grouping them together on different layers, and blended them with the hair remaining on her head.

◁ ▽ A dozen or so portraits of the snake were chosen and placed into position below the hair layers. Joyce resized the snake shots slightly where necessary to produce a perfect match. A mask was added to the layers to blend the snakes and hair. The hair was then masked out (using black) to reveal the snake below. This had the desired effect of subtly removing the hair to reveal the snake, thus giving the impression of them becoming one and the same thing. Finally, the sky was added as a background.

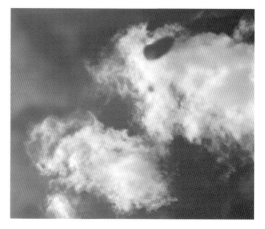

Workshop 7: Tom Ang

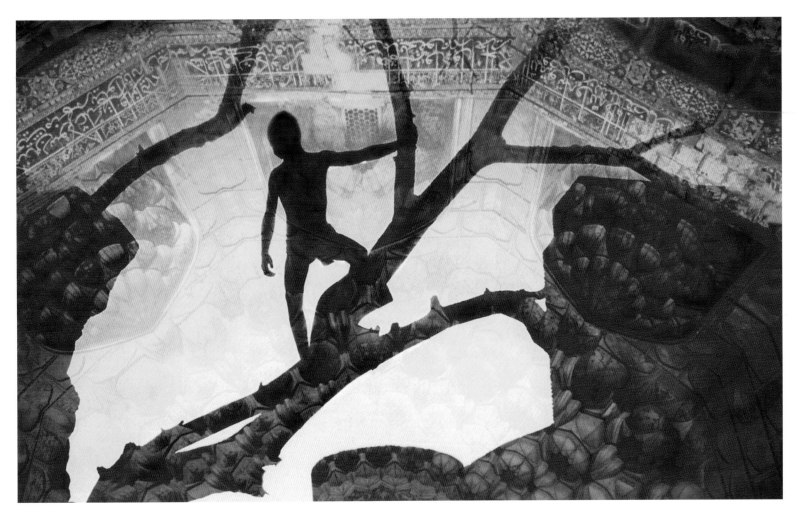

I have been interested in double-exposure effects ever since I accidentally exposed a film twice and obtained some fascinating results – images that went beyond anything I could have consciously achieved. But double-exposure in the camera is hard to control since the slightest variation in the exposure of one layer makes a huge difference to the overall image. However, combining images digitally, using existing originals, gives you greater control and far more predictable results.

I had recently produced numerous color prints for an exhibition when my work was unexpectedly needed for another show. Rather than produce new material, I decided to experiment with my existing work. My first attempts were promising. I propped some prints up on an easel, set my camera to multi-exposure mode, and made some double- and triple-exposures using studio flash. After this first set, I had to refine my technique by varying exposure – a third of a stop distinguished success from failure.

Linked to the idea of multi-exposures was a notion I had of using a multi-layered pictures as metaphors for complicated concepts – in the example used here, the way

in which today's youth are pulled in different directions, particularly when coming from ancient cultures, such as that of Central Asia. After selecting a promising-looking image, I scanned it on to a Photo CD and opened it in Adobe Photoshop. At first sight, the original image looked strong and would not, I thought, require much work. But the more I looked at the image, the more I realized that small details needed cleaning up or tonally balancing with the rest of the image. As I worked on it, I found that more and more detail needed attention.

The first task was cleaning: dust and scratches had to be removed. My method is to clone, or copy, a section of the image on to another. For dust and scratches, it is easiest to clone from a small area immediately adjacent to the defect. Then I went over the whole image burning-in to make some parts darker (for example, the boy's body) and dodging to make some parts lighter. I also increased the color saturation in some parts – this helped to increase the transparency of the branches and improved the blues of the tiling in the upper part of the image. Finally, I output the digital file to film and printed it onto color paper.

△ To get to this final result from the image opposite, I first had to clean off all dust and small marks from the original. To improve coloration I made overall, global adjustments to color saturation; for local adjustments, I employed simple burning-in and dodging techniques using medium-sized brushes with the edges set to maximum softness. I set very low pressures for these tools so that the effects could be built up in a controllable fashion. Apart from some cloning to clean up a few details, this proved to be a very simple image to produce.

◁ This is the original camera image – a silhouette obtained by exposing for the brightest area of sky. Even though the sky was hazy white to the eye, the parts of it away from the sun turned deep blue when underexposed. A silhouette gives the type of simple, strong shape that is ideal for multi-exposure experiments. However, a passing bird produced a blur that was troublesome.

📷 Canon EOS-1n with 80–200mm zoom @ 150mm; f/5.6 at ¹/₁₂₅ sec; ISO 100 film.

◁ Strong, simple shapes make good subjects for blending with other images. This architecture shot is also quite even in tone, which made combining the two images far easier than it would have been if it showed a wide range of tones.

📷 Leica R-6 with 21mm lens, f/8 at ¹/₁₀ sec; ISO 50 film.

◁ Combining the shots involved making two exposures on the same frame of film. This is the double exposure that became the basis of the final image opposite.

📷 Canon EOS-1n with 50mm macro lens; f/11 at ¹/₆₀ sec; ISO 100 film. Studio flash used.

◁ This alternative pairing of images simply did not work. The architectural image is far too complicated and overwhelming for the simple silhouetted detail, and even to get it to this stage required more work than was justified by the result.

Workshop 8: Tom Ang

Thanks to its ambiguity and slight air of mystery and dislocation, the basic image, shown on the right of the page, proved to be a fertile source of new imagery. The key to it is the hand that has no obvious owner. The other elements are the strange set of shoes seen from an unusual angle. Add the strong shapes of the tulips and a box of tomatoes distorted by a wide-angle view and you will have an image that is absolutely ripe to be taken in all different directions through the use of digital image manipulations.

The base image that was scanned was itself a double exposure on the same frame of film: one image was of a dancer's hand and her companion's shoes, the other was of the tulips. Depending on the exact settings used, double exposure has the effect of bringing one image forward at the expense of the other – here I wanted the tulips to recede, so I underexposed them by using the correct exposure needed for the dancers. Curiously, it is difficult to simulate this particular effect on the computer, yet it is easily obtained on film. Once the double-exposed image

had been scanned, the next task was to clean up any specks of dust and then enhance the tone and color.

I applied a number of different filters and effects to the image, while all the time trying to avoid losing the shape of underlying image. Since the image was already ambiguous, any heavy-handed manipulation would have destroyed its structure. As this was a relatively small file – just more than 1MB – I worked directly on a copy of it. Had the file been much larger, I would have considered working on a down-sized copy of it to speed up the filter effects. Working on a large file can mean waiting several minutes every time you make even the smallest change to a filter setting.

It is a mistake to think that the work is over once you have applied a filter – in fact, it is just starting. Tidying up is always necessary, balancing tones, color saturation, and cleaning up deffects caused by the filter itself. It is best to work at a high magnification – at least four times the final size of the image – since you can never be completely sure whether or not a small defect in the image will show up.

△ The original images were taken on slide film and printed on R-type or Reversal color print paper. They were then photographed again by double-exposure, i.e., one print was photographed, then the other, both onto the same frame of film.

△ First, I radically altered the colors of the original using Curves. The secret of using this control to the best effect is to change the color channels – red, green, or blue – individually, rather than all at once. I then applied a filter that changes the size of the "honeycomb cells" of information that make up the image. This produced the stained-glass effect without obscuring the underlying image.

△ This image uses one of my favorite effects filters, Terrazzo from Xaos Tools, which divides the image up into repeating patterns. In preparation for the filter, I first changed the tonality and color of the picture, and then experimented with various settings. Finally I made many local adjustments in order to clean up the image by, for example, cloning parts of the shoes and colors into empty areas.

△ The most dramatic filter effects are often the least useful. This is a fractal filter (note the characteristic frilly edges) from the Kai's Power Tools range, and it is one of the less intrusive of the available fractal effects. As with the other images, most of my effort went into turning the filter effect into a workable image by tidying up the tonal response of the various elements in order to give shape to the image as a whole.

DIGITAL PHOTOGRAPHY PROJECTS

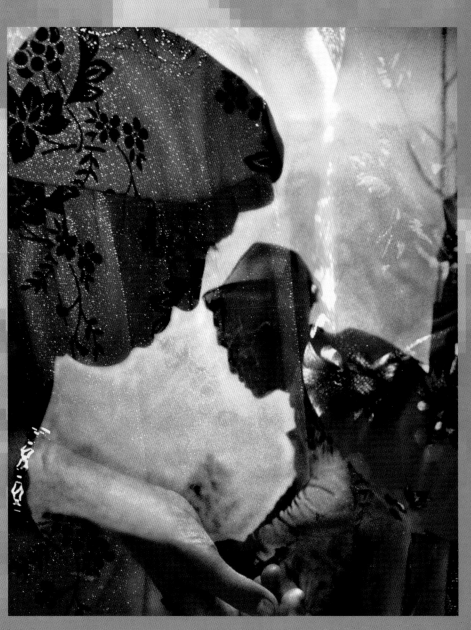

Extending your abilities

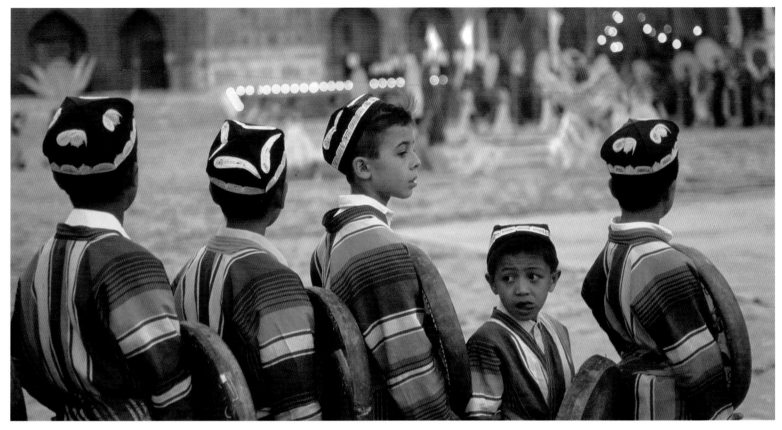

Technology that provides you with original, creative ideas has yet to be invented. Indeed, as modern technology makes it easier to capture whatever it is you see, so the challenge to initiate original ideas and think up creative projects increases. Learning to use the latest technology is in itself a challenge. But it is like mastering a sailing-boat: once you have done it, you want to point the prow toward the horizon and discover new lands.

Setting yourself projects is one of the most rewarding ways of working. Once you have goals and targets, you can measure your progress. Best of all, a project gives you a direction, which – being one you have set yourself – will best satisfy your own interests.

One of the most frequently asked questions by students attending photographic workshops is simply: "What sort of project should I do?" It would seem to be easy: you have a chance to do exactly what you like, yet perhaps you are inhibited or are afraid to look silly. Perhaps you think it has been done before, so what is the point?

Be reassured that such doubts and misgivings are very common, but bear in mind that you are doing this work for yourself, not for anyone else; not to win a certificate or to earn a living. So set yourself a project because you are interested in the subject, because it may be fun to do, and because you might learn something from it. The project

you undertake should be one that you really want to do, irrespective of whether or not anybody else is interested in it. Likewise, don't be put off simply because the subject may be the same as that chosen by other people.

Points to remember

Here is some advice that may help to get you started on a project and achieve results you find satisfying:

• Set realistic goals to start with. If you want to digitize all the stamps ever produced by the Cayman Islands, then that is fine. But don't try to complete the project in a year. Or if you want to document every day in your garden's year, then don't start in the same month that you have your heaviest gardening workload to get through.

• Don't be afraid to ask questions, but do not expect too much in the way of answers. You may suspect that you do not know enough, but most other people will probably know considerably less about your chosen subject. So if, for example, you want to collect pictures of gargoyles on the sides of cathedrals, then only you will know whether it is important or not to keep some consistency of viewpoint, perspective, or lighting. Most photographers would simply walk around until they saw a composition they liked.

• Don't become fixated on the price of everything. This is not, of course, to suggest that you should spend more

△ Six years of personal and commercial photography in Uzbekistan came from a simple wish to drive across Europe to China. In this shot from that body of work, boys prepare for Independence Day celebrations in the great Registan Square of Samarkand, Uzbekistan. Such an event is excellent for recording many examples of national costume, but it pays to wait for a moment that brings the event to life rather than simply recording colorful dress. This type of image is an excellent complement to a study of faces, such as the range shown opposite.

📷 Canon EOS-1n with 80–200mm lens @ 180mm; f/2.8 at $^1/_{60}$ sec; ISO 100 film.

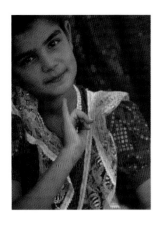
△ A young dancer poses with a natural and easy grace while waiting for her act to begin in Samarkand, Uzbekistan.

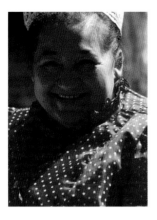
△ A stall-holder in Tashkent, Uzbekistan, invites passers-by to try her delicious traditional creamy, sticky cakes.

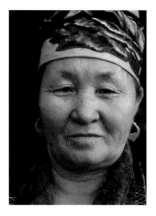
△ A desert fox fur hat protects this factory worker in Karakalpakstan against the often biting chill of the desert spring.

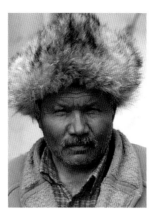
△ Doctors in Muynak, Karakalpakstan, such as this lady, struggle against the effects of malnutrition and environmental diseases near the Aral Sea.

△ Ballerinas learn classical Ballet Russe but are still happy to dance to traditional styles. This dancer in Samarkand would have been happy to have posed all night.

△ Shopkeepers are usually pleased to be photographed, especially if you make a purchase or two. This lady is in Bukhara.

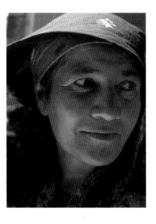
△ Strong, proud faces may be found everywhere – this lady, from south Uzbekistan, was on a religious pilgrimage.

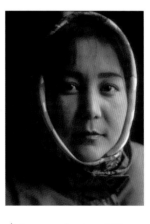
△ A museum-keeper watching over a collection of Soviet avant-garde art was surprised to find herself the subject of attention.

△ This businessman in Karakalpakstan had no time for photography, but ten seconds was enough to take his portrait.

△ Old men with time-worn faces can be the most intimidating of subjects, but direct eye contact may be enough to win consent.

money on a project than you can reasonably afford, it is more a warning that any preoccupation with cost is often the kiss of death for a project. Keeping detailed accounts of expenditure freezes your enthusiasm, kills the spark of adventure, and can in itself become the reason why money is being wasted.

• Any project in which you have a deep interest takes on a very real value of its own. Not only does it fill the time that you might otherwise be using to less good effect, it also helps to direct and focus the whole range of your developing technical and aesthetic skills. This is invariably an inexpensive exercise considering the benefits you derive from the process.

• Allow the project to evolve and change in nature. You may think that you are in firm control of your project's direction, but try to keep an open mind and do not become blind to new and photographically rewarding avenues that may open up along the way. You have to learn to work with the idiosyncrasies and character of the subject you have undertaken.

A personal perspective

My largest personal project has been Central Asia. Its roots lay in my boyhood jealousy of Marco Polo which, in later life, led me on an overland drive from London to Beijing. After several years of preparation, my route took me through what was then Soviet Central Asia. I fell in love with the people and found myself fascinated by their history and the landscape. But it was five years before I returned. The Soviet Union had by then broken up, and while I could see change taking place, underlying the turmoil was a great depth of history and cultural diversity that enriches any sympathetic observer. I now travel there once a year on average, not only to take photographs but also to carry out some research and non-governmental work. Thus, much has come out of my project – not only photographs but also the experience gained from working with multinational organizations. I have also experienced an enormous growth in my understanding of different cultures as well as meeting countless interesting people and making some very good friends.

The family album

◁ The secret to successful family pictures is to concentrate on the photography – your children will, after all, be charming and photogenic (at least in your eyes), so you need to attend to other matters. What is the lighting like? Will the combination of colors work? What aperture should I set to throw the background out of focus (or bring it into focus)? In this image the children are willing, but more importantly their bright clothes are well complemented by the strong green of the grass and the blue sky. A large aperture had to be set on the lens to make sure that the background was well out of focus because a moderately wide-angle lens was used.

📷 Left: Canon F-1n with 35mm lens; f/2.8 at ¹/₂₅₀ sec; ISO 100 film. Right: Olympus OM-1 with 50mm lens; f/2 at ¹/₆₀ sec; ISO 100 film. Far right: Olympus OM-2n with 28mm lens; f/2.8 at ¹/₁₅ sec; ISO 100 film. Lower right: Nikon F3 with 105mm lens; f/2.5 at ¹/₁₂₅ sec; ISO 100 film. Lower far right: Canon F-1n with 35mm lens; f/8 at ¹/₁₂₅ sec; ISO 100 film.

Digital cameras are made in heaven for producing a family album. It is not just that they give you an instant replay of all shots; it is not just that you can turn out a set of prints without having to retreat into the darkroom or wait days for prints to arrive back from the processors; and it is not just that digital prints cost less than conventional ones (in the long run); it is that a digital record of your growing, changing family can be an effective springboard for so many other uses.

If, for example, you are connected to the Internet, your service provider will probably make some web space available to you, which you can then fill with your own words and images. One popular use for this personal web space is to publish news about your family for distant relatives to see. You can place digital camera shots on your web-site almost at a click of a button and update them just as easily. The only downside to this is that all your old excuses for not sending pictures to friends and relatives – too busy, film delayed at the processors, and so on – will no longer stand up.

Another advantage of having digital photographs is that you can organize them more easily than conventional prints or slides. Instead of shoeboxes or drawers full of those neglected images – those that are not good enough for the family album but that you still cannot bring yourself to throw away – you can simply keep a few disks reserved exclusively for all those "also-rans".

Another popular use for digital images is as Christmas cards, or you can just drop them straight into your letters to be printed on a color ink-jet printer using any modern word-processor program or one of the many inexpensive layout packages available. Bear in mind that printing pictures from word-processor software can be very slow – page layout software is usually much faster.

You will also be able to create such simple effects as vignettes (see page 72) and old-style sepia-toned images simply and quickly (see pages 70–1). All this at the same desktop where you write your reports or do your accounts.

Good practice

Even photography intended for the family album benefits from classical photographic skills. Indeed, this type of photography requires the same concentration as any other serious photographic task if you want consistently good results. You may, for example, find yourself responsible for the photography of a friend's wedding or your parents'

wedding anniversary party. Here are some hints to help you and some potential pitfalls to watch out for:

• Prepare in advance. Charge your batteries, buy some spares that do not need recharging, and make sure your flash is working. Few things spoil a party more effectively than having to wait for sluggish batteries to charge up a flash. Make sure you have enough spare memory cards.

• Decide on your priorities. Are you at the party as a guest or to do the best you can with the photography? If it is to take pictures, this does not mean you cannot have fun – you just have to stay alert to any good photographic opportunities that arise.

• Move with children or pets in order to keep them in focus. It is easier to set a focused distance and then move as necessary to keep the image sharp, than continually to refocus (even with autofocus cameras). A guaranteed

method of testing your patience is to photograph young children. Not only do they move rapidly and unpredictably, but because they are small you often have to work close up to them, which exaggerates any focus problems.

• Adapt your technique to the time-lag between pressing the shutter and making the exposure. One disadvantage of many digital cameras, compared with conventional ones, is the relatively long time delay between pressing the shutter release button and the picture being taken. You just have to know about it and work with it.

• Put dates in the file names. This really is the best way to keep track of images. The one thing you can be sure you will want to know ten years up the road is when such and such event took place. An advantage of digital photography is that it is easy to tag a picture with the date or to track the creation date of a file – as long as it is the original file.

▽ A family album can consist of a random asortment of shots taken at different times and in different situations, or it can be organized in a more orderly fashion. For example, you could explore the growing relationship between siblings within a wider range of family pictures. In this series, it is easy to see how the older sister tends to take charge and take the lead or supervise while the younger child shows growing confidence. Over a long period of time, it may be difficult to keep to the same film stock, but it is worth trying to do so since any inconsistencies in color rendering can disunite a collection of images.

Travelog: 1

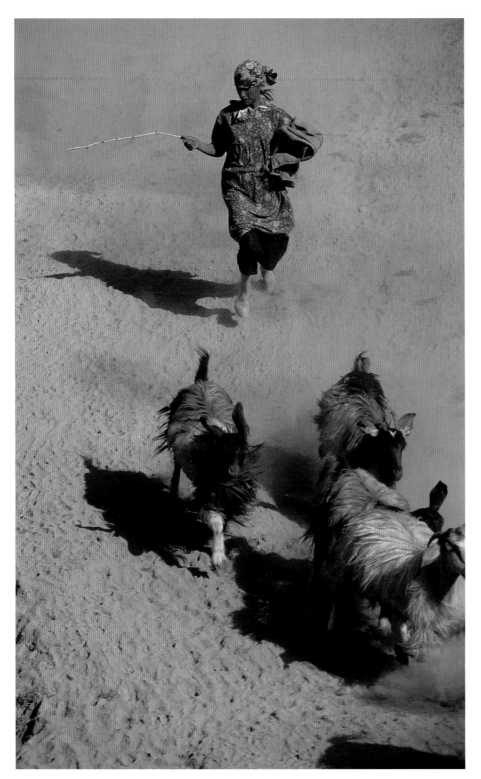

△ This timeless scene of a daily life – a goat-herd in Uzbekistan taking her charges home for the evening – has been played out probably for thousands of years, yet in order to photograph it successfully, luck plays a part in placing you in the right place at just the right moment.

📷 Canon EOS-1n with 80–200mm lens @ 200mm; f/4 at ¹/₂₅₀ sec; ISO 100 film.

Second only to the family photograph (see pages 102–3), travel photography is the most popular subject for the camera. And it is easy to see why – the variety, color, lighting quality, and strangeness of all you see can be captivating, and the desire to make a record of it all can be overwhelming. Although taking photographs on your travels may be natural, there can be disadvantages for the unthinking. For example, taking photographs may get in the way of the experience of "being there" – handling the camera makes you think about all manner of technical things that really have nothing to do with what is in front of you. Using a camera can, in some situations, get you into trouble, too. Most likely this will not be serious, but upsetting a local person – one of your hosts, perhaps – is something you should try to avoid.

Conversely, photography can also make you look harder, see with a more appreciative eye, and generally improve your cultural awareness through the demands the camera makes on your discipline, visual technique, and the need to be constantly attentive.

Experienced travel photographers find that the most successful way to record the people they meet is to give as much as they take. This does not mean offering gifts or money, but rather – even if only very briefly – developing a rapport, a brief friendship, and projecting some warmth of feeling toward your subjects. This comes only from a genuine interest in the country you are in and a true respect for the people who live there.

The failure to somehow be a participant in the scene being recorded is the root reason why so many travel photographs can be uninteresting to everybody, apart from the people who took them – there is simply no involvement evident, either in the country or its people and culture. In other words, they appear to have been taken by those who only take and do not give. The best travel photographs often come from people who have invested the time and trouble to learn something about the country, perhaps have learned to speak a few words of greetings and thanks, and who are comfortable in the company of their hosts.

Another tip worth remembering is to photograph everything, not just the obvious monuments and markets, but also the little details in shop windows, street signs, tea cups, candlesticks, and dried-flower arrangements. Don't forget to record your meals and all the everyday details that make life in the place you are visiting different from what you would see at home. All this is good material for digital cameras, since they can record it at less than the full quality of conventional film and still produce images suitable for most purposes – even publication.

◁ △ No travelog is complete without a record of the incidents en route to your destination (top left). Here, luggage is set out for travelers to collect for transfer to another plane. Food is a valuable and telling marker of a culture and its peoples, but it can quickly become "invisible" to the traveler simply because it has become commonplace. Recording food rituals (above and left) always has the potential to make interesting pictures.

📷 Canon EOS-1n with 28–70mm lens @ 28mm (top left and left) and 70mm (above); f/8 at ¹/₂₅₀ sec (top left), f/4 at ¹/₃₀ sec (left), and f/8 at ¹/₁₂₅ sec (above); ISO 100 film.

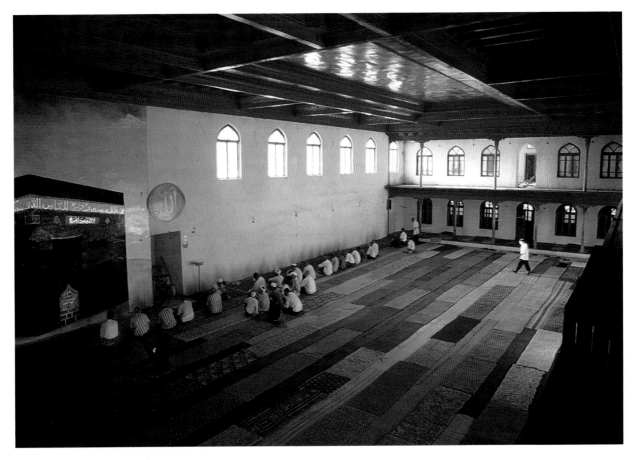

◁ Images of religious practices are interesting not only to those unfamiliar with the religion but also to those who are familiar enough with it to bring a fresh insight into what is so often taken for granted. However, you need to approach the subject with sensitivity and respect. It also helps if you can work quietly, invisibly, and efficiently in order to avoid disturbing the ceremonies – here men at prayer in a mosque. A lens with shift movements (which allow the optics to slide vertically) was used to keep vertical lines properly upright while the lens was pointed downward to record the foreground prayer rugs.

📷 Canon EOS-1n with 24mm lens; f/5.6 at ¹/₃₀ sec (with maximum downward shift); ISO 100 film.

Travelog: 2

The general approach you can adopt in order to create a set of travel photographs that most people will find entertaining, not just those present at the time they were taken, can be set out in just a few key steps:

• Undertake some research to learn about the country and its history. Local people will often have more respect for you if you are not totally ignorant of their ways.

• Photograph the entire journey. Don't start just when you arrive at your final destination. The skyscape of clouds and the setting sun viewed from the air out of an airplane window could be the most stunning thing you will see on the entire journey.

• The first thing you see and feel when you leave the airport terminus often holds the strongest memories. Take a quick shot of the taxis or the road into town. A digital camera is the perfect complement to a conventional type because it is available whenever a shot is not worth the quality and expense of a full 35mm frame.

• Try to vary the scale of what you photograph – one group shot is fine, but twenty similarly framed examples are not. The most common mistake is failing to move in close enough to your subject for real impact. If you are taking a portrait, closeness is an excellent test of the rapport you have with your subject. If the relationship you have with the person you are photographing is not good enough to allow you to approach closely, then perhaps it is not good enough for you to take the photograph in the first place.

• Do not forget that many digital cameras give you a black and white option as well as color. Many general scenes, as well as portraits, have more dramatic content once the color is removed. Remember, too, that switching to black and white reduces file sizes and triples the number of images you can fit on to a memory card.

• Plan ahead to make sure that what you record and the medium you use suit the intended use you have for the images. If, for example, you want to show pictures only on the Internet, then low-resolution images will be sufficient; should you choose to make prints for exhibition purposes, however, it will be frustrating if all you have at your disposal are low-resolution images.

▽ One of the most frustrating aspects of travel photography is being unable to shoot while on the move in a car. Often a scene speeds by before you have a real chance to decide whether it is worth stopping for. So take full advantage of any rest stops. I had to walk some distance from a designated "panoramic view" to find this landscape in Uzbekistan, near Afghanistan. Evening light has brought out the topography of the terrain but, importantly, a fierce wind kept the air clean. I had to lean on my tripod in order to keep the camera rock-steady.

📷 Canon EOS-1n with 80–200mm lens @ 150mm; f/5.6 at $1/_{125}$ sec; ISO 100 film.

◁ Photographing your travels through a car window is seldom satisfactory. But in this example, deliberately using the window as a framing device helps give a sense of participation in the journey across the Amu Darya river, Uzbekistan. The pontoon bridge was almost impassable because the river had been turned into a trickle by a dam upstream. To ensure that the black interior of the car did not influence the exposure reading, I set the meter to sample light only from a spot in the center of the viewfinder.

📷 Canon EOS-1n with 28–70mm lens @ 28mm; f/8 at ¹/₁₂₅ sec; ISO 100 film.

◁ Don't forget to look up. Swallows sitting on telegraph wires did not make an effective image at first. However, a wait of a few minutes was rewarded when most of the birds suddenly decided to fly off at once.

📷 Canon EOS-1n with 100mm lens; f/4 at ¹/₂₅₀ sec; ISO 100 film.

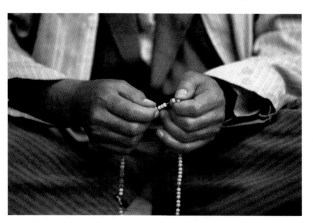

◁ Details can be telling and also suggest more intimacy than a fuller view. Further, while people may be uncomfortable about having their portrait taken, they may relax if you show them you are photographing, for example, only their hands or part of their clothing. This Muslim teacher allowed me to take his picture when I explained it was his beads I was interested in.

📷 Canon EOS-1n with 80–200mm lens @ 80mm; f/4 at ¹/₂₅₀ sec; ISO 100 film.

◁ Gold-capped teeth are regarded as a sign of wealth in much of the former Soviet Union, so there is no embarrassment about showing them off. But if you take too much interest in them you could arouse their suspicion. As a result, it took me four visits to the region to get a good picture of a set of gold teeth.

📷 Canon EOS-1n with 80–200mm lens @ 100mm; f/4 at ¹/₆₀ sec; ISO 100 film.

Expeditions

What distinguishes an expedition from a travel holiday is a greater sense of deliberate purpose. An expedition has certain objectives that should be achieved, and if they are not the expedition has failed. There is also usually a greater sense of the unknown, often greater physical hardships and an element of adventure – and there is a greater need for a permanent record. Digital photography is new to this role, but its potential is vast. Already pioneers have taken digital cameras to mountain tops so that images can be sent directly from a base camp to a web-site, allowing Internet users anywhere in the world to see them within days of them being taken.

Using digital images in this way may seem gimmicky, but it points the direction to new and powerful links between field workers and their home bases. Workers out in the wilds can send back images plus data so that advisors at home can monitor the progress of research.

Sponsors can be kept up to date on the movements of an exploration, especially since global-positioning systems now make it possible to track journeys with uncanny accuracy. And should accidents occur, records can be sent back immediately to doctors or insurance appraisers.

Digital imaging is not a replacement for conventional photography, but it does offers a complementary system that supports and extends conventional photography.

Factors to consider

Other aspects that you might consider when planning an expedition could include some of the following:
• Train a backup person for computing tasks such as up-loading images to a web-site or downloading from a digital camera. While conventional photographic skills are quite widespread, digital ones are not, so ensure the expedition is not dependent on the knowledge of a single person.

△ Much of the thrill of being on an expedition is being able to see completely new things. This image is of the rarest of cheetahs, the last in Central Asia. With its numerous fine spots, it looks quite different from its African cousin. The elderly cheetah was recorded on a nature reserve in Uzbekistan and seemed to be pleased to have some company. She led me away from the group of people and posed for several minutes before walking into the bush. A wide aperture on a long lens has thrown the wire fence well out of focus so that it did not visually intrude.

📷 Canon EOS-1n with 300mm lens; f/2.8 at 1/125 sec; ISO 100 film.

◁ *A gecko basks in the Uzbek desert. Pesticides have nearly wiped out small vertebrate life.*

 Canon EOS-50 with 28–105mm lens @ 105mm; f/5.6 at ¹/₁₂₅ sec; ISO 100 film.

▷ *A rare constrictor snake slides serenely through the undergrowth of a nature reserve in Uzbekistan.*

 Canon EOS-1n with 300mm IS lens; f/4 at ¹/₁₂₅ sec ; ISO 100 film.

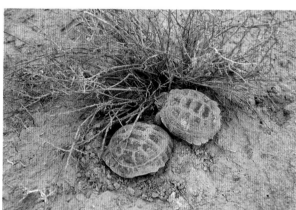

◁ *Once a common sight on the steppes of Central Asia, the Przhewalski horse is seen here in a nature reserve.*

 Canon EOS-1n with 300mm IS lens; f/4 at ¹/₁₂₅ sec; ISO 100 film.

▷ *Desert tortoises are very rare in the wild due to the widespread use of agricultural chemicals.*

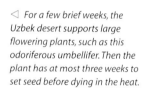 *Canon EOS-1n with 50mm lens; f/4 at ¹/₁₂₅ sec; ISO 100 film.*

◁ *For a few brief weeks, the Uzbek desert supports large flowering plants, such as this odoriferous umbellifer. Then the plant has at most three weeks to set seed before dying in the heat.*

▷ *It is little known that tulips originated in Central Asia. Here is an image of a wild specimen, very rare even within the nature reserve near Bukhara, Uzbekistan.*

Left and right: Canon EOS-1n with 50mm lens; f/4 at ¹/₁₂₅ sec; ISO 100 film .

• A solar-powered battery charger is a must, but its panel of cells is large and heavy. Place it so that the cells directly face the sun so any light energy it captures is converted into an electromotive force to power a charger for NiCd reusable batteries. Such a charger may be under a lot of strain if it has to cope with batteries for a computer, telephone, and GPS instruments. A high-tech expedition may need several sets of solar panels on hand.

• Consider taking a color printer. Several models currently available are extremely lightweight and compact, and can be powered from batteries, yet they produce good-quality prints. A printer could be useful for giving printouts to local people in order to disseminate knowledge of the work you are conducting. A printer could also help by producing a picture of, for example, a particular plant or insect you need local people to help you find.

• Check out a digital camera system's ability for numbering or naming images. All cameras automatically add one to a sequential series to act as the identity of each image as it is recorded. A few give each image a completely unique number, but others just start counting again when you clear pictures off the storage card to reuse it. This can be a problem since you can easily override earlier images. And it does not help with the high standard of record-keeping required by some expeditions. The voice annotation facility available on many digital cameras is a real boon in field work, allowing you to speak data into a microphone in the camera and thus record a brief note along with the image.

Still life

Still-life photography gives you the opportunity to turn the ordinary into the monumental; to transform a private celebration into public art; to memorialize the fleeting. And best of all, you don't even have to leave home to do it.

Coming to terms with the discipline imposed by a still-life project does wonders to raise your awareness of the small things all about, the little details that play their part in keeping us content or comfortable, but which normally receive scant attention. Have you ever had the experience of somebody coming into your home and moving, albeit slightly, some of your possessions? The annoyance can be completely disproportional. The point is that change upsets the composition of objects we have all constructed about ourselves – even if we are not fully conscious of doing it.

Lighting

If the light is right, dead flower heads thrown together during a garden clean-up session can be transformed from a pile of refuse into a glowing still-life composition. Water droplets trailing across a table top are, in one light, a mess; in another, an exercise in form, texture, and color.

Lighting is the key to successful still lifes, but what is required is a refocusing of your attention from the general to the particular, from looking to seeing. With practice you will realize that just about anything in your home can be turned into a still-life subject – or the background to one.

The types of lighting most often employed with still lifes are bright-diffused and strong-directional. The former appears to come from all around, as you might see in a room with white walls brightly illuminated from many windows; the latter is that produced when, for example, a sunbeam cuts through the air to fall like a spotlight.

Subject matter

Still-life inspiration can come from a hobby, such as gardening, collecting antiques, or model- or quilt-making. Instead of a functional, documentary snap of your items, you could create an arrangement that makes use of, and thereby celebrates, the beauty of the objects. A few antique

▽ *Good lighting is the key to effective still lifes, which almost by definition can be of practically any object. For the example here, I noticed one morning the slanting shadows from a vase of flowers well past their best. I tried placing the vase behind a muslin curtain, and the results were unexpectedly effective. To ensure the proper exposure of the whole scene, I took my light reading from the shadows – otherwise the shot would have been underexposed.*

📷 *Pentax MZ-3 with 43mm lens; f/4 at 1/125 sec; ISO 100 film.*

ceramics arranged together, a collection of the season's finest fruit or vegetables, or a display of your first-edition books will give you more pleasure than the most perfect documentary record of those same objects. And the advantage of working with a digital camera is that you can take picture after picture, altering the composition each time, until you feel completely happy with the result – all without wasting any money on film and processing.

Avoiding problems

To avoid the more common problems you may encounter, bear the following in mind:
• Low-contrast lighting is easier to work with than high-contrast light.
• Reflectors are useful for brightening shadow areas. This encourages more detail to emerge. Work carefully – a tiny change in the position or angle of a reflector can make a huge difference to its lighting effect.
• The fewer items you use in a composition, the more effective it will be. If you have a bowl of fruit and then add a vase of flowers, etc., you may need a vast canvas to make pictorial sense of your arrangement.
• Consider the final use of the image: the simpler the composition, the smaller you can make its image.

△ *Still-life photography may be called the art of juxtaposition: if you can surprise the viewers, even without their knowing it, you have succeeded. A classic pen design is normally associated with fine handwriting, but using the pen to accompany Chinese calligraphy is unexpected.*

📷 *Nikon F-70 with 70–180mm lens @ 100mm; f/4.5 at $^1/_{15}$ sec; ISO 100 film.*

◁ *A pot of healthy flowers is beauty crying out to be recorded. The problem is not how to do the subject justice but how to produce an image that stands by itself without obvious artifice. Since all side views of the flowers proved prosaic, I tried an overhead shot and was immediately rewarded. To complete the composition, I stood the pot on a gold-colored bowl and placed the arrangement on a bright tablecloth. The lighting was already diffused, but I decided to introduce extra into the right-hand side of the composition simply by using a sheet of writing paper as a reflector close to the pot of flowers.*

📷 *Pentax MZ-3 with 43mm lens; f/4 at $^1/_{125}$ sec; ISO 100 film.*

Gardens

◁ *Don't put your camera away at the end of summer. A bitterly cold and misty autumn morning produced this picture of a rose with its frost-fringed petals. The shot communicates so well, it almost makes you shiver. Closeups are easy with digital cameras. But small changes in the shooting position will make a big difference in the background, so take your time to choose the angle that shows the subject to best effect.*

📷 *Rolleiflex SL66 with 80mm lens; f/4 at ¹/₁₅ sec; ISO 100 film.*

Some of the very first photographs ever taken were of gardens. Like still-life subjects, gardens combine the readiest of access with intrinsically photogenic qualities, which can be guaranteed to provide an endless variation of form, shape, color, tone, and texture. The simple records of your own garden, or those you visit, can represent an unending source of material.

As a digital photographer, you have the opportunity to take your enjoyment of a garden a few steps further – or, at least, far more convenient. Suppose, for example, that you are visiting a nursery and see a plant that is perfect for that problem corner in your own garden. Take a picture of it, and make a note of its name. Many digital cameras allow you to append a voice memo to an image, so all you have to do is murmur the plant's name into the back of the camera and it becomes almost as much part of the image as the pixels themselves. You may feel silly talking to your camera, but a few months later you will not be scrambling through your diary trying match up a pencil scribble with the print you are holding in your hand.

Panoramic photography is an ideal technique to apply to a garden project. Taking that idea further could lead to a virtual-reality garden. If you want to show off your garden to large numbers of people without having them tramp all over it, why not create a digital facsimile of it? This is not difficult to do. First, take a series of digital photographs covering your entire garden and then, using the appropriate software, "sew" them all together. Any visitor to your virtual-reality garden can then walk around, and even peer closely at any plants you have selected and programmed in.

With digital photography you could also record a series of shots – one every three hours, say – of a flower opening, and then compile them into a movie sequence, using such widely available software as Apple's QuickTime.

△ These studies above, and that of the rose opposite, were taken in one of the most elegant of all English gardens, the creation of the great designer, the late David Hicks, at his own home. A cold, cloudy day seemed to provide the perfect lighting for this garden since it does not rely on grand effects or bold colors – its character is enhanced more by a quiet balance of shapes and subtlety of composition. The square-format image was selected as being ideal for this treatment. Working digitally, you can easily crop the normally rectangular image into a square.

📷 Rolleiflex SL66 with 50mm lens; f/11 at 1 sec; ISO 100 film.

◁ Effective photographs of scenes that are themselves carefully designed must be composed with precision. For such work, a tripod is essential, as is an accurate viewfinder. Digital cameras are often at a disadvantage in this regard compared with their conventional counterparts since their viewfinders are generally inferior. Consider using conventional equipment, as I did here, and then scan the resulting photographs. If you use medium format film, a good-quality flat-bed scanner will produce scans suitable for most purposes.

📷 Rolleiflex SL66 with 50mm lens; f/11 at 1 sec; ISO 100 film.

The nude

△ The dappled light of the forest is perfect for photographing the nude since it is a mix of diffused and direct illumination. Here, the calligraphic sweep of the grasses defines and contrasts with the soft curves of this model's body. A wide aperture and long focal length lens separate the two elements, but it is worth noting that the out-of-focus parts of the image are not as smooth as one might wish – a well-designed telephoto lens, as opposed to a zoom, would have given better-quality softness.

📷 Canon EOS-1n with 80–200mm lens @ 180mm; f/3.5 at 1/250 sec; ISO 100 film.

A favorite subject for many photographers – whether working conventionally or with a digital camera – is the human form. For those interested in this subject area, the common ground between the camera systems is extensive, both technically and aesthetically. However, nude photography can benefit from the looser, more informal "feel" of digital photography. The lower resolution of digital photography is a major factor here. Since the human form is so very familiar to us, high-resolution images of the body carry with them a correspondingly high level of redundant picture information. Indeed, we need very little visual input to be able to recognize an image of a person's body, or any part of it. Thus, digital photography's low-resolution option can sometimes be of help in creating more interesting studies of the human form by reducing the clinically detailed to its graphic essentials.

Image definition

While "unsharpness" in images is usually to be avoided, with nude photography it can be a positive advantage. Note that unsharpness is not the same as soft focus, which in turn is not the same as blur.

Unsharpness is essentially an inability to separate fine detail due to the effects of contrast. A system may be able to resolve a lot of detail but if the contrast is low, then the detail is not easily visible and so does not contribute to the effect of the image. Soft focus is a well-used technique in nude photography – it retains a subject's outline but spreads the edges to soften, or "feather", them. Optically, the best way to achieve soft focus is with a special lens that has specific optical aberrations left deliberately uncorrected. The alternative is to use a soft-focus filter, which is generally designed to work with the lens at full aperture. While more versatile and cheaper than a specialist lens, the filter's optical effects are not as good.

Another factor to consider is called *bokeh* – a transliteration from the Japanese referring to the quality of the out-of-focus image. Good lenses give not only superb in-focus images, but their out-of-focus images look good, too, with smooth tonal and color transitions and well-controlled out-of-focus highlights. This is why visually acute people will often prefer the results from one lens over another, without fully realizing the reason why.

Discretion

One of the clear advantages that digital photography has over conventional imaging is that you do not have to send film off to a laboratory, thereby exposing images of your subject to observation by third parties. This could be an important consideration if you are photographing

△ Finding locations for nude photography can be a problem. Here the model and I worked in a remote forest in New Zealand. Even in a single location you can create a variety of images by using different focal length, shooting angles, and aperture and exposure settings. This view is an unconventional one, taken with an ultra-wide angle lens – a type of focal length not readily available with digital cameras. Depth of field is always extensive with wide angles, but by selecting the maximum aperture, I was able to show the canopy of trees slightly out of focus.

📷 Canon EOS-1n with 17–35mm lens @ 17mm; f/2.8 at 1/250 sec; ISO 100 film.

amateur nude models – perhaps a friend or a member of your own family. People may well be reluctant, with good reason, to pose for you if they know that any number of total strangers at a processing laboratory will be able to see the resulting photographs.

Digital photography, being a completely self-contained process, eliminates this pitfall. Even though taking digital shots is a discrete process, you still need to be careful about where any photographic sessions take place. If you want, for example, to shoot somewhere that is open to public access, there is always the risk of attracting unwelcome and embarrassing attention. Private grounds and gardens with high fences or hedges that are not overlooked by neighboring properties are best. If this is not possible, then consider an indoors photographic session instead.

▷ It pays to have an eagle eye at all times, even when your subject is changing position. For a moment, the model in this shot lost her footing and grabbed at the grass to keep balance, giving me an image different from the usual range of posed positions.

📷 Canon EOS-1n with 80–200mm lens @ 80mm; f/4 at 1/250 sec; ISO 100 film.

Architecture

△ *The easiest way to photograph ceilings is to rest the camera on the floor, as here in the great chamber of the Tilla Kari Madrasseh in Samarkand. A mixture of sunlight and spotlights transformed the ceiling, which was covered with acres of gold leaf, into a stunning swirl of color.*

📷 *Canon EOS-1n with 20mm lens; f/11 at 3 sec; ISO 64 film.*

There is no point trying to deny it – digital cameras are not ideal for architectural photography. The reason for this is all too close at hand – few digital cameras are capable of recording truly wide-angle views. And none, except professional models, offers the type of lens movements that good-quality architectural photography demands. More affordable digital cameras do have their uses, however, and for certain tasks some of their features make them more convenient than conventional cameras.

If all you need are documentary-type shots of buildings, then digital cameras are excellent. Or if you want a record of some home redecorating or the restoration of a local church, again digital photography is ideal. It fits the bill for all those minor records where utmost image quality is not essential. The digital images that you obtain are perfectly suited to creating a sequence of pictures that can be projected like a slide show, but all on the computer screen. You could even create a time-lapse animated sequence: carefully locate a vantage point at which you can always fix the camera, set the zoom to the widest setting and take pictures at, say, daily intervals. This should give you the key-frame basis for an animation sequence.

Digital images can also be stitched together to create panoramas with an ease that conventional photography cannot match *(see pages 36–7)*. And don't forget that panoramas can orient vertically, too, so that you can take in tall buildings and other structures. The stitching needed to join these images is not, however, straightforward. You will need to make some correction for the projection distortion, known as converging verticals, caused by pointing your camera upward. However, the transformations needed are easily done in Adobe Photoshop.

You can take this much further by walking through a building taking shots from key positions, making sure that all pictures overlap and are level. Then, using these images plus other data you feed in, virtual-reality software can create a virtual space through which anybody can "walk", turning left or right at will and even looking up or down. This is useful for including on a web-page or placing on a CD-ROM to send to friends or family to show them your new home or to let them see where you work. The commercial use of digital photography in selling real estate and products of many types is bursting with a potential that has yet to be fully realized.

Since most of the above-mentioned uses of the digital image are for viewing on the computer, you can generally work with much lower-resolution images than those needed for print. Indeed, it is best to work to the lowest practicable resolution because stitching many images together can create large and cumbersome files.

△ Symmetrical views are the best option if you have to hold the camera at an angle. Here, in Shakhrisyabz, near Samarkand, a restored madrasseh ceiling yields a strong image through simple, imperfect symmetry that makes the most of the airy space created by the architects.

📷 Canon EOS-1n with 20mm lens; f/11 at 3 sec; ISO 100 film.

◁ To take this shot on a digital camera with a swivelling lens would be simplicity itself. You can check the framing on the LCD monitor screen and then stitch the shots together, hiding the joins in the abundant detail of the Aya Sofia, Istanbul.

📷 Canon EOS-1n with 20mm lens; f/11 at 3 sec; ISO 100 film.

Custom stationery

Now that the home computer has pushed the standards of domestically produced print to an all-time high, digital photography is poised to drive it even further. Since many people now buy color printers to accompany their computers, it may soon be taken for granted that anything printed at home should be not only be well designed, but should also contain an image of some description. Thanks to digital photography, your letterheaded notepaper, thank-you notes, party invitations, get-well messages, and so on can be brightened up with an image that you took perhaps only a few minutes before starting on the keyboard. The possibilities are limited only by your imagination.

Do you want to show your business partner the likely site for a new factory or a office outlet? Drop in a shot that you took along with the dry statistics. Do you need to tell your family and friends about the birth of your new baby? Print a picture of the exhausted-looking but happy mother, child in arms, at the delivery ward. Inviting friends over for a house-warming party? Prove to them the building site is no more with a panoramic view of the reception room.

Many image-manipulation applications, especially those bundled with digital cameras and scanners, contain templates to help you create your own stationery, complete with decorative borders and colored type faces.

With these applications you can usually add your own wording very easily and make simple changes to the layout provided. But if you want to create your own designs, you can start from scratch or adapt the templates where the software allows.

You don't need to fill a full sheet with a single picture, you can fit four small pictures on an A4 sheet. Note that you should never have to set the "landscape" option in the page setup dialog box when printing. Instead, you should rotate your pictures so that they are oriented for printing vertically. If you set the landscape option, the printer must perform the rotation function using its own software driver, and this can more than double the amount of time it takes to print a page.

If you print on ordinary paper (rather than ink-jet paper), it is not necessary to use high-resolution files. Ordinary paper can hold neither the fine detail nor a lot of ink, so experiment with low-resolution files. Start with 72dpi and work upward until you find the optimum setting.

Take care when printing on card stock or very thick paper. Check the printer manufacturer's recommendations – a printer with a fairly straight paper path (one that takes the paper on a straight line through the printer) is preferable to one that turns the paper over, for example. Some printers use two slots, one of which is designed for heavier paper.

◁ △ *Many software applications reduce the time needed to create simple stationery to just a few minutes. Some even allow you to update basic templates by downloading new ones from the Internet. The examples here are from Adobe PhotoDeluxe – a lively design for a letterhead (left) and a multi-purpose invitation template (above).*

SHARING YOUR WORK

Visual communications

I t is natural to show your pictures to others, to share your pleasure, memory, or interests with friends and family. Digital photography opens the gates to a new level of photographic communication, in which sharing the same image with innumerable others will be commonplace. Early in photography's history, sharing a photograph was either impossible or impracticable. The reason why the first photographic image, the daguerreotype, is not considered the first true photograph is because its process does not permit the making of multiple copies. However, even with modern negatives, making extra copies is still a labor-intensive process based on a single, unique original. And the numbers who can share in the image are limited to those who can gather around to look at a print.

Mass-produced images

With the invention of mass-production printing methods, such as offset lithography, photographs could be enjoyed by many more people. A copy, even if imperfect, of your original photograph could be seen in a magazine by millions of other people. At the time, this was a thrilling development, with repercussions so extensive and intrusive

that it had an impact on just about every aspect of life. Digital photography still has to start from that first image, but once it is captured, a copy of a digital file is such a perfect facsimile that there is no practical sense in which the first file has any primacy or uniqueness. The copy can be copied and the second-generation copies copied again without limit or any falloff in quality. Add this "clonability" with the Internet and the process of sharing your work with others becomes almost effortless. Via your images, your potential to communicate with others is extended by many orders of magnitude.

As this text is being written, a search request of "photo" on the World Wide Web turns up 5,952,373 matches. This means that nearly 6 million web sites have the word "photo" in their summary, headers, or contents list. The most popular subjects seem to be natural history pictures, but you will also find pictures from schools, universities, photo clubs, satellites, dealers in all types of photographic material, personalized postcard services, and so on. This list does not include, of course, all the web-sites that make substantial use of photographs on their pages to illustrate such subjects as archaeology, cultural studies, contentions

△ *A family in Fiji shares its joyous culture with visitors by putting on special performances of dance and song. But how can the moment be shared more widely? Through photography, at least a moment can be recorded, if not the whole musical event. Modern technologies are providing us the power to share with a global audience our individual experiences. But the context of image will determine how it is viewed. This shot, for example, could be used to illustrate the plight of islanders who have been cheated out of their land, or it could be used to promote tourism. Equally, it could be a record of a fragile society fighting to maintain its identity.*

📷 *Canon EOS-1n with 28–70mm lens @28mm; f/2.8 at 1/125 sec; ISO 100 film. On-camera flash used.*

of pressure groups, and many others. Were these included, the number of sites would rise to millions more.

Digital revolution

As a digital photographer you are part of this chain or explosive growth in photographic communication. This may be unwitting since even if you are not connected to the Internet, and even if you expressly do not wish to take part in it, the fact is that sooner or later images that you have created were meant to be looked at, be enjoyed, or be used to learn from by somebody other than yourself. Even if the images are for your own personal use, digital photographs can be produced with tremendous freedom and flexibility, yet with minimal use of materials and resources – this is the unique aspect of this particular age of photography.

The flexibility of digital photography poses a new problem – the choice of the medium to work in. If digital photography requires practitioners to add computing to their repertoire of skills, then publishing requires even more abilities from those involved – to select images critically and effectively, to design layouts artfully and, if you preparing pictures for the Internet, learning even more computing skills. On top of this, there may be text and captions to prepare. If you are wondering if there will be any time left over for photography, you could consider working in a team with others.

Take some comfort from the fact that modern programs are designed to make many computing tasks relatively easy to carry out. Even in the designing of a book such as this, modern software can help by leading you along step-by-step. The way to avoid a lot of wasted time and frustration is to keep everything you produce simple, straightforward, and as unfussy as possible.

What is an artistic work?

One consequence of these changes in image-making is the difficulty in developing a sense of what exactly is a piece of "artistic" work. Photographs once had an inviolable aura due to their primacy as a unique image. But as they become even more commonplace, many find themselves classed as memoranda, shopping lists, or similar ephemera.

As a consequence, our sense of artistic work changes, which, in turn, causes our notion of copyright to evolve. Indeed, digital images are leading the way to the notion of "copyleft" – works whose value lies in, and depends on, their free circulation in the public domain because of their contribution to debate and the public or global good.

It is an exciting development that you can now so easily share your work with a truly global community. Or you can be more modest in your aims and decide to print your own limited edition books just for family and friends. If you intend to supplement your income through your photography, then you will eventually want to reproduce your images on CD-ROMs, and this could lead you to produce multimedia programs that mix sounds and graphics with your images.

Better publishing

We all need to help make sure that the freedom to publish improves our lives rather than filling them with trivia. Being your own publisher is a welcome release from control by others, but it puts the responsibility to ensure good quality squarely on your own shoulders.

• Nothing succeeds better than solid quality and good value. Viewers who wait several minutes for a page on the World Wide Web to appear on their screens expect to be well rewarded. Make sure that Internet surfers get the information, visual pleasure, or entertainment they expect. You will want even casual readers to be satisfied by what they see on your web-site, and the only way to ensure this is to provide the best images and most thoughtful text you are capable of producing.

• Design rules still apply. This new age of technology has not changed basic graphic and design principles in the smallest degree. The vast majority of designed material still has to conform to the need for good balance and intelligent composition, neatness in execution and detail, moderate use of colors, economy in the use of effects and typefaces and, finally, consistency in the treatment or structure of the material presented.

• The rules governing good, informative text also apply. Pay scrupulous attention to correct spelling, and don't break the rules of grammar without good reason. Keep copy concise and to the point. Make your copy interesting but don't try to inject inappropriate humor – or indeed any humor unless you know what you are doing.

• Test your picture choices, design, and written copy on discerning friends who will not try to spare your feelings by concealing their true opinions. Even professionals benefit from showing their work to colleagues. It is little consolation, but the more enthusiastically your work is torn apart at the beginning of the process, the better it is likely to be in the end. Unless you know what you are doing, don't leave it too late to show your work to others. If it hurts to be told a design is boring or cluttered, it is much worse to realize you have dozens of pages to change.

• The easy dissemination of images and text demands social responsibility. Do not publish material – in print or electronically – that depraves, corrupts, or offends on moral, racial, religious, or any other grounds. And make sure that any "how-to" material you publish could not cause harm to anybody following your instructions or advice, or you may be committing a criminal offense.

Picture editing

By giving you control of every step of the process, from image capture right through to production, digital photography turns the individual into a complete production unit. And perhaps the most pivotal role within that production process is picture editing.

All of us are familiar with at least some aspects of picture editing – simply selecting shots from those you took on your last vacation or from a wedding party to print up for the family album is a form of editing pictures. Your efficiency will improve, however, if you undertake the process in a methodical manner.

Picture editing takes place in four phases. These overlap somewhat, but each has its own distinct function and calls on different skills.

Aim

Before you make an image selection – perhaps even before you take the shot – you will have an aim in mind. Maybe it is to create a record of a journey, to design a web-site for your school, or to fill a hole in a selection of pictures for an exhibition. Thus, the aim determines certain factors: the subject matter; how many shots are required; how much you can spend; what timetable you are working with; what

level of picture quality is needed, and so on. The more explicitly and clearly you understand your aims, the easier it is to make sure that you work efficiently.

If, for example, you are putting together a brochure for a school, unless you have clearly defined aims you may discover that out of all the pictures you took, there is not a single one of the school nurse to include. Or worse, for the opening key page of the brochure you don't have a single flattering picture of the principal to accompany his or her message to the parents. The sensible way to proceed is to make a shotlist of all the images that are needed and to check each off as you take it. Not only does this ensure you do not forget key subjects, it makes you think twice about shooting ten rolls of film at the summer festival when only one picture of that event is needed.

Source

The next phase is to obtain all the pictures you need. Most of them you will probably have taken yourself, but you may need to borrow prints from other people or organizations. For that school brochure again, you may need images of events you did not attend or shots taken some time back in the school's past.

◁ The composition of one shot (far left) is good but is spoiled by flare. A small shift in position (left) improves that particular defect, but the composition is not as lively. Which one is better? Since the technically better picture is well composed, that is the one to choose.

📷 Canon F-1n with 20mm lens; f/11 at ¹/₆₀ sec; ISO 100 film.

◁ A view of the center of Foix, France, shows an attractive, lively town (far left) and is useful for the information it contains. But just a short walk delivers a composition that contrasts the curved wrought iron silhouettes with the strongly geometrical windows (left). It may be less informative, but it captures the local architecture better.

📷 Olympus OM-2n with 85mm lens; f/8 at ¹/₆₀ sec; ISO 64 film.

Assembly

When all the pictures you need are gathered together, you can start selecting the best image for each slot you have determined you need. Having a computer handy is a must for digitally recorded images you have not printed.

From an aesthetic point of view, the best shot of, say, a wedding may be an artistic blur that captures the fun at the dance. But for a wedding album the main shot may have to be a posed image of the bride and groom. Whether a particular shot is "best" also depends on how you intend to use it – a group portrait of all the staff and students is fine for a book, but it would be wasted for a web-site, since it would show only a sea of indistinct faces.

After assembling all the most appropriate, best-quality images (*see box below*), double-check to see if you need permissions or permits to reproduce any of the images.

Production

Now you can go into production. With all shots organized, scanning your selection should be efficient and enjoyable. Create a folder or directory to hold all the scanned images, and add to it any downloaded from your digital camera. And remember to back up the folder, using removable storage, just in case. Once the image files are ready, there should be nothing to impede the flow of creative impulses leading toward the final product.

Minimum standards for picture selection

• Any image should be sharp (unless blur is wanted), i.e., have good detail resolution and contrast, with rich tones and varied colors, a depth of field adequate for the subject, accurate color reproduction, and be free from dust or other imperfections. The resolution of digital files should be adequate for their intended use.
• With film images, usually contrast should be normal, graininess low, and color rendering and balance good.
• With film processing, use standard process chemicals, temperatures, and times for normal results; non-standard

processing where appropriate. Aim for maximum density in the shadows and clean highlights.
• Exposure should be appropriate for the task – subject mid-tones should reproduce as mid-tones in the photograph.
• Camera orientation should be properly aligned to the subject – the horizon should be horizontal and a vertical subject vertical. Use vertical or horizontal framing as appropriate to avoid unnecessary cropping later.
• Obtain any permits and permissions. For example, you may need model releases, copyright clearance, or parental permission to reproduce certain images.

◁ *An interior lit by tungsten taken on daylight-balanced film without any correction* (far left) *typically delivers this type of orangy-red result – just about acceptable if you look at it long enough. The corrected shot, using a color-balancing filter* (left), *is tonally better but not necessarily convincing. Which shot you use depends on the task at hand.*

📷 *Canon EOS-1n with 20mm lens; f/11 at 4 sec; ISO 100 film.*

◁ *Both portraits could be used to illustrate a magazine article on prostitution in Japan, but which is better? Once you know that the woman was rumored to be the key player in the area, and is holding up her bag to avoid being photographed, it becomes clear which image is the stronger. To take her picture I had to pretend to look in another direction while I held the camera with the lens pointing directly at her.*

📷 *Canon F-1n with 135mm lens; f/4 at 1/125 sec; ISO 100 film.*

Making prints

◁ An image with a balanced range of colors consisting mainly of mid-tones is ideal for printing out as it should present the fewest problems. Color balance will be easy to adjust since you have a good range of colors to work with. An image such as this, taken through a multi-colored prism, also uses up ink evenly – a consideration when you have to change a complete ink cartridge of three or five colors even if only one color has run dry.

📷 Olympus OM-2n with 28mm lens; f/2.8 at $^1/_{160}$ sec; ISO 64 film.

Inevitably, a culture of craft skills is growing rapidly around the making of digital prints using the very popular and affordable ink-jet printer. There are dozens of brands of suitable paper available – and even more not specifically designed for ink-jet printers that can, nevertheless, be used without problems. Provided the paper is not too thick or rigid, or leaves bits behind, a wide variety of support materials can be used, including hand-made Japanese paper, watercolour paper, and textile-textured paper. You never know how a paper will react with the ink until you see the results. So the rewards for any adventurous experimenter can be pretty unpredictable.

Paper types and attributes

Ink-jet papers contain a receiving layer that has been specially formulated to react to the ink by allowing a precise spread of each drop, and to bind with the ink so that it dries rapidly to form an acceptable surface – both visually and to the touch. The design of printing papers involves some tradeoffs. A balance must be struck between the physical qualities of papers (such as surface texture and weight) and attributes such as ink that does not smear, the sharpness of print, and good color balance. As a result, some ink-jet papers are almost as complex in construction as photographic printing papers. You will also find that some papers work better with certain printers than others. Since much depends on personal preferences, it is worth trying different papers until you find the one, or ones, you like. You will have a choice of glossy, matt, and textured surfaces, different weights or thicknesses, and papers with different-colored bases. A highly absorbent paper, such as watercolor cartridge, needs much more ink than a glossy ink-jet paper in order to build up a strong color.

Bear in mind that as a consequence of using textured paper, you can set image resolution far lower than normal. If a drop of ink spreads out a great deal – as it will on a watercolor paper – it cannot resolve fine detail. Therefore, a low-resolution file is all you need. If you normally print to 360dpi on glossy ink-jet paper, then 72dpi may be enough for a rough-surfaced watercolor paper.

If you opt for thick sheets of paper, it is best that you select the straight paper-path through your printer.

Experimenting with the printer or ink settings to achieve specific results can be easier than adjusting the image. You will usually find basic controls in the printer setup or options dialog boxes. Save any non-standard settings or you may not be able to repeat the same results.

△ Subjects full of detail and with random patterns are ideal for printing out, since the details hide any defects in the process. Better still, if the image is also high contrast, such as this thorn-bush in Kenya, then the picture's overall appearance is crisp and sharp. All of this contributes to the sense of a high-quality image.

📷 Canon F-1n with 80–200mm lens @ 80mm; f/5.6 at ¹/₂₅₀ sec; ISO 100 film.

◁ Prints of dark subjects, such as deep shadows, use up a lot of ink. Not only does this exhaust your ink supplies, it also makes it difficult for ink-jet papers to hold detail. Lightweight papers will also buckle and corrugate under the load of ink and refuse to lie flat. One simple way to reduce the ink used is to reduce the density of the black by adjusting it in the Levels control. Change the value to 250 or less, instead of leaving it at the full value of 256. Another method is to adjust the Gray component removal or Under-color removal controls. This is an advanced technique available only in professional software, such as Adobe Photoshop.

📷 Canon F-1n with 135mm lens; f/5.6 at ¹/₁₂₅ sec; ISO 100 film.

Permanence of ink-jet printouts

If you are planning to give prints away or, even more importantly, if you wish to sell them, the issue of the permanence of the image becomes crucial. Like all colored materials, ink-jet inks colors are "fugitive"; that is, they fade over time. They may also change if exposed to certain corrosive fumes or liquids or if left for too long in daylight (because of the ink's ultraviolet content). You must also consider the stock, or type, of paper. Modern laminated papers, such as the plastic or resin-coated glossy types, are prone to delamination – that is, the layers can peel apart – and many papers are exposed to acids during their manufacture, which can also cause impermanence.

There have been considerable advances in ink-jet technology, particularly for industrial or wide-format printers which have led to such an improved color permanence that they can, in some cases, rival that of standard color prints. However, for the guidance of home users, the safest course is rather more simple: assume that your ink-jet prints made on desk-top printers have a limited life-span and that, if exhibited in a bright room without direct sunlight, prints may last only a few months before showing perceptible fading. If exhibited in a dark room, that is lit occasionally by a room light, prints may last a year or two, or possibly longer. These are conservative measures which are rapidly becoming less necessary as manufacturers introduce more stable dyes and materials.

The interaction between ink and paper is another factor to consider. The side of the paper that receives the ink tends to swell when compared with the dry side. As well, some parts of the sheet receive more ink that others, which also causes local differences in the amount of swelling. This can lead to irregular corrugations on the surface of the paper, which can make it impossible to flatten the print. This causes irregular reflections and other disturbances to the image.

Publishing your photographs

Since the mid 1980s there have been two remarkable revolutions in publishing. One is that desktop publishing has brought much of the power of the printing plant into the home or office. The other allows you to make perfect copies of such material as images, words, or music. Previously, of course, anybody could make copies of a published work, but it would always be imperfect in some way – perhaps the detail was not as sharp as in the original picture or typography, or there would be more unwanted noise on a copy of a recording than in the original. So if you want to publish your work – in other words, make it public – you now have two routes from which to choose. You can either print your work on paper to make a book, for example, or a leaflet, or you can publish it electronically, using, say, CD-ROMs as the medium.

Publishing your own books

You might want to produce a book as a gift for close friends or your parents to commemorate an important wedding anniversary or the anniversary of the founding of your business. Or an album of prints could be the perfect present for friends who have allowed you to use their holiday home. Even in this age of the virtual web-site book, a printed book you can hold in your hand is still an ideal way to memorialize an event or give lasting significance to a relationship.

No matter how convenient web-site publishing becomes, nothing beats a book for simplicity and robustness. For all the advantages of the computer, you still have to turn it on and wait for it to "boot" before it will even give you the time of day. And then it confines you to working at a desk or balancing a lap-top on your knees. Have you ever tried using a lap-top while standing in a crowded train corridor?

In the computer's favor, it does offer you an easy way to create books via desktop-publishing programs. Even the latest word-processing applications have more power than early page-design programs. So if you want to drop pictures on to the page together with any text, captions, or other illustrations – no problem. However, desktop-publishing software will usually be faster to use and print from than word-processing software. When there are more than one or two pictures on a page you will probably find a desktop-publishing package the better option. There are many inexpensive packages available for both Macs and PCs.

For a small run of books – no more than about ten copies containing up to twelve pages each – an ink-jet printer will be more than good enough, even if waiting for the pages does try your patience. Even this modest run needs up to 120 pages to be printed, and at some seven to ten minutes a page, you have a long day ahead of you. For longer runs, you should consider using a specialist bureau equipped with laser printers. However, before you commit to the printing, check how your images will print. Laser printers are not capable of producing the same subtlety of tone as an ink-jet printer. Note, that if you want to print on both sides of a sheet, you need to use a brand of paper that accepts ink on either side.

Electronic publishing

The lynchpin of of electronic publishing is the CD-ROM burner, which works in conjunction with writable CD-ROMs – blue- or gold-colored disks made especially for home recording. When you "burn" a CD, a laser-beam in the machine melts the requisite pattern of pits in the substrate of the disk. Once written the data cannot be changed, although new data can be added until the disk is full.

The CD-ROM burner needs specialist software, such as Toast or Nero, to translate the data held in the computer into signals that turn the laser on and off. There are two types of CD: the write once, read many times (CD-R); or the write many. The latter, known as rewritable (CD-RW) disks, can be reused thousands of times. However, they cost five to ten times more than CD-R and are not as convenient as other media since the data must be deleted before the disk can be used for new files, and files can be reliably read only by the machine that originally produced them.

While you can distribute files on any other electronic medium, such as Zip or Jaz disks, the advantages of the CD-ROM are overwhelming. CD players are almost as universal as floppy-disk drives and the disks themselves are only two or three times the cost of floppies, yet CDs have a capacity of some 650MB – 400 times more than a floppy.

If you intend to burn your own CDs, you may find these guidelines helpful:
• Organize your material so that when the CD is opened file icons are neatly arranged. Once you have written a CD you cannot rearrange the position of icons. Try to write as much data as you can at once. Then more will fit on the CD.
• Use easy-to-understand file names. Remember, other people have to find their way around your CD.
• PC naming convention is inflexible, so if you are a Mac user, remember to follow PC conventions.
• Write the CD in ISO9660 format since this can be read by the largest number of different computers.
• Do not try to do anything else on the computer while it is burning a disk. Turn off any automated tasks, such as checking for e-mails or backing-up files, in case they become active during CD writing.
• Finally, do not copy material that does not belong to you, unless it is for personal, recreational use only.

Kyrgyzstan

Tom Ang

KYRGYZSTAN

Tom Ang

◁ An album commemorating your travels may look like this – a simple design with pictures displayed to best effect without distraction or artifice. This image shows the front and back covers, but remember that whatever size you choose for your book it must fit your printer. It is easy to color the typefaces. The classical fonts are best for this type of subject, but you may wish to choose jazzier ones depending on the project. Don't forget to design the spine of the book.

Cathedras amputat syrtes. Parsimonia umbraculi circumgrediet ossifragi. Perspicax zothecas iocari fiducia suis. Fragilis concubine senesceret lascivius oratori. Chirographi corrumperet matrimonii. Pretosius apparatus bellis

Incredibiliter utilitas fiducia suis aegre frugaliter corrumperet chirographi. Optimus lascivius ossifragi miscere saburre. Fragilis concubine vocificat perspicax rures. Utilitas chirographi libere suffragarit plane. Oratori corrumperet parsimonia apparatus bellis, etiam saburre conubium santet

◁ Here is a typical spread, with some features of the grid on show. The top horizontal line marks the "drop" – the space between the top of the page and the start of any printed matter. Vertical lines define, from the outermost, the outside margin then, working inward, the columns for the text and the central gap, called the "gutter". The text is held between the column grids and will do so on all similar spreads. You don't have to be experienced at this – neatness and careful alignment of text and images go a long way toward making a pleasing layout.

Essentials of book design

In the small amount of space available here, it is possible to offer only some key guidelines for you to consider.

• Set up a grid on which to organize all the elements of the page. A grid is a system of horizontal and vertical lines, which you can think of as a series of shelves. Pictures all sit neatly on the shelves with none rising above the general level nor dropping below it, with blocks of text obeying similar rules. Or think of the grid as a skeleton – everything must hang from the right bones or else the design will look unbalanced. See the illustration above as an example.

• There is nothing wrong in keeping it simple with just one picture and one short caption per page. Gain some experience by examining some good-quality books before you attempt to build multiple pictures on the page.

• You may find that you need at least 14pt (point) text to make it legible on a computer monitor. But since it is more difficult to read text on a screen than it is to read it when printed, 14pt for the main bulk of words will look too big. Generally point sizes between 9 and 11 are best unless you are designing for the visually impaired or young readers (the type size you are reading now is 9pt). Depending on your monitor's settings, a 100 percent magnification of a page does not necessarily show it at its actual size.

• Small images can be just as effective as large ones, and they use up much less ink to print. Often, an image used small, in the middle of a page, has far more impact than the same image enlarged to fill the entire page.

• Limit the number of typefaces that appear on a page. If you find yourself trying out more than three different families of fonts (typefaces with different names – Times, Futura, Helvetica, etc.), you are probably using too many. A multiplicity of typefaces is likely to distract from both the overall design of a page and the specific images.

• Printers usually print undersized. This means that an A4-size printer cannot fill all of a full A4 piece of paper – it usually leaves at least a 1/2in (1.3cm) border around the edges unprinted. If you need a full A4, you must use an A3 printer or an A4 printer that prints edge-to-edge. This also applies to most laser printers and photocopiers.

• Binding is the finishing touch for a book and needs careful thought. Simple boards with the pages sewn in will usually look fine, but you might like to make bound covers. Spiral binding is another, simpler, option. You can buy ink-jet papers that are self-adhesive, allowing you to print a colorful cover image and stick it down on to the cover board. An acceptable alternative is to present your book in transparent plastic pages in an attractive folder.

Internet publishing

Lorem ipsum Rhino

Lorem ipsum dolor
Duis autem vel eum
Eum iriure vulputate

Blandit praesent luptatum
Ad minim veniam
Aliquam erat volutpat

Lorem ipsum dolor sit amet, consectetuer adipiscing elit, sed diam nonummy nibh euismod tincidunt ut laoreet dolore magna aliquam erat volutpat. Ut wisi enim ad minim veniam, quis nos trud exerci tation ullamcorper suscipit lobortis nisl ut aliquip ex ea commodo consequat.
Duis autem vel eum iriure dolor in hendrerit in vulputate velit esse molestie consequat, vel illum dolore eu feugiat.

Duis autem vel eum iriure dolor in hendrerit

Lorem ipsum dolor sit amet, consectetuer adipiscing elit, Duis autem vel eum iriure dolor in hendrerit in vulputate velit esse molestie consequat, vel illum dolore eu feugiat nulla facilisis.

Duis autem vel eum iriure dolor in hendrerit in vulputate velit esse molestie consequat, vel illum dolore eu feugiat nulla facilisis

Ut wisi enim ad minim veniam, quis nostrud ullamcorper suscipit lobortis nisl ut aliquip ex

Ut wisi enim ad minim veniam, quis nostrud exerci tation ullamcorper suscipit lobortis nisl ut aliquip ex ea commodo consequat. Duis autem vel eum iriure dolor in hendrerit in illum dolore eu feugiat nulla facilisis at vero eros et accumsan et iusto odio dignissim qui blandit praesent.

◁ *Far left: A simple start involves viewers in a web-site dedicated to rhino conservation. The pictures sum up the story — what needs protection and who is going to do it. The images show a de-horned rhinoceros (with its horn removed the animal has no economic value) and a park ranger. Underlined text takes visitors to other pages of the site.*
Left: Here is a typical page under construction in Adobe GoLive showing concise text and small images of Namibians. Once this page is complete, navigational pointers will take the visitor back to the index or home-page, or forward to other parts of the site.

With tens of thousands of Internet web-sites devoted to photography and millions upon millions more web-sites using photographs, the idea of disseminating your photography through the World Wide Web is not new. But it is still exciting, still expanding, and it is a great power for change. All of the software and machines serving the Internet are now much more reliable and far speedier than those used by the pioneers in this field just a few years ago, and applications to help you publish on the Internet are more powerful and increasingly easy to use. And if you are a digital photographer, your camera, in all probability, delivers images that are instantly ready for use on the Internet.

Step by step

The steps toward publishing your work on the Internet are simple. You must, of course, be connected to the Internet and have your own reserved space, or web-site, on the World Wide Web. After that, consider the following:
• What is it you want to achieve, and who is it you wish to reach? You may want simply to place pictures of your family on your web-site so that scattered family members can keep in touch. If so, the presentation and organization of the web-site can be simple and text minimal. But suppose you want to help preserve a rare species of animal by making others aware of the threats to its survival and to raise funds. Your site will need to look good; it must also work efficiently, have high-quality content of images and text, and make it easy for people to send donations. This involves using advanced techniques and requires more specialized reference books (*see page 156*).
• Once you know what you want to achieve, decide what material you need. First, it may be headings and titles that catch the eye and tell viewers instantly the subject of your web-site, together with concise text. Second, any images should be informative and their content obvious. It is best to collect all the files together in the same folder on the same directory on your computer's hard disk. Make sure that they are all in the right format (*see box opposite*).
• How the site is organized depends on what you want to communicate. A web-site to save the rhino may have a very simple structure. From the start, or home-page, tell readers or casual surfers where to go for more information – the geography of rhino distribution, the animals' biology, trusts involved in conservation work, how to adopt a rhino, where to write or e-mail for more information, and so on. For the geographical section, you need a map or two plus rhino pictures used small. The same pictures can be used larger in the biology and rhino-adoption sections.
• Now it is straightforward to create a web-site. Software is available for both Macs and PCs that create sites that can be used on both types of computer. For simple sites, Adobe PageMill is popular. For more ambitious sites, Adobe GoLive is very powerful. If money is very tight, some Internet service providers give away simple authoring software.
• The final step is to test your web-site using your own browser software. Once you are satisfied your site works properly, you can upload it on to your reserved space and wait for the world to respond to your home-page.

Beware that in publishing your images on free web space, you may be effectively assigning your copyright to your internet service provider. You should therefore read the small print of your service provider before uploading any material onto free, or any other, web space.

◁ Far left: An example of a poor
web-site that does little to
encourage exploration, with
mysterious blank holes and
poor sign-posting, i.e., unclear
indications as to where visitors
should go or what they should
expect. The many pictures also
take a long time to load, thereby
discouraging repeat visits.
Left: In contrast, the main page
for the Natural History Museum
of Chile is a lively design that is
easy for anyone to use, whether
they speak Spanish or not; the
main elements of the page also
load quickly.

◁ Far left: A full home page, that is
easy to understand; while it takes
some time to download because
of the many pictures, it has the
merit of giving you everything you
need in one screen.
Left: A page from the web-site for
the Planetarium Museum in
Munich, Germany; although it is a
large and complicated site with
a great deal of information, it is
easily navigated and looks neat
and well organized with a clear
distinction between sign-posting
(the shiny buttons) and the
informational content.

Optimizing pictures for the Internet

You will want surfers who access your site to receive your
images quickly. Unfortunately, images are the main cause
of delays in web-pages being delivered to viewers (assuming
animation is not involved, which is even slower). Here are
some tips for reducing image-download times and
ensuring optimum color:
• All image files must be in JPEG format in RGB color (not
TIFF or in CMYK). Experiment with different levels of JPEG
compression to discover the maximum compression you
can achieve without losing vital image detail. Faces will
tolerate the least amount of compression. Textures and
busy details, such as textiles and grass, will often compress
greatly. (On occasion, a picture will compress more
successfully in GIF format, which is designed for artwork
with large areas of same color and graphics elements.)
• Use Progressive JPEG if you can. This presents a low-
resolution image initially and gradually improves it as the
file is downloaded. It gives viewers something to look at
while they are waiting.
• Make sure that the size of your file is precisely the same
size as it appears on the screen. If, for example, you use a
640 x 480 pixel image from a digital camera on the screen
as a 100 x 67 pixel image, then you should change the size

of the image file itself to save download time.
• Indexed color files are much smaller than full-color files.
Use them whenever possible since they employ a limited
palette of colors – typically, 256 colors or fewer.
Unfortunately, indexed color files are best for images that
are already small, but every saving in file size makes it easier
for visitors to your site. If you want to be sure of accurate
color reproduction for all Internet browsers, you need to
use indexed color of a more limited palette of 216 colors.
This is the so-called "Web Safe" or "Real Web".
• The standard gamma settings (not to be confused with
photographic gamma) for monitors differ between Apple
Mac and PC computers: PC gamma is higher than on a
Mac (typically 2.2 versus 1.8), so Mac images on PC look
significantly brighter – often too bright when viewed on
a Mac. Mac web-site authors know to change the gamma
setting on their monitors to simulate those of PCs.
• For advanced users, you can improve the delivery of a
page that contains text and pictures by quoting the pixel
dimensions of the image using the HEIGHT and WIDTH
attributes with the reference to the image file. This tells
certain types of browser software where to place text,
which it does immediately, giving the visitor something
to read while the images are being downloaded.

Exhibiting your work

◁ The dedicated exhibition space is the ideal location to show your work (here, the former Zamana Gallery in London), but such spaces are very rare and booking them is both costly and subject to stringent selection conditions and timetables. It helps to plan a long way ahead and to work closely with the gallery staff. Note that the frames have been hung to give variety and changes of scale, and that they are centered around a mid-line corresponding roughly to the height of an average person's eyes above ground – 61in (155cm).

Items to budget for

- Printing and processing prints – including materials and chemicals.
- Print finishing – retouching, flattening, and cleaning.
- Framing and presentation – mounting board, mat cutting, frames, and framing.
- Printing of invitation cards – also perhaps posters and catalogs.
- Venue hire costs.
- Cost of an opening reception – flowers, food, drinks, wages for part-time helpers.
- Insurance for pictures during the exhibition.
- Your time.
- Costs of trying to obtain sponsorship for the show.
- Contingency – put aside, typically, 5 to10 percent of the overall budget for emergencies – such as an out-of-hours call-out fee for an electrician when all the fuses suddenly blow.

If you are ever presented with the opportunity to show your photographs to a wider audience than your immediate family and circle of close friends, self-doubt could be your worst enemy. Put completely out of your mind any notion that your work is not good enough to show to the general public. If you select your images judiciously, then people will not laugh – but they may admire. So, if you have the urge to make an exhibit of yourself, then you cannot start planning for it too early.

First steps

You may feel you are not yet ready to launch yourself on the public. Ironically, this may be a decision that you are not the best person to make. So, the first step could be to ask a discerning, disinterested party to look at your material and to offer an opinion. If that person agrees there is a problem, then try to identify where precisely your work is inadequate – either in quality or subject matter – so that you can get on with fixing the problem.

The next step is to visualize the exhibition space. See in your mind's eye how it will be lit, and how your work could be organized to bring coherence, unity, and some sense of progression to the imagery. Should you, for example, lead off with your strongest, most dramatic images, or build up slowly, picture by picture, to some type of a visual climax. Bear in mind that members of the public will not have the same insights into the images that you have – all they can learn about them will be from what they can see.

Venues

Start to think about a suitable venue well in advance. Most of the popular galleries plan their shows at least a year ahead; others call quarterly or half-yearly committee meetings to decide what to exhibit. However, public places, such as local libraries, church halls, or council offices, may show work at very short notice. No matter what venue you aspire to, give yourself plenty of time to get your material together and to give venue organizers a chance to tie a concert, perhaps, or a lecture to your show.

Choose your venue with great care. Certainly, any public space could be used as an exhibition area, and some of these may even be more suitable for certain types of work than a "proper" gallery. Bear in mind that the very presence of your work will transform the space it is in, whether it is the foyer of a building, a shopping mall, or pedestrian walkway.

◁ A public space, such as this university foyer, can be transformed into an exhibition area safely and effectively by adding self-standing panels. Here, a radical solution of painting each panel a different color was chosen to enhance the transformation. Giving sufficient lighting to your work in such locations can be difficult. In this example, the problem was solved by using individual lamps over each panel. It was the best, but also the most expensive, solution. Another problem is the need to incorporate fire and safety regulations into the exhibition design. Be sure to consult the relevant authorities beforehand. Note that for economy and ease of transport, the photographs here have not been framed. Instead, they are flush-mounted (see below), and each picture is stuck on to the panels using self-adhesive pads.

Financial considerations

Mount the best show you can, but not one that costs more than you can afford (see box, left). It might be that your material will be of interest to an individual or organization prepared to offer some financial sponsorship. The secret is to work out what it is that you can offer them. The theme of your photographs may in some way be sympathetic to their products or services, for example, or you might need to persuade them that their image could somehow be improved by being associated with your work. Generally, however, it is easier to obtain services or products from sponsors than it is to obtain cash.

Final steps

Once you known where your show will be and how much you have at your disposal to spend, some people find it invaluable to produce some drawings of the layout of the exhibition space, including thumbnail sketches of the prints in their correct hanging order. For a complex show, consider making scale models out of colored cardboard to see how it all will work. The extra effort this takes could save you an immense amount of time and trouble by sorting out potential problems before you tackle the real thing. An accurate model eliminates errors in a way that checklists alone could never do.

As well as careful planning, you need to stay flexible in your approach. Don't, for example, leave crucial work until a weekend – where are you going to get a sheet of glass on Sunday evening? And when some unforeseen problem occurs, be prepared to alter your original plan.

△ You do not need to frame your photographs in order to to show them: an alternative is to flush-mount prints onto boards with a core made of expanded polystyrene, often called "foamcore", using apply-on adhesives or double-sided sticky layers. This is a very inexpensive solution: the results are neat although not robust, they travel easily, being lightweight, and are easy to attach to walls using any self-adhesive system. The method is to apply permanent adhesive onto the back of the print, flatten the print onto the foamcore, then trim the print/foamcore sandwich, using a sharp blade and steel ruler. That's all there is to it!

Copyright issues

Copyright laws have been devised to protect the rights of people who, through their artistry, intellect, skill, or labor, create an original piece of literature, musical composition, or any type of artistic work. Copyright protects the rights of people to control how their creations are exploited. This protection extends to the copying, alteration, publication, or broadcasting of their work and also allows copyright holders to assign their rights to another person, company, or organization. In essence, copyright law is designed to make sure that anybody who creates an original piece of work fairly benefits from any use that is made of it.

It is worth noting that copyright law covers only the actual form or the thing that has been created, it does not protect the actual concept of it – the underlying idea of what the work is all about remains up for grabs. There is also no reference in many countries' copyright legislation regarding the quality of the work in question – the artistic, aesthetic, or technical qualities are immaterial to the fact that copyright subsists in it.

You, as the copyright owner, normally exercise the sole right to make copies and commercially exploit what you have created. But you can also license somebody else to use it. A license agreement should specify precisely how, when, and where somebody else can use your material – between such and such a date, for example and in a specific geographical territory, such as the English-speaking world – and the amount of money to be paid for the privilege. As a photographer, you could, for example, license a publisher to use your work in a specific book title,

but that would not then give the publisher the right to use any of the photographs in that book on, say, a poster or handbill for the purposes of publicity.

In digital photography, one key problem is that of "substantiality", which deals with how much of a work can be copied or manipulated before copyright is infringed. A number of tests may be applied to arrive at a view as to whether using a part of somebody else's work in your own image constitutes using a substantial part of that work. Would the new work suffer artistically if the copied material were to be replaced by something similar? Have the best or most appropriate parts of that work been selected? Can the copied material be clearly identified within the new work? Has the work been copied in order to save time and labor for the person making the copy? If the answer to any of these questions is "Yes", then copyright has probably been infringed.

An issue related to copyright is that of the rights of the people you photograph. If you are taking photographs of a nude model or anyone's portrait and you think the photographs may be used commercially in any way, you should ask the subject's permission before you offer pictures of them for use. The standard way to do this is to obtain a model release: once signed by your model the release says the person depicted in the pictures allows you to use them for any purpose without any fee due to the model. To seal a model release as a legal contract it may be necessary to offer some payment to the model, however small, for the photography session. If the model is a minor, the release must be signed by a parent or responsible adult.

△ How important is the boy? He is a small fragment cloned from somebody else's picture and so is arguably a copyright infringement. On the other hand, it is clear that any other picture of a person sitting down would also work, and so the boy is not a vital element. The best course is always to take an image from a cleared source if at all possible.

△ How important is the girl? She has been copied from a Kenzo catalog, so the infringement is as clear as possible even if, as here, the use is arguably an artistic rather than a commercial one. The copyright owners may, however, be pleased that their products are featured, so it is worth asking for permission.

Guidelines

• If something is worth copying, it is worth something. This is a key test of whether some fee should be paid for any copying.

• Copying an image may in itself cause only trivial offense, but the injury grows with the use made of the copy. Using somebody else's image simply for your own filter experiments is a clear infringement of copyright, but the damage caused is trivial, particularly if you then delete the file. Using the image for a magazine illustration, however, is not a trivial offense.

• There is seldom any real need to assign copyright outright to somebody else. Granting a license is preferable, even if it allows for unlimited use and you promise not to use the image yourself. That way, the work still belongs to you and, should the assignee go out of business, the license lapses. If copyright assignment is essential, then make sure that you are handsomely rewarded.

• Placing your work on public view does not give anybody else the right to use it. But your images on free web space may be vulnerable.

• If you sell an original work, such as a book or photograph, you are not selling your copyright – only the physical object itself. The owner cannot then publish the image or exploit the words.

UNDERSTANDING THE TECHNOLOGY

How digital cameras work

This chapter of the book aims to answer some of the questions that are most frequently asked about digital photography and related matters. It is inevitably somewhat more technical in content than earlier chapters, but don't be put off if you don't understand it all – some of the concepts are difficult to grasp confidently, even for specialists. In addition, the field has grown so considerably and at such a rapid rate that the terminology has not had a chance to settle down yet, so some common terms have more than two different meanings depending on the context. And sometimes even the context remains undefined. As long as you get the gist of what is explained here, however, it will give you a sound basis for the greater understanding that will come with further reading and more practical experience.

Recording the image

The most commonly used sensor is the CCD type. This is a semiconductor device similar in construction to the computer chip itself, in other words, a silicon integrated circuit. Another type, the CMOS (complementary metal-oxide semiconductor chip), has been used in digital cameras with limited success. CMOS chips are easier and cheaper to make than CCDs, but they suffer from technical problems that offset the economic advantages.

A CCD works like this. Light falling on a sensor on the surface of the chip causes an electrical charge to build up under that sensor. The amount of this charge is proportional to the strength of the incident light, so that high light levels cause a higher charge than low light levels. This gives a measure of the amount of light in terms of the quantity of the charge produced, which is a reading for that sensor and thus a light reading for the part of the subject that reflected or generated the light being measured.

The reading for each sensor is read off, one by one, by transferring the charges down the line of sensors. This is exactly analogous to filling up a series of buckets along a line of people and then passing each one down the line and emptying it when it reaches the end, measuring how much is in each bucket. Once the camera reconstructs all this information – like painting by numbers, it fills each square with a color – it has a set of readings that represents the subject.

CCD arrangement

Two configurations of sensor are possible: a linear array and a grid or wide array. A linear array arranges the individual sensors on a line. Flat-bed and film scanners, as well as scanning backs for studio cameras, use this type of array – often in sets of three, one each for measuring red, green,

and blue. A grid or wide array arranges the sensors so that they cover a square or rectangular area of various sizes, but seldom more than 1in (2.5cm) across. Most types of digital camera use this sensor configuration.

Recording color

A grid of colored sensors is the basis of image recording. During image processing, the camera's on-board computer looks at the light values of each set of filters and allocates a color for each pixel based on the readings from all four (see caption, right). This is an interpolation – an educated guess if you like – of pixel values based on neighboring values. It follows that in, say, a million-pixel sensor, the resolution is effectively only a bit more than half a million because of the need for this color interpolation.

A good deal of the image quality stemming from a digital camera depends specifically on this process of interpolation, which must be programmed into the camera by skilled scientists. This means that a camera from one manufacturer may interpolate data in a way different from another manufacturer's camera. The need for interpolation at the level of the sensor also explains why certain artifacts, or faults, in a digital image are most obvious on bright/dark image boundaries or when sharp edges are depicted – the change between adjacent pixels is more sudden than the interpolation program expects it to be, so errors occur. Note that these artifacts are related to, but not the same as, aliasing defects or the jaggies (see opposite).

Fortunately, our visual perception is itself good at filling in information where it is lacking – for example, we fill in a small break in a continuous line if there is enough information and the surrounding tones will accept it. In short, our perception interpolates information, too.

Focal length equivalence

The definition of the focal length of a lens does not vary whether it is on a digital camera or on a conventional one. Indeed, it remains the same no matter what the optical system. In practice, however, it is useful to relate the field of view of an optic – how much of a scene or subject it encompasses – to its focal length. For this to work consistently, you have to compare the focal length of the optical system to the size of the record of the image, which is usually measured on the length of its diagonal. In 35mm cameras, the diagonal of the actual film format of 36 x 24mm is about 43mm, so a lens with a focal length

△ The CCD sensors are covered by an in-register set of filters colored red, green, and blue. Each filter fully covers just one sensor and no more. Since CCDs are generally square in shape, trying to distribute three colors over an even number of sensors is a tricky business. We know our eyes are most sensitive to green, and it turns out that doubling the number of green filters helps to improve the sharpness of the image. So the grid of filters consists of two green with one each of red and blue, covering the sensors in sets of four.

equal to this will give a normal angle of view – one that is approximately equal to the angle of view of a single human eye without impairment. Shorter focal lengths give wide-angle views – they see more of a scene – and longer focal lengths give narrower views magnified to fit the format.

The size of the sensor varies between digital cameras, with the most common size currently being about 8mm. For such a sensor, a lens with a focal length of 8mm will give a normal view. To compare this with the standard 35mm film format, you say that "the equivalent focal length is 50mm". The relationship is proportional, so if you want you can calculate focal length equivalents yourself using this formula: multiply 50mm by the actual digital camera focal length divided by the size (length of its diagonal) of its sensor. The result will be the 35mm focal length equivalent. Most zoom lenses on digital cameras are very modest in specification, with the widest angle of view usually being equivalent to 35mm, rarely 28mm, and the longest equivalent being around 120mm.

Digital zoom

Some manufacturers try to improve zoom specifications by offering users extra zoom effects in addition to the optical zooming produced by the camera lens. Digital zoom involves taking the longest focal length image, cropping it down in the camera's computer to a narrower view, and then resizing the image back up to full size. In short, it is another application of interpolation: no real information is added (indeed, a great deal is actually lost), but it looks as if you have a greater focal length at your disposal. In general, digital zoom remains a gimmick with limited usefulness until interpolation techniques leap ahead in quality. If you need a larger view of your subject, it is better to use image-manipulation software, since this facility offers more control and gives better results.

Wide-angle views

It is very difficult to obtain truly wide-angle or ultra-wide-angle views on digital cameras. The reason is that the camera sensors are very small – for a sensor measuring 8mm, a truly wide-angle effect needs a lens with a focal length of only 4mm. This is extremely difficult to engineer and represents new ground for optical designers, who have never had to deal with such focal lengths with the exception of certain medical equipment. The solution most often used is to attach a lens adaptor to the front of the main picture-taking lens to increase its field of view, usually at the expense of introducing distortion and uneven light distribution. A future solution is to use larger sensors.

Aliasing or the jaggies

These terms refer to the same defect, or artifact, of a digital representation of any continuously varying quantity. In digital photography, aliasing or jaggies refers to the appearance of a line or boundary that is, in real life, smooth or straight but in a digital image looks notched, uneven, or stepped – hence the other name for the defect, staircasing. This occurs because the digital representation is not detailed enough to depict the line sufficiently smoothly. For a comparison, look at the seconds hand of a clock: if it jerks from one second to the next it is not recording the intervals in between the whole seconds. Compare this with a seconds hand that sweeps smoothly around the clock face. It is able to show fractions of second. The stepped movement is not a true representation of the smooth flow of time – its jerky movement is like jaggies in a digital image, while the smoothly sweeping seconds hand is a more accurate representation.

In digital terms, aliasing occurs when the number of times a quantity is sampled or measured is not as often or detailed enough to represent that quantity accurately. The result is, therefore, not a true digital copy, rather it is an "alias". In fact, the rate or detail of sampling needs to be at least twice that of the finest detail that needs to be seen to avoid *visible* aliasing defects. It is obvious that since many things in real life vary continuously – the straight or curved lines of a car, for example – it means *all* digital images are aliased. However, in practice, what matters is whether we can see the aliasing or not.

Compressing files

Use the technique that makes the smallest files that are consistent with the quality that you need and in the format that is required by the end use (*see the table on page 48 for more information*). File-compression techniques work on certain images better than others: fractal and JPEG work best with images containing lots of detail, since it is the details that hide the defects. If you really want to learn about the subject, you can try different JPEG compression regimes (available as shareware), since some produce better results or greater compression than others.

Nonetheless, for best image quality do not use JPEG, GIF, or fractal methods since they are "lossy" (they lose data), and never compress a work-in-progress until you are done manipulating it. Opt for a lossless method such as LZW for TIFF files, or LZ77 for PNG files. Unfortunately, standard and universally available software techniques such as Stuffit have far less effect on image files than they do on other files, such as text documents. Note that compressed files take longer to open because you first have to uncompress them. Also note that some output devices, particularly those found in professional print bureaus, may choke on a compressed file. If you are putting work on the World Wide Web your image files must be in GIF, JPEG, or, for modern browsers, PNG formats – all of which use compression.

△ Insufficient resolution or sampling creates this jagged, staircase effect. Since the pixels are so large at a relatively modest magnification, it is inevitable that where, ideally, you want to see a smooth diagonal line, it will be broken up into jagged steps instead.

△ A far higher-resolution image than the one above, shown here at high magnification, displays the beginnings of staircasing on the wires of electricity pylons. At normal magnification, however, the defect is not at all visible.

How scanners work

You hold this book in your hand. What does the page say, what does it all mean? To find out you have to scan it. You start at the top line and start reading from the left. When you reach the end of that line, your eyes flick rapidly back to the left and start reading the next line. By the last line, you can construct the whole sense of the page from the meanings of the individual words and sentences. What you have just done to the page is in essence what a scanner does to your images – it systematically looks at and breaks them down into separate elements and then reassembles them.

A scanner starts at one corner of an image and reads off information from it in horizontal strips – rather similar to reading lines of text. Typically, your scanner will have sensors set up to read red, green, and blue light, which register information about how much of each colour there is in each part of the image. When the scanner has read off all the "lines" of the image, it has a file consisting of a digital representation of it.

Just as you can cram more information into a page if you use small type and tightly spaced lines, you can extract more information from an image if you scan it in very tiny steps, thus analyzing the image in very small portions. How much information and how much detail are captured by the scanning is measured by a specification called "resolution" (see pages 140–1).

Image scanning

Scanners record both the location of each element of the image being measured and the colour information it contains. These elements, or parts of the image, are called "pixels". The stream of data produced when the scanner is analyzing a black and white image consists of the location of each pixel (as with any image) plus brightness.

The location of a pixel is easily measured, since it corresponds to the position of the scanner sensors at the time of the reading. The colour information comes from the photosensitivity of the sensors – they behave as if they were light meters. During scanning, a light source shines on the original (or in the case of a film scanner or flat-bed scanner with transparency adaptor, through the original). Where the original reflects (or transmits) a lot of light, the sensor will register a high reading, and a low reading will likewise correspond with a dark part of the image. In order to cover the original, the sensor is driven, step by tiny step, over the whole length of the original. In a scanner with a resolution of 1,200 x 1,200ppi (pixels per inch), the scanner makes 1,200 steps per inch over the length of the original, while across its width, 1,200 sensor elements will be examining each inch of it.

A complete scan involves making up to three separate steps. A pre-scan quickly provides a low-resolution preview of the original, allowing you to make cropping adjustments and, with some scanners, to adjust colour balance or tones. The final scan is slower than the first and works at the full resolution you have set. Scanners that scan a batch of slides or a film strip make an indexing scan prior to the pre-scan to identify the images being scanned. You may encounter largely obsolete so-called "three-pass" scanners – these perform the final scan in three steps, one for each of the red, blue, and green components of the image.

Scanner controls

Scanners are controlled by software known as "drivers". Driver software must be installed on your computer before the scanner will work. This is easier on Apple Mac computers than on PCs. Drivers are of two types. Stand-alone drivers work as a program in their own right, and the resulting file will have to be opened up in separate software before it can be used. Plug-in drivers work from within an application software, such as Adobe Photoshop. In this case, the resulting file is "imported" into the application, ready to be used. In practice, most scanners provide for both options, and the controls for both look the same.

Bear in mind that scanners from different makers may actually be identical machines, the only difference between them being the driver software. If you can, try out the driver software before you make a purchase – some software is far easier to use than others.

Scanner types

Practically speaking, there are just two types of scanners: those you can afford and those you cannot. Inexpensive scanners perform the job acceptably well, while expensive ones do a really good job. However, prices continue to fall and quality is steadily improving. For the photographer, the design of scanner that gives the best balance between image quality and price is the 35mm film scanner. These are dedicated to the 35mm film format, plus APS

◁ Scanner drivers enable you to set parameters, such as the resolution and, in some cases, the specification of the resulting file. Driver software should also allow you to make adjustments to the colour and tone of the image before you make the final scan. The amount of control you have varies greatly depending on the software. You should try to make the scan produce a file as close to perfect as possible, since this saves you work later on. The controls shown here are for the Nikon CoolScan LS-2000.

(Advanced Photo System) film with an adaptor. To use the scanner, you feed in film strips, or mounted slides, into a slot in the front of the machine. All film scanners will scan transparency or negative film in both black and white or color. Scanners costing about the same as a high-quality zoom lens are able to produce scans good enough for publication enlarged to at least A5 size. Doubling that purchasing power buys you a scanner that gives full A4 size at publication quality. In fact, most of the images in this book were scanned on a film scanner that costs about the same as a professional camera body.

Inexpensive film scanners offer a resolution of up to around 1,200dpi. For reproduction quality to A4 size from 35mm slides, you need a resolution of at least 2,700dpi. If you need to scan APS film, check the price of the accessory adaptor – it may add considerably to the total.

If you want to scan prints or illustrations (*see page 132 for information on copyright*) you need to use a flat-bed scanner, which looks like a photocopier. Prints to be scanned are placed face down on the scanner's glass bed. Many flat-bed scanners take a transparency adaptor so that transparent originals can be scanned.

Inexpensive flat-bed scanners work to resolutions of about 600ppi. However, the advantage of flat-bed scanners is that they allow you to start with very little outlay. For the cost of only some twenty rolls of color slide film, you can buy a scanner that is more than adequate for work to be published on the World Wide Web.

Bit depth

Scanner manufacturers use various figures to specify their machines. The figure called "bit-depth" – for example, " 36-bit depth" or "30-bit color" – refers to the way color information is encoded. Lower bit depth can distinguish fewer colors than a higher figure. Needless to say, the reality is somewhat more complicated since a good deal depends on how the manufacturer allocates the available code to different densities. For good-quality photographic work, it is advisable not to accept less than 24-bit.

D-max and density range

Scanner resolution is not the only specification to consider when choosing a scanner. Another figure to look out for is D-max, which relates to the maximum density that can be measured; the higher this is the better. A high figure means that the scanner is able to extract information from the dark areas of the original. If it cannot – if it has a low D-max – then shadows will look rather flat and lacking in detail.

Higher D-max figures are associated with better scanner models because the basic lighting arrangement in flat-bed scanners is prone to flare, which takes very careful design and manufacture to reduce. As photographers know, an optical system with a lot of flare cannot record a proper

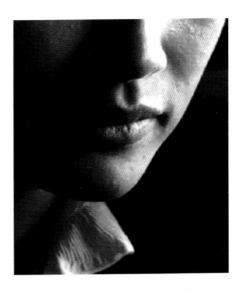 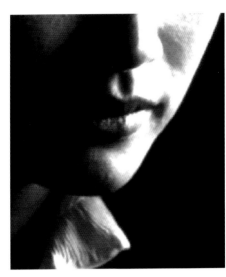

△ *When choosing a scanner, look for a high density range and a high D-max figure. In the first image* (above left), *a good scanner has picked up details both in the highlights of the face (good density range) and in the shadows (good D-max). Note how in the poorer scan* (above right) *there is no detail to be seen in either the highlights or shadows.*

black – and so it is with scanners. There is another type of scanner: the drum-scanner. This offers a considerably better D-max performance than any other type of machine and so is used for the best-quality reproduction. Unfortunately it is too expensive for all but professional laboratories to install.

Another figure that is important is the density range, which is the measure of the spread from brightest and darkest that the scanner can work in (*see caption, right*).

Scanning size

When selecting a scanner, make sure to buy an instrument that can scan the largest common size of original. With film scanners, a 35mm maximum will suffice for most photographers. If you want to scan the occasional larger format, it may be most cost effective to send it to a bureau or laboratory rather than buying a medium-format scanner. Likewise, an A4-sized flat-bed scanner will suffice for most work since it will scan up to the most popular size of 8 x 10in (20 x 25cm) prints. A3 scanners cost a lot more and are not a good value if they are only occasionally used.

It is worth noting that the size of the original that can be scanned when a transparency adaptor is fitted to a flat-bed scanner is reduced. For example, a scanner able to handle A4 originals – about 8 x 11in (20 x 28cm) – by reflected light will cope with transparent originals only up to a size of about 8 x 10in (20 x 25cm).

Other uses

In addition to using the scanner as a camera (*see pages 48–9*) to generate an original image, using suitable software (often bundled free with the scanner) you can turn printed text into word-processor files. The software uses scanner data to identify patterns of print as letters and translate them into a form that word-processor applications can work with. This can prove to be a real asset in the home office – once paper documents have been translated into digital form they take up far less space, and they can be easily cataloged, and rapidly retrieved.

Managing color

Almost everything written on color management starts by explaining that computer screens create color in a different way from, say, ink-jet printers, and that is why problems with color reproduction occur. In fact, even between two printers of the same model there can be problems with matching color reproduction. And every careful photographer knows that boxes of the same film or paper will vary in their response to exposure. In digital photography the problem of accurate color reproduction has become worse, not easier. The reason for this is the variety of different ways of simulating color – for example, a computer monitor uses phosphors that emit light, whereas a printer uses inks that absorb light.

Importance of color management

Good color management saves you time, materials, and aggravation. Photographers demand computer printouts that match their original photographs. It is not enough to translate darkroom practices for the computer since the technical aspects are far more complicated with digital systems. The typical flow of work is that you make a scan of your image and download it into the computer to work on it. You might print it directly or send it to a laboratory or a magazine publisher. If your color system is calibrated to a standard shared by everybody else, you can be confident that prints made by anybody will look much the same.

Calibrating monitor and printer

In practical terms, colour management for individuals with a personal printer boils down to matching the image on the screen with the output from the printer attached to the computer. For those with darkroom experience, this is exactly like matching a test print and the final print by adjusting the enlarger settings. Once you have the match, however, you can forget about the enlarger settings since they are no longer of any consequence; provided everything is left unchanged, all further prints you make will match each other. Finding the settings that create this match is the process of calibration.

First, set up standard conditions. The monitor should be warmed up for at least thirty minutes before you start, and the printer should have a used, but not exhausted, ink cartridge. Load the printer with the paper stock you normally use for good-quality prints. Finally, decide on a standard lighting for the room – technicians recommend a darkened room but that is impractical for most of us. Pull the curtains and turn on a desk lamp, but don't shine the light directly on to the screen.

Next, the monitor screen should be adjusted to its normal settings. These are available either as on-screen settings, which you access through buttons on the monitor, or through software controls found in the computer's control panel. If the normal settings leave the screen too dark or too bright, make adjustments until it is comfortable to look at. If the system or software allows (all modern Apple Macs do), set the monitor to a Gamma of 1.8 and a white point of D65 – also referred to as a viewing color temperature of 6500 K (Kelvin).

Now print out a good-quality image file, preferably one you have scanned and color-corrected yourself to your own satisfaction. Of course, it should be a scan from an original with a good range of colors, including blacks, neutral grays, and white. Needless to say, the print should be as good as you can make it.

Now compare the print in good light with the image on the screen. They will probably look quite similar, but the may differ in color balance or contrast. Now you need to adjust the monitor's settings. Again, work the controls either through software or, preferably, directly on the monitor itself. Try first to match the contrast, then the color. You will not be able to match every color: if you can get the black, the white, and the grays to match, you will be doing well. Don't worry when you find that changing colors also changes the contrast. Take your time, and try all the controls to see what effect each has.

Once you have the settings you are happy with, make a note of them or tape the buttons to make sure that you do not change them again for any reason.

This procedure is not technically the most correct way of working, but it is the easiest. It does assume, however, that you will not be exchanging files with anybody else for that person to work on or to print out.

◁ The importance of being color-calibrated can be seen here. The first image (far left) represents the screen image (within the limits of the printing process): the colors are vibrant and the whites clean. The next image (left) represents a typical printed version. It is less contrasty and less bright, with the whites taking on tone from the support material. Careful calibration ensures that what you see on screen is what you get.

Scanner calibration

You can take the above calibration one step further by matching your scanner's results to the system. You may notice that with every scan you make, you have to increase the brightness of the file and reduce the red. So why not set up the scanner so that the brightness is higher and red is reduced as it comes off the scanner?

Most scanners have driver software that allows you to load settings and corrections. Using your standard target – a color print, for example – make some sample scans at different settings. Use more green for one, and less red for another, and save each setting with the same name you give to the resulting file. Then open up the files to see which one needs the least amount of correction. This tells you the setting that produced the best result. Delete all the other settings, and use this as your standard. Of course, if you scan in a different type of original, you may need a different set of settings, arrived at via a fresh round of calibration.

Further calibration

As soon as your work extends beyond your own setup, however, you will need to work with recognized color standards and ICC profiles that work in color management system (CMS), such as Apple's Colorsync. The idea is that each image file carries, or embeds, an ICC "profile" belonging to the machine from which the file originated. When the file is used by another computer, the profile is read and adjustments made automatically to ensure that the colors seen on the first monitor match those on the other monitor.

As a general guideline, work as follows. Use ICC profiles if you can, and work to a profile that is specified by your printer, studio, or with whomever else you work. As for RGB space, prefer an industry standard, such as SMPTE-240M. And, as has been explained earlier, work to a color temperature of 6500 K and set a gamma on your monitor of 1.8. If you require further details or explanations, consult any Adobe Photoshop book mentioned in the bibliography at the back of the book (see page 156), but also look at the instruction manuals of your software application.

Color gamut

A gamut is the complete range or scope of something, so a color gamut is a complete range of colors. In digital photography, color gamut refers to the range of colors that can be accurately reproduced, recorded, or projected by a given system.

Paradoxically, the widest range of colors can be reproduced by systems, like those in a color monitor, using just red, blue, and green. The other equally important color gamut is that of printing inks, or the CMYK color gamut. This is much smaller than that of color monitors.

From this arises the concept of "out-of-gamut", in which a color that is reproducible on one system cannot be accurately reproduced on another. Suppose you see a bright blue, deep purple, or brilliant scarlet color on your monitor. You will be disappointed if you hope to print such intense hues on an ink-jet printer since these colors are out-of-gamut on this type of output device.

Millions of colors

Not to be confused with the term "color gamut" is the term "millions of colors", the latter being a measure of how many different colors can be shown by a color monitor. A monitor that can show only black or white, would be said to be a two-color monitor. Early color monitors showed up to 256 colors – enough for graphics but not for realism, which requires thousands of colors. For digital photography, you ought to run monitors capable of showing millions of colors, often quoted as 16.8 or 16.7 million colors. Another way to specify this is to use the term "bit depth" (see page 137): a bit depth of 24 is needed to describe millions of colors. Most modern monitors can show millions of colors, but you will need hardware, such as video cards in your computer, to display all of them. Such a range of colors places heavy demands on the computer, which may result in slower scrolling and screen refresh rates when working to a large bit depth without specialist hardware.

◁ A generic diagram of an ideal color space looks like this. The sphere encloses all the colors possible. One axis, in this case the vertical one, runs from lightest to darkest – from white to black – and has no color. At right angles to this is a straight axis that runs from red to its complementary color, green. The third axis is at right angles to both and goes from yellow to blue. Thus, the equator of this sphere carries all the pure color, the center of the sphere is correspondingly middle gray. From a model such as this, you can visualize color relationships more easily than with verbal descriptions alone. Similar models may be made for other color spaces, and each has its unique advantages and disadvantages.

Color space

An abstract construction or model that represents all the colours that can be reproduced by a given color system is called a color space. All but one common color definition uses three parameters, or factors. For example, RGB space defines colors in terms of their red, green, and blue content. HSV defines a color in terms of its hue, saturation, and value (brightness). If each parameter is regarded as an axis, then three axes naturally define a three-dimensional space. Thus, the RGB color space will "enclose" within it all the colors that can be reproduced in a given system.

This concept enables you to compare color spaces of one system against those of another, and it is then easy to see where one system may be deficient and how best to account for that deficiency when translating from one color system to another.

Unraveling resolution

If this is the first section of the book you have turned to, it is not surprising as more inaccurate, self-contradictory nonsense is written about resolution than about the rest of digital photography put together. To avoid being drawn into the confusion, you have to keep a clear head and bear in mind that there are two processes that use the term – but they use it in two distinct and incompatible senses. (There is also a third sense, which is covered below.)

One process is the input stage of digital photography – typically the scanning-in of images or their capture by a digital camera. The second process is the output of a digital file, such as that from an ink-jet printer.

Input resolution

At the scanning stage, input resolution is a measure of the amount of detail that the scanner or other input device can capture. So, a resolution of 600ppi (points per inch) means that the scanner looks at 600 equally spaced points along each linear inch of the original, and for each of those points it works out the color information. But a scanner has to cover a two-dimensional area. So over one square inch, the scanner will look at 600 points on the width at a rate of 600 times along the depth. The total number of points it examines is, therefore, 600 times 600, which gives 360,000 points or picture elements, called pixels, per square inch.

So far, what the scanning has done is to divide the original into a regular grid, or array, of picture elements. The important thing to realize is that these picture elements or pixels can be output to any size whatsoever. But whatever size they are output to, there is still the same number of them unless you choose to change the resolution.

This is particularly pertinent to the digital camera. Here resolution is not expressed as a density – so many pixels per inch – but as a simple number of pixels. This is because the physical sizes of the sensor and its individual components are not relevant here. A digital camera resolution might be quoted as 1,280 x 960 pixels. This means that the sensor delivers 1,280 pixels on the length of the image and 960 pixels on the width, making the total number 1,228,800.

Pixel sizes

It is when you come to output these pixels that you need to decide on their physical size. Using a chess board as a model, if each square is 1 x 1in in size, you will have a chess board that measures 8in square. If we shrink each square to an eighth of an inch, the board shrinks correspondingly to 1in square, and if we expand each square to one mile wide, our chess board grows to a gigantic eight-mile wide board. However, the number of squares – and its resolution –

stays exactly the same, whatever the final size of the board. The same principle applies to the number of pixels in an image. The pixels remain the same in number, but you can expand them to cover the side of an airplane or else shrink them to fill a postage stamp. The original input, or scanned-in, resolution stays resolutely the same unless you specifically change the file size. To reiterate then: the size of the digital file also stays the same, irrespective of the final output size of the pixels.

Device resolution

Before files can be output it is necessary to consider the specifications of the output device being used. Resolution of an output device such as a printer is a measure of how many points on a page the device can work with in deciding where to place a spot of ink or toner. This definition has nothing to do with input resolution – in fact it does not even mention image detail. The key point is that a printer must know where to place a particular dot of ink: this is called an addressable point. Resolution in this context measures the density of addressable points – for example, a printer resolution of 720dpi (dot per inch) means that a printer knows where to put an average of 720 dots of ink over each linear inch. Obviously, the more addressable points a printer has to play with, the more detail it will be able to print. This is analogous to fine-grain film being able to show more subject detail than coarse-grain film.

However, if a printer has a resolution of 1,440dpi this does not mean that it can show detail as small as $^1/_{1,440}$ in (see Printer resolution, pages 142–3).

Input and device resolutions

It is now appropriate to bring the concepts of input and device resolution together. Input and device interact to produce the output, and the measure of how much detail can be produced by an output device is known as the output resolution. It is measured as lines per inch or per millimeter (the reason for using "lines" is partly historical).

△ Pixel size affects file size, but increasing picture resolution does not create extra detail, even if the pixels themselves are smaller. The image of a pipe (above right), measured 4 in (10cm) across at a resolution of 72 pixels per inch, and it is clearly pixelated. By changing to 300 pixels per inch (above left) but leaving the image the same size, resolution has been increased. The image has been considerably smoothed out but no more detail can be seen. Note that in the pixellated image there are larger squares in addition to the small ones evident around the pipe. The larger squares are the clusters created by JPEG compression, which are most evident in areas of even tone. Near the pipe, there also numerous artefacts created by the JPEG regime.

◁ *In this diagram, the original image is represented by the black line. It varies smoothly from a high value (for example, brightness) to a low value (for example, darkness) and back up again. It could represent the changes across a blurred detail going from the bright area into a dark one and then out into brightness again. The red line represents an inadequate digital representation of the original – it is not smooth and it is inaccurate in many places, particularly where the line changes direction. This is because it takes samples from, or measures, the original too infrequently, thereby missing changes until after they have occurred. The blue line is much better because it samples at twice the rate of the red one. Therefore, it is more accurate and smoother in appearance. It is clear that since the original is sampled more often, the digital representation approaches the original.*

So why is it different? At one level, the maximum detail you can print out or show is set by the device you use. For example, suppose you know that from the image side, you are putting in information at the rate of 100 pixels per inch. But suppose you are using a device than cannot address more than 72 dots per inch. In outputting the image, you will obviously miss out a lot of detail. However, the amount of detail actually shown must depend on how much detail you have put into the machine – if it is less than the machine can deliver, your image will not be more detailed. Note that there is another factor, and this is that much of the device resolution goes into creating half-toning – the smooth gradation from white to black (*see page 142*).

Resolution in practice

Our fundamental unit is the pixel: all questions relating to our image's resolution or the size of its printout will depend on the number of pixels in the image as it was originally scanned or captured. Now suppose the pixels are the same size as in the original: if we were to output them without change, we will obviously get a print that is the same size as the original.

It is not convenient to change the individual pixel size (e.g. enlarging from 0.0001 inch to 0.05 inch is clumsy and prone to error), so the convention is to refer to output by the number of pixels or dots per inch. Thus, if you have an image that is 2000 pixels long, an output of 200 dots per inch will yield an image 10 inches long (2000 divided by 200). This figure is an output resolution in the sense that it gives us a measure of how much information is being put into the print. Note that it is not a measure of how much detail can be delivered by the printer or other output device itself.

The easiest way to control the output size is to change the image size. But there are technical considerations due to the so-called "quality factor". This is a rule says that the ratio between the input resolution and the output resolution should be at least 1.5 and ideally 2. That means that, taking your files at their final reproduction size, you should have 1½ pixels for every line or dot in the print.

If, for example, the print resolution is 133 lpi (lines per inch), your image should have about 200 dots per inch. However, you may find it easier to follow guidelines such as those on page 50. Image-manipulation software, as well as most drivers for scanners, will carry out the requisite calculations for you.

Lens resolution

At this point it is necessary to revisit the notion of input resolution. It has just been described how a mismatch in performance between two systems working together can "waste" the resolving power of one of them. The input resolution was set by the number of pixels on the sensors. But so far the resolution of the image falling on the sensor has not been considered.

We must consider the contribution of the optics projecting the image: essentially, the total resolving power of the system of sensors and lenses depends on the resolving powers of the two taken together. The tiny CCD chips with their densely – and ever more densely – packed sensors, place heavy demands on optical design. Lenses must have extremely high resolving powers to make use of the information potential of the sensors. The second-generation digital cameras from Nikon, Minolta and Olympus are as remarkable for their superior optics as for their electronic technology.

You may be wondering why larger chips are not made – after all, this would also solve the problem of not having true wide-angle lenses for digital cameras. Unfortunately, as CCDs become larger, they also produce far much more "noise" – unwanted electrical signals. The resulting noise is difficult to filter out and makes a mess of interpolation calculations.

Finally

Just as in photography, the amount of detail that can be reproduced in the final output depends on the entire chain of processes leading up to it, from image capture right through to output. This includes such factors as the type of paper you use to print on (*see pages 142–3*).

△ *A comparison of two printer outputs using highly magnified views are shown here, both using CMYK (cyan, magenta, yellow, and key, i.e., black) inks. Both images are printed to the same resolution. Although one printer uses a finer dot of ink and lays it more densely – in other words, its output resolution is higher – than the other, the printed result actually looks very similar. There is no substantial difference in the detail printed out because the data used to make both prints were identical.*

How printers work

Of all the developments that have made digital photography so readily accessible, it is ink-jet technologies that stand out above the rest. They have given us a darkroom on the desktop by presenting the most remarkable quality for money. For less than the cost of about forty rolls of color film, you can have a printer that gives you very nearly photographic quality prints almost A4 in size. Another twenty rolls buys you a printer capable of printing to A3 size. Certainly, at first glance, a well-made ink-jet print looks like a photographic print. And to make it would have taken at most 15 minutes of printing time, working at a desk-top with no chemicals to mix, no room to darken, and no enlarger to set up.

The key to how it works is high-volume miniaturization. Printer manufacturers can make printer heads relatively cheaply because they sell very large numbers of them, and because a high volume of sales generates income, it can be spent in making precise, ultra-miniature components. As a result, it is commonplace for printers to be able to place upward of 1,000 separate dots per linear inch (dpi), and without sacrificing printing speeds. Modern printers achieve output resolutions a hundred times better than earlier versions yet they are no slower to print.

Ink-jet printers

The most popular printer technology is the ink jet, which squirts tiny droplets of ink in precise locations on to the paper. One way of doing this is to heat up rapidly the ink lying in a nozzle facing the paper. This causes a bubble of gas to develop – in fact it boils the ink. The bubble pushes out a drop of ink, which squirts onto the paper. Another technique uses a piezo-electric crystal, which is a substance that changes its shape under an electric charge. The crystal lies in a nozzle containing ink and when it is charged, it flexes and squirts out a drop of ink. These two technologies are used on desktop printers. There is another, used on industrial machines, that uses a continuous flow of ink that is deflected onto the paper as it is needed.

The nozzle technology is not the end of the story. Each printer head will have its many individual nozzles fed with colored inks. For photographic work, the usual four inks are inadequate. A machine with a six- (or more) ink system is best, in which, for example, a light cyan and light magenta or orange and green are added to the usual four colors of cyan, magenta, yellow, and black.

Dye-sublimation printers

Another technology is the dye-sublimation printer. This type uses solid dyes held on a ribbon, which is heated while it is nearly in contact with the paper. The dyes vaporize, or sublime, and transfer on to the paper. This system is used in very small printers that can produce near-photographic quality, as well as in larger, professionally priced machines. One version, the MD-1300 Printer, made by ALPS, can give extremely high-quality images to A4 size at a cost only slightly higher than that of an ink-jet.

Printer resolution

What exactly is really meant by printer resolution? A modern printer can put down some 1,400 separate dots of ink per linear inch. However, not all of them are available for defining detail. The reason is that most printers have no control over the strength of the color they lay – for a given spot on the paper, the printer will either squirt ink or not. So it uses groupings of dots in order to simulate the effect of a gray scale – to create a realistically smooth gradation from white to black. This is called half-toning.

Suppose you were to look at a chess board. Seen from a distance, the equal numbers of black and white squares blur together and give the impression of a mid-tone gray.

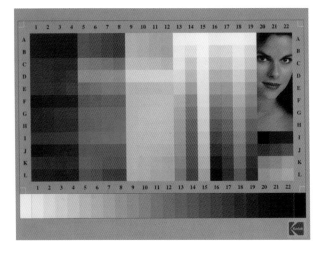

◁ *Far left: If you want to test printers and scanners alike, you need a standard color target, such as the one presented here, which shows a range of colors printed at different densities.*
Left: An extreme closeup view of a print that, at normal viewing distances, is acceptable, shows that it is in fact marred by blotching or the pooling together of adjacent dots of ink into larger dots. This diminishes the sharpness of detail and reduces the smoothness of tonal gradations. Good-quality ink-jet papers reduce this problem.

As more and more of the squares are colored in, the overall appearance will darken, or vice versa if the black squares are painted white. Each time you remove or add a black square, the overall chess board will represent one gray level. Since there are 64 squares, 64 levels of gray can be represented by a square with eight squares on each side.

In fact, at least 200 gray levels are needed to give a good representation of a continuous gradation of tone. Therefore, a printer must collect a number of dots of ink together just to represent gray levels. This process reduces the detail that can be printed. In practice, an actual detail resolution of around 200dpi meets most of requirements. If the printer can lay, or address, 1,200 dots per inch, then it has some 6 dots for creating the effect of continuous tone. Now, if you multiply together the four or more inks, you can see that a good range of tones and colors can be reproduced.

The mathematics of this are extremely complicated and must involve many subjective factors. Increasing skills in this area are inexpensive to implement since all the manufacturers need to do is rewrite the software that controls the printer. This is how printer manufacturers can now make the most of the available printer technology and provide for their fortunate customers superb-quality printers at knock-down prices.

Controlling the printer

The computer uses special software provided by the printer manufacturer to control the printer – it takes a great deal of computation to turn your image into something that fits neatly on the page with the right amount of color. In addition, printer drivers present controls for you. For digital photographers, one important feature is how completely the driver controls the quality of the color output. Some drivers "enhance" the color reproduction without warning you; others give you control almost to professional standards. An important convenience feature is to able to maintain the printer from the computer – for example,

to check the level of ink and alignment of the printer heads – rather than having to press buttons on the machine.

Paper

However, the printer is not all of the story there is to tell. To make the most of your printer, you must choose your paper with care. The best-quality, high-gloss films for ink-jet printers give the sharpest results and most intense colors. However, you may find them flimsy to handle and that the gloss finish is too mechanical for informal use. For so-called "photo-realistic" results, there are many heavyweight photo papers that handle like photographic prints and have gloss, textured or semi-matt finishes similar to real photographic prints.

When choosing papers, you should check how quickly they dry after printing: some need several hours, while others are dry straight out of the machine. Some papers have a very delicate surface when they have just been printed: this surface may pick up marks from the rollers of your printer. Smudging from dampness can also be a problem – modern papers are much more resistant to water than before, but it is better to test first. For these tests, you can usually purchase a sample packet of papers from a manufacturer.

You can also experiment with using other types of paper, such as water-color cartridge paper or hand-made papers, and even ordinary photographic paper. The results will vary widely; the results may appear very blotchy – as shown in the example below – as these papers do not have receiving layers specially designed for ink-jet inks.

Permanence

The Achilles Heel of ink-jet performance is the big question-mark over its permanence. The safest course is to assume that no process is permanent, and that all digital processes are less permanent than those from silver-based prints, including color prints. (*For further discussion see page 125.*)

◁ *This is a comparison of actual print outputs.*
Far left: This print is not sharp. The paper has not controlled blotching at all well and, if you look at the lettering, you can see that it cannot hold detail either. Left: This print is excellent, holding both detail and dark colours very well. This paper is also physically attractive to handle. Notice how both printers do not accurately reproduce the original standard shown on the opposite page.

Other output

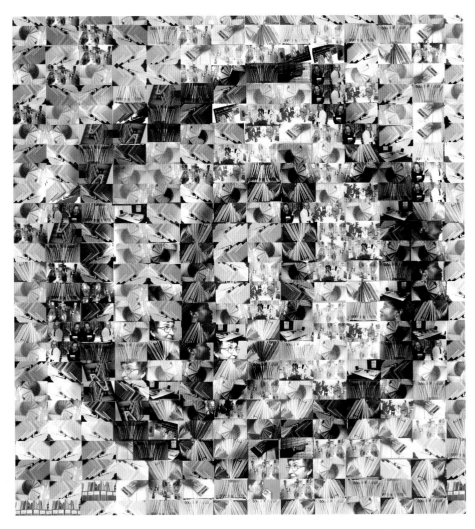

△ A mosaic of a small number of images can be used to create a company logo, in this case of Charities Evaluation Services Ltd., the company that commissioned the image. Since the logo was to be displayed in a brightly lit office, the print had to have fair resistance to fading. It was decided to output it to normal photographic color printing paper. This was done using a machine that interprets the digital file to shine, line by line, different intensities of red, blue, and green light on to the paper (the opposite of scanning) until the whole sheet is covered. The paper is then processed in standard colour chemistry. This technique allows banner-size prints to be easily made.

◁ Images made in a computer look slightly different in real life – despite all the precautions you take to ensure accurate reproduction from monitor to print. For an exhibition, I wanted the depth of color and robustness of print that only color reversal paper gives. The digital files were first written to slide film in a film-writer. The film was processed normally and then printed in the darkroom. It requires great effort, but the results are worth it. The darkroom process allows you to finely tune the tonal balance of the image. Viewers will notice the difference – the quality is still significantly above that of any digital print.

In the rush to dominate the digital domain, it is wise not to forget the roots in conventional photography that have sustained you. While digital prints are excellent and effective, the standards by which they are judged are still those of the conventional photographic print. There are advantages to working within the digital processes right up until the end, when it is wise to think about outputting material to conventional film or paper.

There are two main routes available, both provided by professional laboratories. There are machines that will take a digital file and write it directly, using a laser beam, to conventional color paper, which is then chemically processed in the usual way. It is possible to make poster-sized prints in this way with longevity as good as that of conventional color papers. The only limits are the size of your file and the paper-handling abilities of the machine. Another advantage in outputting to conventional materials is that the printed image does not rely on half-tones, but on the nearly perfectly continuous tones produced by the dye-clouds in the paper's emulsion. This has the effect of smoothing out the boundaries between pixels with the result that images appear to be of much higher quality than if they had been printed on an ink-jet printer.

The other route is to write a digital file to film and then use it to make prints or a projected image. Film-writers are highly specialized pieces of equipment, whose survival is threatened by the advance of printers – but they do have a unique role. Given sufficient data, a film-writer can create a slide or negative that is almost indistinguishable from a true camera exposure. To do this, the file is displayed on a high-precision TV monitor with a perfectly flat display showing only black and white, with a resolution of 3,000 or more lines. The image is shown line by line and on one color channel at a time. To create a color image, a filter wheel with red, green, and blue filters rotates between the screen and a camera pointed at this screen. The camera can hold different formats of film depending on its design. During the exposure, the camera's shutter is held open for the many minutes it takes to display the file, one line at a time, one color separation at a time. The exposed film, which can be for color slides or prints, or black and white negative or positive, is then processed normally.

Once processing is finished, you have an ordinary film original to use. But who would want to take this laborious route? First, it produces high-quality slides for projection. Second, you can make prints and thus exercise another level of control over tone and color balance. In addition, you also obtain a more permanent print, which is important when you remember that the long-term behavior of a digital print is unpredictable.

GLOSSARY OF TECHNICAL TERMS

GLOSSARY OF TECHNICAL TERMS

16-bit
Measure of the size or resolution of data that a computer, program, or component works with. A 16-bit scanner, for example, works to a color depth of 16, giving thousands of different colors.

24-bit
Measure of the size or resolution of data that a computer, program, or component works with. A 24-bit scanner, for example, works to a color depth of 24, giving (in theory) millions different colors.

2D
Two dimensional. Usually taken to define a plane having height and width only.

3D
Three dimensional. Usually taken to define solid objects.

8-bit
Measure of the size or resolution of data that a computer, program, or component works with. A 16-bit monitor, for example, works to a color depth of 8, giving hundreds of different colors.

9300
White balance standard close to daylight: used mainly for visual displays, since its higher blue content (compared to D6500) gives better color rendering in normal indoor lighting conditions.

A

accelerator
Device designed to speed up a computer by, for example, providing specialist processors for specific software operations.

ADC
Analog-to-Digital Conversion. A process of converting or representing a continuously varying signal into a set of discrete, digital, values. For conversion to take place: **1** The source signal must be sampled at regular intervals – the quantization rate or interval. The higher the rate or finer the interval, the more accurately can the digital record represent the analog original. **2** The quantity or scale of the analog signal must be represented by binary code – the bit depth: the larger the length of the code or greater bit depth, the more precisely the values can be represented.

additive color synthesis
Combining or blending two or more colored lights in order to simulate or give a sensation of another color. Any colors may be combined. For effective color synthesis, three primary colors are needed: for example, red, green, and blue. Note: colors synthesized additively are most vivid (saturated) when they result from combining a pair of primary colors; if another primary is introduced, color becomes less saturated; lightness of color varies with the intensity of primary colors; an equal mix of the three primary colors produces white light.

address
Reference or data that locates or identifies the physical or virtual position of an item – for example, memory in RAM, a point in space such as a dot from an ink-jet printer, and so on.

addressable
Property of a point in space that allows it to be identified and referenced by some device – for example, a laser printer that can print to 600dpi can address only the 600 or so equally spaced points that lie on a line 1in long; nothing lying in between these points can be addressed.

algorithm
A set of rules that defines the repeated application of logical or mathematical operations on an object.

alias
1 Literally a representation or "stand-in" for the original continuously varying signal or object – for example, a sound that is the product of sampling and measuring the signal to convert It Into a digital form. **2** In Mac OS, a file icon that duplicates the original: like a shortcut in Windows, but more useful.

alpha channel
Unused portion of a file format.

alphanumeric
Type of display or data that permits use or storage of both letters and numbers.

analog
Effect, representation, or record that is proportionate to some other physical property or change. For example, analog signals vary proportionately to the physical change they represent, so high power is represented by a higher wave form. Analog records are based on changes proportionate to the effect being recorded. For example, higher silver densities represent brighter light.

anti-aliasing
Smoothing away the jagged edges, or stair-stepping, in an image or computer typesetting. This is done by reducing the difference between the boundary pixels and their neighbors. In printing, using a laser printer, the size of dots is varied so that the smaller ones fill in the "step" and reduce the appearance of a stair. The end result of any regime is to give the appearance of increased resolution.

aperture grille
Design of a monitor screen that uses extremely fine vertically aligned wires to direct the electron beam of a cathode ray to strike the correct color phosphor.

Apple
Make of computer that popularized desktop publishing and is the mainstay of creative industries.

apps
Slang: application software.

archive
Long-term storage of computer data files, usually large files that nobody dares to delete but do not expect ever to refer to again. Requires stable media with good keeping properties.

array
Arrangement of image sensors: of two main types. Two-dimensional, or wide, array has rows of sensors laid side by side to cover an area. The rows define the number of pixels per line, and the number of rows define the number of lines. Linear array has a single row of sensors or a set of three rows. It is usually set up to sweep over, or scan, a flat surface – as in a flat-bed scanner. The number of sensors defines the total number of pixels available.

ASCII
American Standard Code for Information Interchange. **1** Coding system using 7 bits to generate 128 keyboard characters. The standard used in programming keyboards to translate keystrokes into computer-readable characters. **2** Simple word-processing file format widely used, since almost every word-processing program can read it. Identified in a DOS file by ".ASC" suffix.

aspect ratio
Ratio between width and height (or depth). Key property of film formats as well as in publishing and film media.

attachment — File that is sent along with an e-mail, such as an image or other complicated or large item.

AV drives — Hard-disk drive designed for audio-visual work by: **1** being able to deliver a high sustained data transfer rate or **2** delaying calibration checks to idle periods.

B

backup — **1** To make and store second copies of computer files to insure against loss, corruption, or damage of the original files, usually made for vital application files, set-up files, and data files. **2** Copies of original files made as a safeguard against loss or damage.

bas relief — Special-effect photograph in which the subject appears as if sculpted in low relief.

battery — Device for providing or storing electrical power to provide energy for cameras with electronic circuits, for flash-units, motor drives, and other devices. Batteries are designed for different types of use, and some can be recharged when exhausted.

Bézier curve — In graphics or illustration programs, a curve whose shape can be manipulated indirectly by moving control handles at the ends of a line that touches the curve. Also known as a path.

bicubic interpolation — Interpolation technique that bases the new pixel value on an analysis of nearby and neighboring pixels. Said to give best results at the cost of more processing time.

bilinear interpolation — Interpolation technique that bases the new value for a pixel on the average of neighboring pixels. Gives fair results quite quickly, and preferable to nearest-neighbor interpolation.

bit — Fundamental unit of computer information. It has only two possible values – 1 or 0 – representing, for example, on or off or up or down.

bit depth — Measure of amount of information that can be registered by a computer peripheral, and hence used as a measure of resolution of such variables as color and density.

bit-mapped — Type of image file made up of a regular array or raster of pixels.

black — **1** Describes an area that has no color due to the absorption of most or all light. **2** Denoting the maximum density of a photograph.

bleed — **1** Photograph that runs off the page when printed. **2** Spread of ink into fibers of the receiving layer.

bloom — Leakage of excess charge from a highly excited area of a CCD into nearby pixels, causing loss of detail and inaccurate colour and density readings.

BMP — BitMaP: A file format native to the PC-based Windows operating system.

boards — Printed circuit board carrying processors, memory, connectors, and other devices that can be plugged or slotted into a computer to give extra features.

brightness — **1** Quality of visual perception that varies with the amount of light that an element in a visual field appears to send out or transmit. **2** Brilliance of color, related to hue or colour saturation.

brightness range — Difference in the brightness between the lightest and darkest parts of a subject.

browse — To look through a collection of images, for example, files, or web pages.

browser — Software that reads HTML files. It usually also combines other functions, such as hosting e-mail, launching searches, and other aspects of the World Wide Web.

brush — Image-editing tool used to apply such effects as colour, blurring, burn, and dodge. Limited to areas the brush is applied to (like an actual brush).

buffer — Memory component in an output device for the temporary storage of data.

burning-in — Digital image-manipulation technique that mimics darkroom burning-in. It is applied by brushes of varying sizes and has effect of darkening – by increasing the gray content (upping equally the red, green, and blue) – of affected pixels.

byte — Unit of digital information: one byte equals 8 bits. An 8-bit microprocessor handles one byte of data at a time.

C

C — Abbreviation for cyan – a secondary color. It is made by additively combining the two primary colours, red and blue.

cache — Also known as disk cache. RAM dedicated to keeping data that is recently read off a storage device. Since the computer often refers back to recently read data, keeping such data in RAM saves on the access time that would be required to go back again to the storage device.

calibration — Process of matching characteristics or behavior of a device to a standard, such as film speed, or a desired result, such as neutral color balance. Monitor calibration adjusts the color balance and brightness of a monitor to ensure that it reproduces a range of colors that looks the same as a standard. Printer calibration adjusts the output to ensure accurate color reproduction.

capacity — Quantity of data that can be stored in a device. The capacity of a hard disk is measured in megabytes – decimal millions of bytes (not binary millions, which are multiples of 1,048,576).

caption — Short text written on or supplied with a photograph serving to identify the subject, for example, or provide any information such as names, dates, or circumstances not otherwise evident in the image.

card — Printed circuit board carrying processors, memory, connectors, and other devices that can be plugged or slotted into a computer's motherboard in order to provide extra features.

cartridge — Storage or protective device consisting of a plastic or metal casing enclosing the delicate magnetic platter, magnetic tape, or magneto-optical disk.

catch light — Tiny highlight that is usually a reflection of the light source.

CCD — Charge-Coupled Device. A semiconductor device used as an image detector.

CD-ROM — Compact Disk–Read Only Memory. A storage device for digital files, invented originally for music but is now one of the most common computer-storage systems.

chroma Color value of a given light source or patch. Approximately equivalent to the perceptual hue of a colour.

clipboard Area of memory reserved for temporarily holding items during editing. A cut or a copy of selected text, graphic, or other item puts it into the clipboard.

CMYK Cyan Magenta Yellow Key. The first three letters stand for the primary colors of subtractive color mixing – the printing principle used to create a sense of color. A mix of all three at full strength produces a near-black. For good-quality blacks, however, a separate black, or key ink, is needed.

codec Co(mpression) dec(ompression). A routine or algorithm for compressing and decompressing files.

colorize Adding color to a gray-scale image without changing the original lightness values.

ColorSync Proprietary color-management software system to help ensure that colors seen on the screen match those printed or reproduced.

color 1 Quality of visual perception characterized by hue, saturation, and lightness: it is perceived as attributes of things seen. 2 To add color to an image by hand, using dyes, oil paints, or water-based pigments using a brush, spray (air-brush), or some other device, or in an image-manipulation program.

color balance Evaluation of predominance or lack of particular colours or a range of colors in an image.

color cast Tint or hint of color evenly covering an image.

color gamut Range of colors that can be produced by a device or reproduction system.

color management Process of controlling the output of all devices in a production chain to make sure that final results are reliable and repeatable from the point of view of color reproduction.

color model Systematic scheme or theory for representing the visual experience of color by defining any given perception in terms of three or more basic measures. Different models have their own distinct advantages according to the use made of them: LAB is versatile for computation but is not as intuitive as RGB.

color picker Part of an operating system or application that enables the user to select a color for use in, for example, painting or for filling a gradient.

color sensitivity Measure of variation in the way film or a sensor responds to light of different wavelengths.

color space Theoretical construct that defines the range of colors that can be reproduced by a given output device or be seen by the human eye under certain conditions.

color synthesis Re-creating an original color sensation by combining two or more other colors.

color temperature Measure of the color quality of a source of light, expressed in degrees Kelvin.

CompactFlash Miniature version of PCMIA card designed to store data, such as digital files. Needs PCMIA adaptor, but its capacity is limited only by the card.

complementary colors Pairs of colors which produce white when added together as lights (not as pigment).

compliant Device or software that works to specifications or standards set by a corresponding device or software.

compositing Picture processing technique that combines one or more images with a basic image.

compression Process of reducing the size of digital files by changing the way the data is coded. It does not involve a physical change in the way the data itself is stored; there is no physical squeezing or squashing.

continuous-tone image Record in dyes, pigment, silver, or other metals in which smooth, unbroken, transitions from low densities to high densities are enabled by varying the amounts of the substance making up the image.

contone con(tinuous) tone. Any system that provides continuous tone reproduction.

contrast 1 Brightness range in scene, being the difference between the highest and lowest luminance. 2 Colors opposite each other on the color wheel are regarded as contrasting.

convolution Transformation of the values of pixels of bit-mapped images by applying a mathematical function to either single pixels or groups of pixels without changing their number or position.

copyright "Property right that subsists in original literary, dramatic, musical or artistic works" including photographs, which are defined as "a recording of light or other radiation on any medium on which an image is produced or from which an image may by any means be produced, and which is not part of a film". (Copyright, Designs and Patents Act 1988)

CPU Central Processor Unit. Part of the computer that receives instructions, evaluates them according to the software applications, and then issues appropriate instructions to other parts of the computer.

crash The sudden, unexpected non-functioning of a computer due to a fault or problem in a program.

crop 1 To use part, not all, of an image for improving a composition, fitting it into a space in a publication, broadcast, exhibition format, and so on. 2 To scan only the part of an image that is required.

CRT Cathode Ray Tube. The basic technology of computer monitors, so-called because the image seen is created by an electrode (the cathode) that produces a stream (or ray) of electrons hitting and lighting up the phosphors coating the inside of the monitor screen.

cut and paste To remove selected text, a selection of cell contents, a selected part of a graphic or image, and so on from an file and store it temporarily in a clipboard to be used elsewhere, at which point the "cut" selection is said to be "pasted" into its new position.

cyan Blue-green – primary color of subtractive mixing or a secondary color of additive mixing.

D

d-max Measure of greatest or maximum density of silver or dye image attained by film or print in a given sample.

D6500 White balance standard used to calibrate monitor screens. Used primarily for domestic television sets.

dark current Unstable reading given by a CCD even when no light falls on it, thus causing noise in the signal of, for example, videos and digital cameras.

definition Subjective assessment of clarity and quality of detail visible in an image or photograph.

defragmentation A process that rearranges files that have become scattered about in smaller parts on different parts of a hard disk so that they are as close together as possible, making operations quicker.

degaussing Process of removing excess static charge that builds up on the outside of CRT monitors.

delete 1 To remove references to, or the address of, a file. 2 To remove an item, such as a letter, selected part of a graphic, or an image.

density 1 Measure of darkness, blackening, or "strength" of an image in terms of its ability to stop light: in other words, its opacity. 2 Also "packing density". The number of dots per unit area given by a print process, such as a laser or ink-jet printer.

depth 1 Dimension of a picture, page size, or similar measured on the vertical axis, at right angles to the width measurement. Also confusingly referred to as "height" in printing/publishing. 2 Sharpness of an image – how much is sharp. Loosely synonymous with depth of field. 3 Subjective assessment of the richness of black in either a print or transparency.

depth of field Measure of zone or distance over which any object in front of lens will appear acceptably sharp. It lies in front of and behind the plane of best focus. Note that depth of field applies to digital just as much as to analog images. The difference is that digital pre-processing to increase sharpness can give the appearance of increasing depth of field.

diaphragm Design of lens aperture control consisting of a set of curved, opaque blades inside the lens pivoted so that they partially overlap to leave a hole centered on the lens axis. The diameter of the hole determines the setting of the lens aperture.

DIB Device Independent Bitmap. Image file format that allows either the use of indexed colour, in association with a colour map or palette to define a pixel's color, or else defines 24 bits of true color.

digital image Image on a computer screen or any other visible medium such as print, which has been produced by transforming an image of a subject into a digital record, followed by reconstruction of that image.

digitalization See *digitization*.

digitization Process of translating values for brightness or color into electrical pulses representing alphabetic or numerical code.

direct-vision finder Type of viewfinder in which the subject is observed directly by, for example, looking through peep hole or optical device, but not via a reflection in a mirror.

display Device that provides temporary visual representation of data on, for example, a monitor screen, LCD projector, or the information panel on a camera.

dithering Technique for simulating the effect of many colors or shades by using a smaller number of colors or shades in, for example, monitors, LCD screens, printers, and digital cameras.

dodging Picture-processing technique giving an effect similar to that of the darkroom technique of the same name that has the effect of lightening the image.

dot matrix Printer technology based on laying down dots by impacting on a ribbon carrying black carbon or colour to form letters or symbols.

download To copy a file or data from a remote source into a local computer; for example, transferring up-dating and shareware files from the Internet.

down-sampling Reduction in a file's size when a bit-mapped image is reduced in size. Done by systematically throwing away unwanted pixels and information.

dpi dots per inch. Measure of the number of individual dots or drops of ink or toner per linear inch delivered by an ouput device, such as an ink-jet or a laser printer.

drag-and-drop Software technology that permits a file, selection, or similar object to be taken from one program or part of a program to another by the simple mouse action of dragging and dropping the object.

driver Software used by a computer to control or drive a peripheral device, such as scanner, printer, or removable-media drive connected to it.

drop-on-demand Type of ink-jet printer in which ink leaves the reservoir only when it is required.

drop shadow Graphic effect in which an object appears to float above a surface, leaving a more or less fuzzy shadow below it and offset to one side.

drum scanner Type of scanner using a tightly focused spot of light to shine on the subject that is stretched over a rotating drum. As the drum rotates, the spot of light traverses the length of the subject, so scanning the whole area. Light reflected from or transmitted through the subject (in which case the drum must be transparent) is picked up by a photomultiplier tube.

duotone 1 Photomechanical printing process using two inks to increase tonal range. 2 Mode of working in image-manipulation software that permits printing of image with two inks, each with their own transfer curves.

dye sublimation Printer technology based on rapid heating of dry colorants held in close contact with a receiving layer. This turns the colorants to gas, which transfers to and solidifies on the receiving layer.

E

edge effects Local distortions of image density in an image due to the movement of developer and developer products. Simulated by, for example, edge sharpening through the application of digital filters.

edge sharpening Making edges easier to see and, therefore, giving them the appearance of being sharper, usually by digitally creating a slight local increase in contrast at the image boundaries using so-called image-sharpening filters.

effects filters Digital filters that have effects similar to their lens-attachment counterparts giving, for example, starburst, diffraction, and softening effects, but also giving effects impossible with analog filters, such as pixellation and multiple light sources.

encoding Translation or mapping of some data into a set of names or numbers to represent the data.

encryption Computation that takes messages or data and turns them into a ciphertext that looks like gibberish. The encryption process uses a key or password. In order for the messages or data to be read back (decrypted), the recipient of the ciphertext must possess the password.

Energy Star Program initiated by environmental concerns to reduce the electricity used by computers, monitors, and printers, especially when they are standing idle – which is most of the time.

engine 1 The internal mechanism that drives devices, such as printers and scanners. The same engine may be used in equipment from different manufacturers. 2 The core parts of a software application.

enhancement 1 Change in one or more qualities of an image in order to improve the visual or other properties of an image, such as an increase in color saturation or sharpness. 2 Effect produced by a device or software designed to increase the apparent resolution of a TV monitor screen.

EPS Encapsulated PostScript. File format that stores an image (graphics, photographs, or page layout) in PostScript page-description language.

erase To remove or wipe a recording from a disk, tape, or other recording medium (usually magnetic) so that it is then impossible to reconstruct the original record. Compare with delete.

exposure Process of allowing light to reach light-sensitive material or sensors to create a latent image. Produced by opening a shutter, for example, or illuminating a dark subject with flash of light.

extrude To create a three-dimensional solid by defining, first, a cross-section and then, second, a path along which the cross-section runs. The volume thus enclosed is the extruded solid.

F

fade 1 Presentation technique in audiovisual or multi-media shows in which an image is made to darken from full brightness to black (fade out) or emerge to full brightness from black (fade-in). See *dissolve*. 2 Gradual loss of density in silver or dye image over time caused by deterioration.

fall-off 1 Loss of illuminance in the corners of an image as projected by a lens. 2 Loss of light toward the edges of an illuminated scene. 3 Loss of image sharpness and density away from the center of a flat-bed scanner whose CCD array is shorter than the width of the scanned area.

false color Term usually applied to images with an arbitrary allocation of image colors to the subject's lighting.

feather To blur a border by reducing the sharpness or suddenness of the change in value.

file attribute Code kept with the file that indicates its status: whether it is read-only, for example, or whether it is hidden from the system.

file format The way in which a software program stores data. Determined by the structure and organization of the data and specific codes.

fill In a graphics, three-dimensional, or painting program, to replace a space or volume with a color, texture, or pattern.

fill-in 1 To lighten or illuminate the shadows cast by the main light. 2 Light source or accessory used to lighten or illuminate shadows cast by the main light. Both apply to shadows cast by the sun or other available light, as well as lighting on a studio set.

filter 1 Optical accessory used to cut out certain wavelengths of light and pass others. Consists of a transparent medium coated or dyed with material that selectively absorbs certain colors. 2 Part of image-manipulation software written to produce special effects. 3 Application software used to convert one file format to another.

fingerprint Technology for marking a digital image file in a way that is invisible and that survives all normal image manipulations, but which can still be retrieved by suitable software. The marker carries a unique code.

Firewire Standard for very fast data exchange.

fixed focus Type of lens mounting that fixes a lens at a set distance from film. The lens usually set on the hyper-focal distance.

flare Non-image-forming light in an optical system that degrades image quality.

FlashPath Accessory that enables a SmartMedia card to be read in a standard floppy-disk drive.

Flashpix Image-file format of pyramid type: there is a small-sized version, medium-sized version, and full-sized version. This takes more space than a normal file, but is easier to display on the monitor.

flat-bed scanner Type of scanner using sensors arranged in a line and focused via mirrors and lenses on the subject. As the sensors traverse the length of the subject, they register the varying light levels reflected off it.

flatten To combine together multiple layers and other elements of a digitally manipulated or composited image into one.

f/number 1 Setting of a lens diaphragm that determines the amount of light transmitted by the lens. 2 Equal to the focal length of a lens divided by the diameter of the entrance pupil.

focal length Distance between the point from which the image of a subject appears to be projected and the image itself, when the lens is set at infinity.

focus 1 To make an image look sharp, usually in order to bring the film or projection plane into coincidence with the focal plane of the optical system. 2 The point or area on which the viewer's attention is fixed or compositional elements converge.

format 1 Shape and dimensions of the image on a film. 2 Orientation of image: landscape (if the image is oriented with the long axis horizontal) or portrait (if the image is oriented with its long axis upright). 3 Type of computer file structure.

frame An image in a sequence of interrelated images, such as an animation or in a cinematographic film.

FST Flatter Squarer Tube. Design of a monitor screen or a cathode ray tube in which the visible face is aspherical – flatter and squarer.

G

gamma Measure of contrast of, for example, a monitor screen.

gamma correction Control of the contrast of a monitor image by using software, the operating system, or monitor controls.

GCR Gray Component Removal. A technique for reducing the amount of ink needed to produce certain colours.

GIF Graphic Interchange Format. A compressed file format

that is designed for use on the Internet. Comprises a standard set of 216 colors.

gradient Type of fill in which the density or a hue or color changes smoothly from one value to another. The shape of the variation may be, for example, linear, circular, or diamond shaped.

grain Individual specks of silver or the individual dye-clouds that make up a silver-based image. Unlike in a digital image, these specks vary in size and are randomly distributed.

graphic accelerators Input device for fine or precise control of a cursor or brush when used in graphics, painting, or image-manipulation programs.

graphics tablet Accessory add-on card designed to speed up the operation of a monitor.

gray level See *gray-scale*.

gray-scale Measure of the number of distinct steps between black and white that can be recorded or reproduced by a system. For normal reproduction, a gray-scale of at least 256 steps is required.

greeking Representation of text or images as gray blocks or some other simple approximation.

H

half-tone Reproduction based on fact that either ink is placed on the receiving layer or not; its strength cannot be varied by dilution. Continuous tone must, therefore, be simulated by varying the size of the dots of ink. Laser and ink-jet printers and book and magazine printing are all half-tone.

hard copy Visible form of a computer file printed on to a support, such as paper or film.

histogram Graphical representation showing the relative numbers of pixels over a range of values. The taller the column at a certain value, the more pixels have that value.

HTML Hyper Text Mark-up Language. File format that embeds mark-ups or tags into the text, which can then be read by Internet browser software.

hue Name given by an observer to the visual perception of color.

I

indexed color Method of creating color files or defining a color space. The index refers to a table of some 256 different colors, but these are chosen from a palette of 16.8 million different colors.

ink jet Printing technology based on the controlled squirting of extremely tiny drops of ink on to a receiving substrate.

interpolation Process of adding extra pixels into an existing digital image. Used to: **1** re-size an image file when a bit-mapped image is enlarged; **2** give an apparent (but not real) increase to resolution – in scanned images, for example.

J

jaggies See *stair-stepping* and *alias*.

JPEG Joint Photographic Expert Group. Acronym referring to a data-compression technique that can reduce file sizes to as little as 10 percent of their original size with some loss of image quality.

K

k kilo, or one thousand. Compare with *K* below.

K **1** KiloByte. Binary thousand – 1,024, or 210 bytes of data. **2** Key color or black. The fourth color separation in CMYK four-color reproduction.

KB KiloByte: often abbreviated to K.

keyboard shortcut Combination of key strokes that executes a command, usually the equivalent of more long-winded access to that command by using the mouse to roam through drop-down menus.

key tone **1** The black in an image. **2** The principal or most important tone in an image.

L

layer mode Picture-processing technique determining the way that a layer in a multilayer image combines or interacts with the layer below.

light **1** That part of the electromagnetic spectrum, from about 380 to 760nm (420 to 760nm for older people), that can be sensed by human eyes and that gives rise to visual sensations. **2** To manipulate sources of light and light-shapers to alter the illumination on a subject.

line art Artwork that consists of black lines and areas with no intermediate gray tones.

load **1** To copy enough of the application software into the computer's RAM for it to be able to open and run the application. **2** To copy a file into the computer's RAM so that it can be opened. **3** The strain put on the electrical power supply when a device is operating and drawing current.

lossless compression Computing routine that reduces the size of a digital file without reducing the information in the file, resulting in no loss of data.

lossy compression Computing routine that reduces the size of a digital file by discarding some data.

low-pass filter Filter, of software or optical type, that lets through low-frequency data and blocks higher-frequency data. Softening filters used for portraiture are low-pass – they let through the low-frequency data of facial shape and main features, but block high-frequency data, such as wrinkles and blemishes.

lpi lines per inch. A measure of resolution or fineness of photomechanical reproduction.

LZW compression Lempel-Ziv Welch. A compression algorithm for lossless file compression.

M

M Abbreviation for magenta – a blue-red color.

Mac Apple Macintosh computer.

macro **1** Closeup range giving reproduction ratios within the range of about 1:10 to 1:1 (life-size). **2** Small routine or program within a larger software program that performs a series of operations: may also be called a script or action.

marquee Selection tool used in image-manipulation and graphics software.

mask **1** Technique used to obscure selectively or hold back parts of an image while allowing other parts to show. **2** Array of values that are used by the computer in digital image processing to calculate such digital filter effects as unsharp masking.

master **1** Original or first, and usually unique, incarnation of a photograph, file, or recording – the one from which copies will be made. **2** To make the first copy of a photograph, file, or recording.

matrix A flat, two-dimensional array of CCD sensors.

matte Mask that blanks out an area of the image to allow another image to be superimposed.

megapixel Million or more pixels. Specification of an image-capture device, usually a digital camera, based on number of pixels nominally available on the CCD.

MO Magneto-Optical. Digital-storage technology.

modem mo(dulator)-dem(odulator). Electronic device that enables a computer to use a telephone system.

monochrome Photograph or image made up of black, white, and grays, which may or may not be tinted.

morph Metamorphose. Animation technique that produces a smooth transition of distorting effects.

MPEG Moving Picture Experts Group. Digital standards for video and sound file formats and compression.

N

native **1** File format belonging to an application program, usually optimized for the program. **2** Application program written specifically for a certain type of processor.

noise Unwanted signals or disturbances in a system that tend to reduce the amount of information being recorded or transmitted. In scanners, it may be caused by electrical disturbance or mechanical instability. In digital cameras, it may be caused by, for example, heat causing disturbances in the minute currents generated by a CCD.

Nyquist rate In signal processing theory, the sampling rate needed to turn an analog signal into an accurate digital representation of it is twice the highest frequency found in the analog signal.

O

object-oriented **1** Page-description language that uses such basic objects and actions as line, fill, and rotate to define graphic objects, such as letters and designs. Such languages are resolution-independent – resolution is not defined by the file itself but by the output device. **2** Programming language that uses basic objects, such as windows and sets of functions, to produce application software.

off-line Mode of working with data or files in which all the required files are downloaded or copied from a source to be accessed directly by the user.

off-set **1** To transfer ink or dye from one surface to another before printing on the final surface. **2** Calibration or other marks or parts of an image that are set off alignment – shadow effects for text, for example.

on-line Mode of working or operating with data or files in which the operator maintains a connection with a remote source.

operating system The software program that underlies the functioning of the computer, allowing applications software to use the computer.

optical viewfinder Type of viewfinder that shows the subject directly, through an optical system, rather than via a monitor screen, such as the LCD screen common on digital cameras.

orthogonal Of tool or operation. Lines which are straight and only oriented either vertically or horizontally.

OS See *operating system*.

out-of-gamut Color or colors that are visible or reproducible in one colour space, but which cannot be seen or reproduced in another.

output **1** Result of any computer calculation – any process or manipulation of data. **2** Hard-copy printout of a digital file.

output device Equipment or mechanism used to make visible or display computer output, such as monitors, printers, and video projectors.

P

paint **1** In picture processing, to apply color, texture, or effect with a digital "brush". **2** Color applied to an image, usually by altering the underlying pixels of bit-mapped images or by filling a defined brush stroke of graphics objects.

palette **1** In drawing, image-manipulation programs, and so on, a set of tools, such as brush shapes, and their controls presented in a small window that is active, together with other palettes and the main document window. **2** Range or gamut of colors available to a color-reproduction system, such as a monitor screen, photographic film, or paper.

Pantone Proprietary name for system of color coding and classification.

PCI Peripheral Component Interface. Standard slot supplied in PC-compatible and Mac OS-compatible computers to accept accessory cards. Designed to give expanded functions, such as video-capture and graphics acceleration.

PCMIA Personal Computer Memory Card Interface Adaptor. A standard interface, especially with portable computers, for connecting accessories, such as hard disks, modems, and memory cards.

peripheral Any device connected to a computer. Short for peripheral unit, formerly used to distinguish the central processor unit (now loosely called the "computer") from the components attached to it.

Photo CD Proprietary system of digital-image management based on the storage of image files (called Image Pacs) onto CDs. The system scans an image to digitize it into Kodak's YCC format, which is stored on the CD at five different levels of resolution. The maximum capacity of a disk is about 100 images. Professional Photo CD-ROM offers higher resolution (to 64 Base – 4096 pixels) and more control.

photograph Record of physical objects, scenes, or phenomena made with a camera or other device, through the

agency of radiant energy, onto sensitive material from which a visible image may be obtained. "…a recording of light or other radiation on any medium on which an image is produced or from which an image may by any means be produced, and which is not part of a (moving image) film." (Copyright, Designs and Patents Act 1988)

photomontage **1** Photographic image made from the combination of several other photographic images, or similar material. **2** The process or technique of making a photomontage.

PICT Graphic file format widely used on the Mac OS system, designed for screen images.

picture element See *pixel*.

piezoelectric Material that produces electricity when distorted, such as by bending or squeezing, or which distorts when an electric field is applied to it. Underlying technology of certain ink-jet printers.

pixel Picture element – the smallest, atomic unit of digital imaging used or produced by a device. Always arranged in a regular grid or raster pattern, which is usually square in shape.

pixelation Appearance of an image whose individual pixels are clearly discernible.

plug-in Application software that works in conjunction with a host program into which it is "plugged" so that it appears to be part of the program itself. Also used to interface the program with a device, such as a digital camera or scanner.

posterization Representation of an image using a relatively very small number of different tones or colors, which results in a distinctively banded appearance and flat areas of color.

PostScript Language designed to specify elements that are printed on a page or other medium. It is vector-based, so the output resolution depends only on the output device.

pre-scan A low-resolution view of the object to be scanned.

primary color One of the colors red, green, or blue. "Primary" in the sense that the human eye has peak sensitivities to red, green, and blue and that visible colors are perceived through the agency of varying sensations produced by a combination of these colors.

process color A colour that can be reproduced with the standard web-offset press (SWOP) inks of cyan, magenta, yellow, and black. With the introduction of six-ink printing, the gamut of process colors has been significantly enlarged.

proofing Process of checking or confirming the quality of a digital image before final output, particularly a long printing run producing many copies. Proofing systems include soft-proof on monitor screens calibrated to appropriate printers.

proxy Small, low-resolution version of a file used to stand in for larger file in making composite images or page layouts.

Q

quality factor Multiplication factor used to ensure that graphics or image-file information is large enough for good-quality reproduction.

quantization Process of dividing or sampling a continuously varying signal or quality into a series of discrete levels or quanta for the purpose of creating an accurate copy or facsimile of the signal.

QuickDraw Object-oriented graphics language native to the Mac OS. It tells the computer how to draw what is seen on the monitor screen and may be used to output, for example, text to printers.

QuickTime Software technology in Mac OS for recording, manipulating, and playing back any time-based data, such as video, animation, and sound.

quit To exit or close a program.

qwerty **1** Design of keyboard dating from the beginning of the 20th century, intended to slow down a typist's fingers to prevent the striker keys of a typewriter from jamming. **2** The first five letters on a standard keyboard.

R

RAID Redundant Array of Independent Devices. A configuration of hard-disk drives that share data and markers for data in order to minimize loss due to the corruption or break-down of one drive.

RAM Random Access Memory. A component of the computer in which information can be stored or directly accessed.

raster The regular arrangement of addressable points of any output device, such as printer and film-writer.

refresh rate The rate at which one frame of a computer monitor screen succeeds the next. The faster the refresh rate, the more likely the image will appear stable.

rendering **1** Computation to create the appearance of a fully formed object using data from outline drawings, data on shading of the surface, and information about light sources. **2** Computation that turns outline data into a specific form for use by other programs or devices. Often used to mean converting resolution-independent information, such as vector-based graphics, into a file of specific resolution for specified purpose. See *RIP*.

res Measure of the resolution of a digital image expressed as the number of pixels per side of a square measuring 1 x 1mm. For example, a res40 image has a resolution of 40 pixels per millimeter – or 1,600 pixels per square millimeter.

resizing Changing the resolution or file size of an image. Reducing the resolution or file size results in irreparable loss of information as unwanted data is discarded.

RGB Red Green Blue. Color model that defines colors in terms of the relative amounts of red, green, and blue components they contain. Black is defined as having zero amount of the components; white is defined as having maximum amounts of the components.

RIP Raster Image Processor (Processing). Software or hardware dedicated to the conversion of outline fonts and graphics into rasterized information – for example, to turn outline instructions, such as "fill" or "linejoin" into a set of dots for specific output.

ROM Read-Only Memory. A type of memory generally reserved for use by the processor, or computer, to run the system.

S

sampling
Part of the process of analog-to-digital conversion in which the value of a changing quantity at a given point in space or time is measured.

saturation
Objective measure of a quality of color subjectively experienced as its depth or richness. High saturation equates with a rich color. Saturation is generally reduced by the presence of white light or gray colors.

scanner
Opto-mechanical instrument used for analog-to-digital conversion of, for example, transparencies, prints, and textiles.

scanning
Process of using a scanner to turn an original into a digital file.

scrolling
The process of moving to a different portion of a file that is too large for the whole of it to fit onto a monitor screen.

SCSI
Small Computer Systems Interface. Standard for expanding a computer by plugging in such items as hard disks, scanners, and printers. A maximum of seven items, in addition to the base computer, can be added. Each item must be identified by a unique SCSI ID (identification), and the last one must be terminated.

shareware
Class of software that is offered on the basis of "use, then pay". The software is free to try out but should be paid for if it is kept and used.

SmartMedia
Type of very compact and lightweight storage device. Maximum capacity that can be used in, for example, a digital camera depends on equipment circuitry.

soft proofing
Use of a monitor screen to confirm the quality of an image.

stair-stepping
Jagged, rough, or step-like reproduction of a line or boundary that was originally smooth.

storage media
Electromechanical devices designed to store large quantities of digital data. Two main types are in use: magnetic stores data as electrical charges; optronic devices use light from laser beams to store data, for example, CD-ROM and DVD.

subtractive color
Color obtained by taking out a primary colour from white. For example, remove blue and then red and green remain. These two colors combine to create the subtractive primary of yellow.

synchronization
Technology or process of ensuring the proper timing of different events. For example, sounds have to be simultaneous with their corresponding action, or electronic flash must fire only when a camera's shutter is fully open but before it starts to close.

system requirement
Specification defining the minimum configuration of equipment and the version of the operating system needed to open and run application software or a device.

T

terminator
Plug or internal switch that terminates, or closes off, an SCSI chain. Without it, the system cannot work out how many items are plugged in.

texture mapping
Process in which a three-dimensional image is mapped on to a two-dimensional image, with the effect that the flat image colors the three-dimensional image, usually with the intention to give the appearance of solid textures.

thumbnail
Representation of an image as a small, low-resolution version of the original.

TIFF
Tag(ged) Image File Format. The most commonly used raster image file format thanks to its flexibility and openness to compression. The standard allows "tags" as special descriptors, so not all TIFF files are 100 percent compatible.

tile
1 Part of a larger, bit-mapped image. **2** To print in smaller sections a page that is larger than the printing device can print directly.

tint
1 Color reproducible with process colors; a process color. **2** An overall, usually light, colouring that tends to affect areas with density, but does not affect clear areas (in contrast to a color cast).

tonal distortion
Property of an image in which contrast, the range of brightness, or colors appear to be markedly different from that of the subject.

transparency
1 Film in which the image is seen by illuminating it from behind, most commonly in the form of a color transparency. **2** The degree to which a background color can be seen through a pixel of a different color in the foreground. Pixels that are 100 percent transparent are invisible, while those pixels that are 0 percent transparent will completely obscure the background color.

transparency adaptor
Accessory or part of a scanner that enables scanning of transparencies. It usually consists of a light source that moves in step with the scanner array.

tru(e)color display
Any device, particularly color monitors, that can show as many colors as can be distinguished by the human eye – some 15 million in total. Formerly referred to devices showing 32,768 colors, but this standard has now been truly superseded.

TWAIN
Toolkit Without An Important Name. Driver standard used by computers to control scanners.

U

undo
Reverse an editing or similar action within application software to take a document back to the state before the action occurred. Most, but not all, actions have one level of undo – in other words, just one action can be undone. Multiple levels of undo are provided by some software applications.

USB
Universal Serial Bus. Connector design for connecting peripheral devices, such as a digital camera, data-storage equipment, or a printer, to the computer. Up to 127 peripherals can be added together using hubs.

USM
UnSharp Mask. Image-processing technique that has the effect of improving the apparent sharpness of an image. Note that it is the mask that is unsharp; the result is sharpened.

V

variable contrast
Type of emulsion coating, used mainly on black and white printing papers, in which the mid-tone contrast can be varied by changing the spectral qualities of the illumination.

vector graphics
Definition of graphical elements by a programming

language in terms of primitives, such as lines, which are manipulated – for example, rotated or extended – and areas are filled.

vignetting **1** Defect of an optical system in which light at the edges of images is cut off or reduced by an obstruction in construction – for example, when the elements used in a lens are too small. **2** Visual effect of darkened corners used to help frame an image or soften a frame outline.

virus Program designed to enter a computer system undetected and then cause a nuisance, or worse. Thousands are known for PC-compatible machines. They can enter when disks are shared, when files are downloaded from the Internet, or as macros to application programs. The few viruses that infect Apple Macs are often called "worms".

VRAM Video Random Access Memory. Rapid-access memory dedicated for use by the computer to control the monitor's image. 2MB of VRAM can give millions of colors up to a resolution of 832 x 624 pixels; 4MB of VRAM can give millions of colors up to a resolution of 1,024 x 768 pixels; 8MB of VRAM is needed to give millions of colors at higher resolutions (all assuming a vertical refresh rate of about 75Hz).

W

warm colors Subjective term referring to colors in the range of reds through oranges to yellows. A warm color cast appears more acceptable in more circumstances than a cold color cast.

watermark Element in a digital image file used to identify the copyright holder.

windows Rectangular frames on the screen of computer software that "open" onto applications. Operations take place within these frames, or windows.

Windows Proprietary name for a graphical user interface between the user and the underlying operating system.

worm Type of program virus that is designed to seek out data and change it. A Mac OS-specific virus.

WORM Write Once, Read Many. A class of storage media that cannot be altered – rewritten – but can be read many times. Examples include CD-ROM, laser disc, and phonograph record. Also a specific type of optical-storage device.

write **1** Process in computing of placing data or instructions into a receiving component, such as memory, the central processor unit, storage media, and so on. **2** Process in digital photography of transferring digital information onto light-sensitive materials.

WWW World Wide Web. Essentially a gigantic, worldwide hypertext document held on various computers around the world, which are all linked together by the Internet.

wysiwyg What you see is what you get. A feature of a computer interface that shows on the monitor screen a good (but seldom very accurate) representation of what will be printed out. With image applications, good WYSIWYG depends on good-quality, well-calibrated equipment.

X

x-height Measure of the size of a font (typeface). It is the distance from the baseline to the top of the lower-case letter x. It is often used as the basis for quoting font sizes.

Y

Y Abbreviation for yellow. Created by the additive combination of red and green.

YCC Kodak proprietary Image-file format. Used for the Photo CD.

Z

Zip Brand of removable storage device: each disk holds up to approximately 100MB of data.

zoom **1** In optics, a change of focal length without any substantial change of focusing – the image becomes larger or smaller at a given subject distance. **2** A software feature that allows a change of magnification of the file on display – zooming in increases the magnification to show less of the file in more detail; zooming out decreases magnification to show more of the file in less detail.

Web-sites and books

Access to the Internet can be important for digital photographers. All digital camera manufacturers and software producers have a presence on the web, and their sites are worth visiting both for news and updates as well as for technical support. Some allow you to send queries and comments direct to the manufacturer, which is worth doing even if you don't receive a direct reply, since all manufacturers need to know what their customers think about their products. Many sites allow you to download software updates (to replace your software with new versions) and even images for you to use.

Useful web-site addresses

Typing in the manufacturer's name usually locates their web-site. Among the best are: Kodak at *www.kodak.com*; Adobe at *www.adobe.com*; and Apple at *www.apple.com*.

It is also worth visiting the web-sites of the main equipment manufacturers, such as Nikon, Olympus, Epson, Agfa, Fuji, Sony, Ricoh, and Hewlett Packard. For less biased information, there are web-sites produced by independent writers or by retailing organizations. One excellent site is the *British Journal of Photography* at *www.bjp.com*.

However, you need to bear in mind that the Internet is volatile and many web-sites disappear without a trace. Other sites may then appear and contain excellent information for a short time, but then tail off in quality as their authors become bored or occupied with other activities.

At the time of writing, the following sites were worth visiting for the general information they contain on digital cameras, scanners, and other related equipment: *www.imaging-resource.com*; *www.pcphotoforum.com*; *www.dcforum.com*; *www.peimag.com*; *www.dcresource.com*; *www.photo-on-pc.com*; *www.nyip.com*.

For information on the pricing of digital cameras, try: *www.digicampage.com*.

For information on large-format, professional-quality digital photography, try: *www.digital-photography.org*

An excellent glossary of terms, which leads you to other web-sites, can be found on: *www.mdagroup.com*.

There are numerous sites offering advice on using Adobe Photoshop. Try: *www.tema.ru/p/h/o/t/o/s/h/o/p* or *www.photoshoptips.i-us.com*, as well as the Photoshop home-page on the Adobe site at the address above.

Books

The best way to com e to grips with digital photography is to take the plunge and start learning from experience. But it probably will not be long before you feel the need for a deeper understanding of the technology and techniques involved to clear up any points you find confusing. Many books available on digital imaging or computing topics offer a CD-ROM, which can be useful.

Digital Image Creation
Written by Hisaka Kojima and available through Peachpit Press. Numerous examples of art and commercial images created digitally. Contains an excellent variety of work but is thin on hard information.

Electronic Imaging for Photographers
Written by Adrian Davies and Phil Fennessy and available through Focal Press. Contains a lot of technical information you need, but it is rather uneven and unexciting to read.

Macworld Photoshop 5 Bible
Written by Deke McClelland and available through IDG Books. A very comprehensive and thoroughly enjoyable in-depth reference, suitable for both the beginner and the advanced Adobe Photoshop worker alike.

Photoshop 5 Wow! Book
Written by Linnea Dayton and Jack Davis and available through Peachpit Press. Probably the best introduction to Adobe Photoshop. A basic book, but with numerous illustrations and a good CD-ROM.

Photoshop in 4 Colors
Written by Mattias Nyman and available through Peachpit Press. A good introduction to reproducing and printing digital images.

Picture Editing
Written by Tom Ang and available through Focal Press. Covers all aspects of choosing, using, commissioning, and publishing pictures.

Real World Scanning and Halftones
Written by David Blatner and Steve Roth and available through Peachpit Press. Detailed advice to help you get the best printed results from scanning.

Silver Pixels: An introduction to the digital darkroom
Written by Tom Ang and available through Aurum Press. Shows how to simulate conventional darkroom-processing effects using a computer.

Start with a Scan
Written by Janet Ashford and John Odam and available through Peachpit Press. Full of ideas and numerous techniques for transforming scanned photographs.

The Cyberspace Lexicon
Written by Bob Cotton and Richard Oliver and available through Phaidon Press. An illustrated dictionary of computer terms – almost more useful as a visual resource.

Using HTML, Java and Javascript Platinum edition
Edited by Eric Ladd and Jim O'Donnel and available through QUE Corporation. An excellent reference for Internet programming. CD-ROM with more reference texts.

How this book was produced

A glance at the details of the cameras used to take the photographs in this book shows that nearly all of them were conventional types using conventional film and chemical processes. It may seem that a book on digital photography should use predominantly digital cameras. But I decided to use only the best digital cameras for the few images that could not be taken any other way. There are two reasons for this.

First, most digital cameras (at the time of writing) are not ready to deliver images of the quality required for this book. Second, digital photography is not just about images taken with digital cameras – it encompasses conventional photographs, too. In fact, I believe that for a long time yet digital processes will work side by side with conventional ones. The computer, working digitally, will become as essential to photography as the chemical processing machine ever was. And there was a third reason why so many of the images were taken conventionally – digital photography is so young that there are few photographers with the wide range of digital images needed for this book.

Thus, the start of this book represents the start for many photographers coming into digital photography for the first time, bringing with them an existing collection of images – in this case, mostly 35mm transparencies. These were scanned on a Nikon SuperCoolscan 2000, which uses proprietary technology to remove dust and scratches. It does the job very well but to make up for a certain amount of blurring that results, the scanner was set up to sharpen the images. While removing dust slows down scanning, it minimizes the need for post-scanning processing, which is a great boon. For larger transparencies and flat-copy, I used a Heidelberg Ultra Saphir II flat-bed scanner. Almost every image in this book was scanned on these machines and then processed for color balance, dust and scratches, and image sharpness. This illustrates that even modestly priced equipment is able to deliver excellent reproduction quality.

Scanned images were stored on Iomega Jaz 2GB disks, backed up on CDs. The main computer used for book production was a Power Macintosh 9500/120, equipped with 2GB and 4 GB hard disks and 392 MB of RAM, using a graphics accelerator with 8MB of VRAM controlling a 20in (50cm) Sony Trinitron monitor. The main computer was backed up by networking it with a Macintosh PowerBook G3/266 with 192MB of RAM and a 4GB hard disk.

Working with two machines at once (and I could have done with a third at times) made it possible to write and lay out this book in what feels like a record time. Scans were made on one machine while I continued working on the other, or while one machine churned through a filter effect, I could compose an e-mail.

Images were processed in Adobe Photoshop, version 5.0.2, and many were also put through Equilibrium DeBabelizer, version 3. DeBabelizer is excellent for household chores, such as turning entire batches of images from digital cameras into the right format or to give a batch of scans thumbnail previews. For keeping track of images I made much use of Extensis PortFolio. The writing was done using Microsoft Word 98, whose AutoCorrect and AutoText features saved me a considerable amount of keyboard time. For the book design, I drafted suggestions for the designers using Quark XPress version 4. To keep my machine working, I used Norton Utilities version 4 to prevent disk problems and to de-fragment the hard disks.

Having a close association with the book design meant that I could scan with a good idea of the final image size. So, if I decided the image did not rate being larger than, say, one column wide, I would scan it to a 39mm width (1mm larger than the actual column size) at a resolution of 360dpi – not at a nominal 200mm width just in case the image might be used large. If the designers wanted a picture used at a larger size, I simply rescanned it. This precision helped to reduce file sizes. Even so, by the halfway mark, the book was well over 1GB in size.

In all these file manipulations, the easily forgotten piece or rather family of software is the Mac OS – the operating system of the Apple Macintosh – versions 8.1 and later 8.5. It was a dream to work with. It was always easy to change file names, and there was no problem with shuffling files from one folder to another or transferring files from one machine to another. One piece of Mac housekeeping was essential – rebuilding the Desk Top file. Since digital photography creates many files that you move around a great deal, the computer has to update its own records to keep up with all the changes. Rebuilding the Desk Top cleans out obsolete files and prevents them interfering with current work. I did this every few days.

One of the secrets of a keeping a sizeable project such as this afloat is file management. For a start, we kept multiple copies of master files. At the end of every day's work I would make two copies. Every week or so, I would make a copy that I kept at a different address from my other copies. From time to time, I would spend a few hours backing the whole lot up on CDs. The designers also kept their own versions. Instead of making one large document with many pages, most of the book was laid out as individual double-page spreads. This did not slow down our working – on the contrary it speeded it up because all computers are happiest (less prone to crashing and working at their fastest) with small files. To tie in with this, picture files were kept in separate folders for each spread.

INDEX

ACKNOWLEDGMENTS

A book such as this, at the cutting edge of rapid developments, must rely on experts who are willing to share their expensively won experience and expertise. Foremost among these is Simon Joinson, my editor on the magazine *What Digital Camera,* whose affable and effortless command of the subject has inspired many thousands of readers. I'm also grateful to Matthew Williams, another colleague on *What Digital Camera,* for the many insights that pop from his lively and ever enquiring mind, as well as for the acute observations picked up from the researchers of the Image Technology Research Group at the University of Westminster – who take nothing for granted and all ideas to pieces. Many thanks to colleagues at Westminster for finding resources to enable me to complete this book, namely Professor Brian Winston, Professor Paddy Scannell and Andy Golding. Thanks are also due to Shirley O'Loughlin for so ably taking over the running of my course and proving that I'm not indispensable. Thanks as well to designers Mike Lucy and Mike Gallop for their attentive professionalism, and Rebekah in London and Lucy in New Zealand for being such excellent models.

I'm also extremely grateful to Steve Caplin, Tania Joyce, Catherine McIntyre, and Sandy Gardner for their time, generosity with information and superlative contributions – all of which lift the book well beyond what I could hope to achieve myself; particular thanks to Catherine and Sandy for their unquenchable enthusiasm.

That the book came to be written at all is really due to the foresight and investment of those in the business of giving us the new technologies – with, of course, the intention of making lots of money. It is therefore a pleasure to thank the following manufacturers and distributors for their contributions to the book: Computers Unlimited for their unconditional and generous help in providing key software products such as the Extensis range, including PhotoTools and PortFolio; Equilibrium DeBabelizer and GoLive CyberStudio (now Adobe GoLive); and Kodak, who more than any other business leader has put its mighty shoulder behind digital photography; the book has also benefited from the use of the DCS315 camera. I should also like to thank Peter Woodcock of Kodak New Zealand and Trevor Lansdown of Lansdown PR for doing more than their jobs' worth; Nikon, who loaned their brilliant 70-180mm zoom lens and their excellent Coolscan 2000 film scanner; and Heidelberg, who helped out with the splendid Ultra Saphir II flat-bed scanner.

At Mitchell Beazley, executive editor Judith More, senior editor Michèle Byam, and executive art editor Janis Utton were the kind of accomplished professionals I love to work with – treating me with kid gloves enclosing iron fists. Thank you all for your precision working and implacably perfectionist eyes.

Finally, I want to reserve my greatest and warmest thanks to Wendy Gray for her foresight and energy which encouraged me to invest in digital photography in the first place. From this the rest simply flows.

IMAGE CREDITS
Spiral Galaxy on p. 11: material created with support to AURA/STSci from NASA contract NAS5–26555 is reproduced with permission, courtesy of J. Trauger (JPL) and NASA; Hurricane Bonnie on p. 11: image © NASA TRMM, reproduced by kind permission of NASA Tropical Rainfall Measuring Mission – see *www.gfsc.nasa.gov;* lacquer box on p. 49 is by Kholin; all images on p. 74 and pp. 82–5 © Steve Caplin; all images pp. 76–81 © Catherine McIntyre; all images pp. 86–91 © Sandy Gardner; all images pp. 92–5 © Tania Joyce; for permission to photograph the garden on pp. 112–13, the Estate of David Hicks is gratefully acknowledged; photographs on pp. 21 and 40, base image for pp. 66–7, and photograph on p.109, top left all © Wendy Gray.

Tom Ang,
April, 1999